THE
EXTRAORDINARY MUSEUMS
OF SOUTHEAST ASIA

THE EXTRAORDINARY MUSEUMS OF SOUTHEAST ASIA

BY KRISTIN KELLY

HARRY N. ABRAMS, INC., PUBLISHERS

FOR CHRIS AND THE AMAZING
CHILDREN, CHRISTOPHER, AHPI,
AHKOM, AND AHMI.

Editor: Adele Westbrook

Designer: Raymond P. Hooper

Library of Congress Cataloging-in-Publication Data

Kelly, Kristin.
 The extraordinary museums of Southeast Asia / by Kristin Kelly.
 p. cm.
 Includes bibliographical references (p.).
 ISBN 0-8109-2994-5
 1. Museums — Asia, Southeastern — Guidebooks. I. Title

AM79.A785 K45 2000
069'.0959 — dc21

 00-058279

Front cover: Detail of the exterior of the Vimanmek Manion Museum
 in Bangkok, Thailand. Photo: John McDermott

Back cover: The entrance to the Raffles Hotel Museum in Singapore.
 Photo: Courtesy Raffles Hotel

Kristin Kelly is a Senior Project Manager at the Getty Conservation
Institute in Los Angeles. From 1990 to 1999, she held the position of
Manager of Administration at the J. Paul Getty Museum. She has an
A.B. from Bryn Mawr College and a Ph.D. in History of Art and
Archaeology from Columbia University.

Printed and bound in Hong Kong

 Harry N. Abrams, Inc.
100 Fifth Avenue
New York, N.Y. 10011
www.abramsbooks.com

TABLE OF CONTENTS

ACKNOWLEDGMENTS

My debts to colleagues and friends in the United States and in Asia are many. Without their help and support, the reader would not be holding this book.

My greatest debt is to my colleague John McDermott, whose astonishing photographs have animated the book and given it more life than I could have ever imagined. Without him, this book would, literally, not have been completed. His sensibility and his acute perspective on Southeast Asia have been of enormous value during the project. His diplomatic skills—often in the face of massive irrationality—were invaluable and salvaged the project more than once. His humor, common sense, and thoughtfulness never flagged. The partnership we have forged on this publication has been one of the most satisfying of my professional career, and this book is as much his as it is mine. His work speaks for itself.

At the J. Paul Getty Museum in Los Angeles, John Walsh, Deborah Gribbon, and Barbara Whitney granted me a three-month leave of absence from my position as Manager of Administration in the spring of 1998. The origin of this book lies in the research I conducted during my wanderings around Southeast Asia at that time. Tim Whalen, Director of the Getty Conservation Institute, was an on-going supporter of the project after I moved to a position at the GCI in the fall of 1999. Mark Greenberg provided the introduction to Paul Gottlieb of Harry N. Abrams, Inc. and thereby began the process of publishing this book. Marcia Kaplan and Linda Kroning provided ongoing moral support and travel companionship, as well as occasional research assistance.

In Singapore, I am grateful to Mrs. Tan Chee Koon, Corporate Communications Director of the National Heritage Board of Singapore and to Suenne Megan Tan of the Singapore Art Museum, Helen Ng of the Singapore History Museum, Juniper Chua of the Asian Civilisations Museum, and especially Serene Tng of the National Archives of Singapore. Mrs. Angela Sim, Director of the Museums at the National University of Singapore was of great help in the preparation of the commentary on that institution. Ms. Renu Nair of Raffles Hotel assisted in providing historical photographs of that estimable institution.

In Kuala Lumpur, Dr. Kamarul Baharin Bin Buyong, Director General of the Department of Museums and Antiquities of Malaysia, and his extraordinarily capable assistant Janet Tee Siew Mooi were of great assistance.

In Thailand, John McDermott and I are jointly grateful to Dr. Prachote Sangkhanukit, Director of Museums and Archaeology for Thailand; Khun Prasart Vongsakul and Khun Anuwat of the Prasart Museum; Khun Busaya Ruangsri and M.R. Sukhumbhand Paribatra of the Suan Pakkad Palace Museum and the Chumbhot-Pantip Foundation; Khun Euayporn Kerdchouay and Khun Kanitha Kasina-Ubol of the Siam Society; Khun Watcharakitti Watcharothai of the Vimanmek Teak Mansion Museum; Khun Somchai Na Nakhonphanom of the National Museum in Bangkok, Khun Natima Indrapana and Ms. Beverly Jangkamonkulchai of the Jim Thompson House Museum; Mr. Eric Booth of the James H.W. Thompson Foundation; Khun Siripan Thirasarichot of the National Museum in Chiang Mai; and Khun Munintorn Tiyayon of the Tribal Institute in Chiang Mai; Richard Engelhardt at UNESCO; and John at Hollywood E-6 Photo Lab in Bangkok.

In Myanmar, we want to acknowledge Ms. Nee Nee Myint and Mr. Vincent Tin Aung Thang of Zarmani Tours; U Thaung Naing of the Lacquerware Museum in Bagan; U Myint Soe Aung of the Bagan Archaeology Museum, the staff of the National Museum in Yangon; and the staff of the Ministries of Culture and Tourism.

In Vietnam, Dr. Dang Van Bai of the Department of Conservation and Museology, Ministry of Culture and Information was very helpful in arranging permissions and reviewing texts; in Hanoi, Dr. Nguyen Van Huyen, of the Museum of Ethnology and Ms. Christine Hemmet of the Musée de l'Homme in Paris and the consultative curator at the Museum of Ethnology; Mr. Le Ma Loung of the National Army Museum; Mrs. Nguyen Kim Dung of the Vietnam Fine Arts Museum; Mr. Nguyen Tuan Dai of the Vietnam History Museum; and the staff of the Hoa Lo Prison Museum. In Hue, we are grateful to Mr. Le Phu Hap of the Royal Fine Arts Museum. In Hoi An, we want to thank all the staff members of the museums there. In Ho Chi Minh City, Dr. Ba Trung Phu of the Museum of Vietnamese History; in Danang, the staff of the Museum of Cham Sculpture. Ms. Le Thi Hanh and Ms. Nguyen Lan Anh of East West Vietnam in Hanoi, Mr. Matt Millard of Vidotour in Ho Chi Minh City, and Ms. Nguyen Cuu Thi Tinh and Ms. Nguyen Cuu Trang in Hue were indispensable in making arrangements.

In Phnom Penh, Cambodia, H.E. Veng Sereyvuth, Minister of Tourism, Mr. Pak Sokhom, Director of Marketing and Promotion in the Ministry of Tourism, H.R.H. Norodoeum Buppha Devi, Minister of Culture; Ms. Sotho Kulikar of Hanuman Tours, Khun Samen of the National Museum, and the staff of the Tuol Sleng Genocide Museum all have our gratitude.

In Laos, we would like to thank Mr. Paul Box.

John gives his special thanks to Narisa McDermott.

Adele Westbrook vastly improved the text of this book, and guided me through my first publication with professionalism and care.

Lastly, to that intrepid group with whom I first experienced Southeast Asia—John, Shannon, Mark, Jennifer, Bill, Doris, Patrick, and Joe—thanks.

I suspect that to many readers of this volume, the words "Southeast Asia" might conjure up visions of brightly colored Buddhist temples in Thailand, idyllic beaches on Bali, sobering war memorials in Vietnam, or gleaming skyscrapers in Singapore. Perhaps fewer—however well traveled—might envision Southeast Asia as a marvelous destination for museum visiting or associate the region with an abundance of diverse, and quirky institutions. Even as a professional in the museum field, I was largely unaware of Southeast Asia's museum treasures until a serendipitous vacation seven years ago.

In February of 1993 I had the good fortune to participate in one of the first organized tours to Vietnam. Led by the late Jim Traverso, our band of travelers flew from Bangkok to Hanoi and worked our way south to Ho Chi Minh City. We cycled the beaches of Nha Trang, sailed around Halong Bay, and trekked through then unspoiled northern regions of the country where some of the minority children had never seen a western face. Halfway through the trip, we visited the town of Hoi An, ancient Faifo, in the central part of the country. While wandering the length of Tran Phu, the main street, I discovered the Hoi An Museum of History and Culture, a small and impoverished, but well cared for and informative place. The labels were handwritten and the museum—like the rest of the country at that point—was visibly suffering from lack of resources, but I was captivated. What other treasures were hidden in these lands less known for their culture and history than for their recent and tormented past? I was touched and amazed by the obvious devotion that had gone into creating this place. It deserved to be better known and more widely appreciated.

Two years later, I had an opportunity to visit Luang Prabang, a city in northern Laos at the confluence of the Mekong River and the Nam Khan River, and discovered perhaps one of the most magical, mystical places on earth. Housed in the former royal palace on the banks of the muddy Mekong, the museum there was filled with wonderful Buddhas in the traditional Lao "praying for rain" posture, and also contained the lovely, sadly evocative furniture of the deposed royal family, most of whom had died in re-education camps during the 1970s. In a room in this museum filled with the gifts of various foreign governments to the people and rulers of Laos is one of the most startling objects displayed anywhere in the world. A piece of moon rock, brought back by the American crew of Apollo XVII in December of 1972 and presented by President Richard Nixon to the people of Laos in 1973, is carefully exhibited in one case. This was the gift of an otherworldly object from a besieged American president to an ill-fated royal family in the year their future would be sealed by the withdrawal of American troops from Vietnam. It was also the year that the American bombing of Laos ended. I tried to think about what that might have meant within the context of the history of the region. Once again, I became fascinated by the variety of museums in Southeast Asia. Why was this souvenir of the moon exhibited here so proudly? What did this mean? What kind of a museum was this? What kind of museums existed around the region? What did they display? Who had founded them? This book is the result of the fascinating answers I found to these questions during the course of several, sometimes arduous journeys.

In the spring of 1998, I returned to Hoi An and Luang Prabang. Hoi An had begun to generate significant revenue from a growing number of foreign visitors and had become something of an arts center as well. The Museum of History and Culture was still there, but spruced up and with siblings, the Museums of Trading Ceramics and Sa Huynh Culture. While regretful on the one hand that my discovery of five years earlier was no longer a secret, I was

delighted to see that the Vietnamese were broadening the preservation and interpretation of their rich culture. On the same trip, I also returned to Luang Prabang where the designation of World Heritage Site was beginning to pay dividends in terms of the conservation and restoration of the French colonial and traditional Lao architecture. The city was cleaner, the temples were better cared for, and the fledgling tourist industry well in evidence. Again, I felt a bit sad, but it was encouraging to see the generally increased standard of preservation. Southeast Asia and its museums were changing, and I was there to observe it

But as the former French masters of Indochina would have said, *Plus ça change, plus c'est le même chose*—"the more things change, the more they stay the same". Hoi An, Luang Prabang, and all of Southeast Asia had changed and will continue to change. However, they were, in their essence, the places they had always been. The museums described in this book exist to record this past, and to remind the peoples of these countries and the rest of the world about the complex realities of the past—both splendid and painful—as well as the promise of the future.

Southeast Asia has always been a crossroads, poised between the cultural, economic, and political giants of India and China and located on trade routes that brought virtually the entire seafaring world to its shores. Its museums reflect this confluence. As the reader and visitor will discover, the museums of Southeast Asia comprise a varied group of institutions. Ranging from the sprawling complex of the National Museum in Bangkok to the compact and focused Lacquerware Museum in Bagan, and from the air-conditioned facilities of Singapore to the crumbling storehouses of Laos, they offer the traveler—whether on foot or in an armchair—a glimpse into the vast history of one of the most intriguing regions of the world. The visitor can marvel at the diver-

sity of hill tribe life at the Tribal Museum in Chiang Mai and fight back tears when reading about the history of Cambodia in the late 1970s at the Tuol Sleng Genocide Museum in Phnom Penh.

Many of the museums of Southeast Asia were established by the colonial powers that held sway here from the middle of the nineteenth to the middle of the twentieth centuries. The French, primarily through the offices of the Ecole Française d'Extrême Orient, built the History Museum in Hanoi, the Cham Museum in Danang, and the History Museum in Ho Chi Minh City, then known as Saigon. They also built the pseudo-Khmer temple that now houses the National Museum of Cambodia in Phnom Penh. The French have continued their involvement in the museum world of the former Indochina. The staff of the Musée de l'Homme in Paris has recently collaborated with the Vietnamese in the brilliant installation of the Ethnology Museum in Hanoi. The British also left a rich legacy of museum culture in Singapore, Myanmar (formerly known as Burma), and Malaysia.

Despite the long reach of the colonial legacy, many of these countries, most notably Singapore, Malaysia, and Vietnam have developed extensive systems of national museums to house collections and serve as educational facilities. Thailand was never a colony and its museums are organized systematically by region, to reflect the ancient cultures of the area.

Many of these institutions have obvious political overtones. In the National Army Museum in Hanoi—and indeed all across Vietnam—the Western visitor may be jolted (or amused) by interpretations of history that emphasize an unfamiliar range of the various aspects of the more than twenty-year conflict in Vietnam. The same is true at the other military and revolutionary museums of the region, in particular the many and varied museums in Vietnam that are dedicated to the life of Ho Chi Minh. Existing jointly with these

polemical institutions are the museums dedicated to the now-lost civilizations and the still thriving cultures of the region.

My travels to explore these museums took me across Southeast Asia for short bursts of time over a period of seven years. On this odyssey of museum visiting, I discovered that the institutions described here are, in many ways, microcosms of their countries. I came upon overlooked treasures, and discovered and rediscovered the great national museums located here. I also encountered a community of dedicated professionals trying to do whatever is possible with limited and finite resources. I am in awe of their dedication and devotion to their work.

Not every chapter in this book has a happy ending. A number of the museums described here were impacted negatively by the Asian economic crisis that was precipitated in the summer of 1997 by the collapse of the Thai currency. Expansion and upgrading plans had to be put on hold. The excellent Textile Museum in Kuala Lumpur, to which I had hoped to introduce many readers, closed its doors for lack of funding at the end of 1999. With luck, the Handicraft Development Corporation, which had overseen its operations, will be able to reopen it at another location in the future.

But there are happier stories as well, and many of the museums included here are well on their way to a brighter future. During the process of writing this book, the Museums of the National University of Singapore moved to new, expanded quarters and are now able to display the full range of their collections of Southeast and South Asian and Chinese art. As I write this, the Asian Civilisations Museum, also in Singapore, is poised to open its second branch at the Empress Place location. The Siam Society in Bangkok is planning the reinstallation of its collection in the Kamthieng House, which is being restored, and is scheduled to reopen in 2001. The Suan Pakkad Palace

Museum has expanded and now has modern galleries devoted to the material from Ban Chiang. The Tribal Museum in Chiang Mai has moved to more spacious and accommodating quarters. The great 1997–1998 traveling exhibition, "Sculpture of Angkor and Ancient Cambodia: Millenium of Glory," introduced a wide audience on three continents to the wonders of Khmer civilization, much of which came from the National Museum in Phnom Penh, an institution that is still struggling with its future, but making progress. In 1998, the Vietnamese opened the Museum of Ethnology in Hanoi, a world-class institution that does a superb job of explaining the history and culture of the minority peoples of Vietnam.

With a limit of thirty museums in a region with several times that number, there are omissions, great and small, public and private, known and yet to be discovered. This book should by no means be taken as comprehensive. None of the wonderful museums of insular Southeast Asia—the island portions of Malaysia, and the Philippines, Brunei, and Indonesia—appear in this book since it is devoted exclusively to the museums of mainland Southeast Asia. I hope the reader will understand and forgive the lacunae.

Southeast Asia is a rapidly evolving region of the world, and the museums are no exception. Many are works in progress. While the information in this volume is as current as possible, I suggest that the visitor always confirm hours of operation before setting out on a visit. I would further hope that the visitor not be disappointed if some of the objects or exhibits discussed here have been changed; something just as wonderful is likely to have taken its place. Lastly, the Western concept of a "museum" should be left at the entrance (where, in addition, the visitor will frequently be required to leave his or her shoes).

A few practical notes on spelling, phone numbers, and appropriate dress:

Many of these place names have been transliterated from the original languages and variations may occur. Sounding out the words is frequently helpful. Spelling is especially puzzling in Myanmar where the government has changed the proper names of many regions, sites, and cities. Pagan has become Bagan; Rangoon, Yangon; and the Irrawaddy River is now known as the Ayeyarwaddy. I have used the current names to denote these places as they are in common usage. (I have, however, used the word "Pagan" to refer to the historical period.)

I have indicated the city codes and phone numbers of each museum where they exist. To reach the museums from the United States—a daunting task given the state of telecommunications and the time zone differences—dial 011, the country code and the number, eliminating the first "0" in the city code if there is one. Be aware that it is extremely difficult to place some of these calls. Some of these institutions, as the reader will note, do not even have telephone numbers. The country code for Cambodia is 855; Laos 856; Malaysia 60; Myanmar 95; Singapore 65; Thailand 66; and Vietnam 84.

Parts of these countries are among the hottest places in the world. The traveler should be aware, however, that this is a conservative region and that dress codes—no bare legs or arms—are enforced at many of these institutions, particularly those with religious origins.

No book that includes information about cultural and historical sites in Myanmar would be complete without a *caveat* about travel to the country formerly known as Burma. Since the 1988 uprising against the government and the overturned 1990 elections, the government of Myanmar has continued to behave as a massive violator of human rights. The presence of Western travelers in the country does, inevitably, aid the government to some degree. It also helps to introduce Western ideals of freedom and democracy to those Burmese with whom the traveler comes in contact. As is always the case, the decision to visit any country must be an informed individual choice.

Over the past seven years, each of these museums has become for me a familiar refuge from the steamy heat, noise, and dirt of the cities of this region. The people acknowledged in this book have become friends and colleagues. Indeed, Southeast Asia has become a second home to me. I hope that this volume becomes an indispensable and well-thumbed addition to the backpacks and luggage of travelers throughout Southeast Asia. I hope equally that it may be read by the light of a fire on a snowy day far from the steamy tropics of the region. Above all, I hope that the reader enjoys perusing this book as much as I enjoyed researching and writing it.

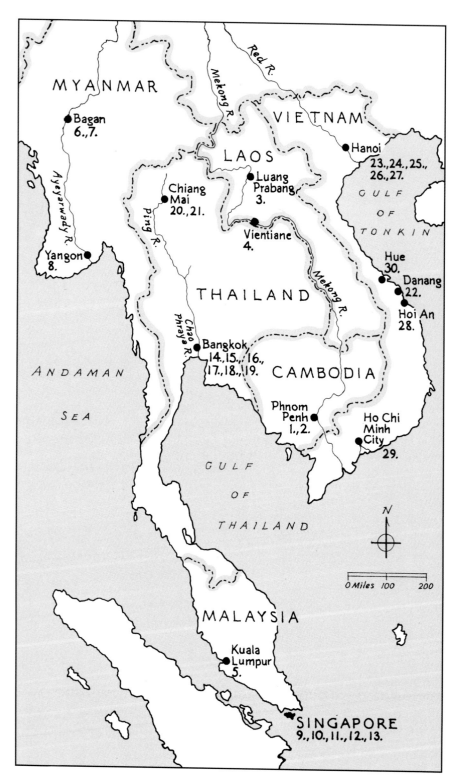

MYANMAR

Bagan
6., 7.

Ayeyarwady R.

Mekong R.

Red R.

VIETNAM

LAOS

Hanoi
23., 24., 25.,
26., 27.

Chiang
Mai
20., 21.

Luang
Prabang
3.

GULF

OF

TONKIN

Ping R.

Vientiane
4.

Yangon
8.

THAILAND

Mekong R.

Hue
30.

Danang
22.

Hoi An
28.

Chao
Phraya R.

Bangkok
14., 15., 16.,
17., 18., 19.

CAMBODIA

ANDAMAN

SEA

Phnom
Penh
1., 2.

Ho Chi
Minh
City
29.

GULF

OF

THAILAND

N

0 Miles 100 200

MALAYSIA

Kuala
Lumpur
5.

SINGAPORE
9., 10., 11., 12., 13.

MAP NUMERICAL LEGEND

1. National Museum of Cambodia, Phnom Penh, Cambodia

2. Tuol Sleng Genocide Museum, Phnom Penh, Cambodia

3. Royal Palace Museum, Luang Prabang, Laos

4. Wat Phra Keo, Vientiane, Laos

5. National Museum, Kuala Lumpur, Malaysia

6. Archaeological Museum, Bagan, Myanmar

7. Lacquerware Museum, Bagan, Myanmar

8. National Museum, Yangon, Myanmar

9. Asian Civilisations Museum, Singapore

10. Museums at the National University of Singapore, Singapore

11. Raffles Hotel Museum, Singapore

12. Singapore Art Museum, Singapore

13. Singapore History Museum, Singapore

14. Jim Thompson House, Bangkok, Thailand

15. National Museum, Bangkok, Thailand

16. Prasart Museum, Bangkok, Thailand

17. Siam Society and Kamthieng House, Bangkok, Thailand

18. Suan Pakkad Palace Museum, Bangkok, Thailand

19. Vimanmek Mansion Museum, Bangkok, Thailand

20. National Museum, Chiang Mai, Thailand

21. Tribal Museum, Chiang Mai, Thailand

22. Museum of Cham Sculpture, Danang, Vietnam

23. Vietnam History Museum, Hanoi, Vietnam

24. Hoa Lo Prison Museum, Hanoi, Vietnam

25. Vietnam Museum of Ethnology, Hanoi, Vietnam

26. National Army Museum, Hanoi, Vietnam

27. Vietnam Fine Arts Museum, Hanoi, Vietnam

28. Museums of Hoi An, Hoi An, Vietnam

29. Museum of Vietnamese History, Ho Chi Minh City, Vietnam

30. Museum of Royal Fine Arts, Hue, Vietnam

NATIONAL MUSEUM OF CAMBODIA

ADJACENT TO THE ROYAL PALACE AND THE SILVER PAGODA,
BOUNDED BY STREETS 13, 178, 19, AND 184;
ENTRANCE AT THE CORNER OF 13 AND 178
PHNOM PENH

OPEN: TUESDAY THROUGH SUNDAY FROM 8:00 A.M. TO 11:30 A.M. AND
2:00 P.M. TO 5:30 P.M. CLOSED MONDAY.

As much of the cultural heritage of Cambodia finds its way to the art and antique shops of Bangkok and Singapore, the National Museum of Cambodia becomes an increasingly precious—and increasingly crumbling—record of the brilliant civilization of the Khmer Empire and of the later history of Cambodia. At its height during the late twelfth century, the Khmer Empire stretched across much of Thailand, Laos, and Vietnam, and down into the Malay Peninsula. Its capital was at Angkor in present-day central Cambodia, on the shores of the Tonle Sap, a broad and shallow widening of the river of the same name. Civilization thrived at Angkor from the ninth through the early thirteenth centuries. After the capital city was abandoned to the Thais in 1431, the great Khmer Empire became a vassal state of the Thais, after which Angkor and the Khmer Empire fell into an extended period of decline. In the dense heat and the humidity of Southeast Asia, the secular wooden dwellings disintegrated but the stone temples survived, encased by vegetation that today looks otherworldly to anyone visiting the archaeological sites left behind.

Though the city of Angkor had been known to European traders in Asia in the sixteenth century, it was not until 1863—when the journals of Henri Mouhot (the French naturalist and explorer) were published—that Europeans became interested in the "lost" civilization of Cambodia. Mouhot had stumbled on the ruins at Angkor in 1860 while looking for butter-flies in the Cambodian jungle. He died of malaria at Luang Prabang in Laos the following year. Cambodia (minus the western provinces that included Angkor) was declared a French protectorate in 1864. Casts of portions of temples that were exhibited at the Universal Exposition of 1867 in Paris whetted European appetites for the real thing, and in 1874, Louis Delaporte, yet another French explorer, set out to bring Khmer sculpture back to France. These sculptures were exhibited at the Universal Exposition of 1878 and by 1880 had found a home in an Indochinese Museum, the forerunner of the modern Musée Guimet in Paris. This was the beginning of the removal of the Cambodian cultural heritage from the country. The flow of sculpture out of the country has not ceased, although recent action by the Thai authorities, and by the United States in banning the import of certain categories of Khmer objects without a Cambodian export permit, may staunch the flood. Even such luminaries as André Malraux took part in the denuding of the monuments of Angkor. In 1923, Malraux and his wife Clara cut seven relief sculptures off the temples at Banteay Srei which they then transported to Phnom Penh. The reliefs were confiscated there. (The ensuing tumult resulted, indirectly, in the conservation of the complex of temples at Banteay Srei.)

The National Museum of Cambodia has a long history. It was dedicated in 1920 under the patronage of King Sisowath and the French Resident Superieur, Henri Bau-

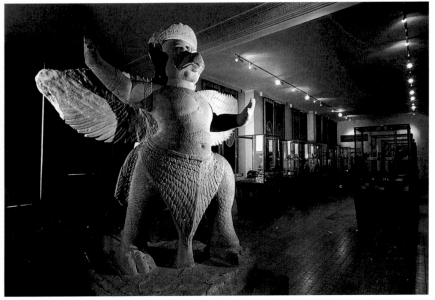

A massive tenth-century statue of Garuda from Prasat Thom guards the entry hall of the museum. Photo: John McDermott.

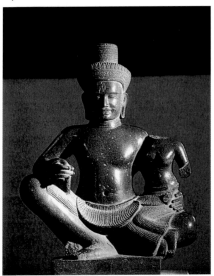

This small sculpture of Shiva and Uma (who lost her head sometime in the 1970s) is a wonderful example of the Banteay Srei style of the tenth century. Photo: John McDermott.

doin, and was named the Musée Albert Sarraut in honor of the French Governor-General of Indochina. Until 1951, all museum activities and archaeological field-work in Cambodia were conducted under the French. In 1951, the French ceded the museum back to the Cambodians. At that time, it was renamed the National Museum of Cambodia.

Designed by French archaeologist George Groslier with help from the staff of the Ecole des Arts Cambodgiens, the

structure is an architectural hybrid, a plastered brick French colonial shell with open-air galleries arranged around a central courtyard and overlaid with traditional Khmer architectural elements. The design on the door is copied from the tenth-century temple of Banteay Srei. (The French had an affinity for Banteay Srei.) The building is currently recovering from decades of neglect. The concept of a museum devoted to the splendors of the Khmer Empire, and its intellectual staff, had no place in the Year Zero philosophy of the Khmer Rouge. When the building was abandoned from 1975 to 1979, it began a decline from which it has yet to recover completely. Through a superhuman effort by those members of the staff who had survived, the museum was reopened to the public three months after the liberation of Phnom Penh in 1979.

But the museum is not out of the woods yet. According to an August 1998 article in *The New York Times*, every day museum workers gather 20 pounds of guano left by the thousands of bats living in the museum, in addition to the half ton gathered from above the ceilings every month. These droppings are gradually destroying the collection, although measures are underway to try to halt this by building a solid ceiling and banishing the bats. (Of course, the sale of the bat guano provides some income for the cash-strapped museum and some of its staff members are not anxious for the supply to be eliminated.) Over the past thirty years, the Cambodians have had few resources to channel toward the preservation of the building and its collections. Understandably, other countries have been reluctant to commit resources to a country that has been in chaos, but the efforts made during the next few years may well determine the future of the rich artistic and archaeological heritage of Cambodia, the only country in the world that displays architecture (Angkor Wat) on its flag.

However, despite the loss of many

key pieces of the country's heritage and the inadequate facility in which the works that remain are housed, the objects on display are powerful and impressive. The visitor should not be deceived by the quasi-western appearance of the building, as this is not a cloistered, soulless collection of the monuments of the great Khmer Empire. This museum and its objects are alive for certain members of the devout Buddhist population of Phnom Penh, who venerate several of the sculptures in the collection. Buddha images (and in one case a head of Jayavarman VII, the builder of Angkor Thom and the Bayon temple) are draped in saffron cloth and honored with incense lit in front of them as if they were objects in a Buddhist temple. This is surely a sight that will never be seen in a North American or European museum.

The collection is divided into the archaeological collections (bronze, stone, and ceramic) and the ethnographic collections (musical instruments, wooden objects belonging to the royal families, objects of everyday life, and domestic architectural decoration). The ethnographic collections are of interest; the archaeological collections are world-class.

The entrance hall of the museum is dominated by a magnificent tenth-century Garuda from Prasat Thom. The gallery to the left is anchored by a lovely and graceful eleventh-century Baphuon style reclining bronze Vishnu that originally came from a temple in the West Baray, or reservoir, at Angkor. It is one of the largest bronze sculptures ever cast in Southeast Asia. Despite its present state of preservation, its power and beauty are unmistakable.

The tranquil central courtyard of the museum with its four symmetrical pools is dominated by the statue of the so-called "Leper King," a figure from the Terrace of the Leper King at Angkor. The statue is neither that of a king nor of a leper—the lichen covering the body of the figure has given rise to the description. (The Leper

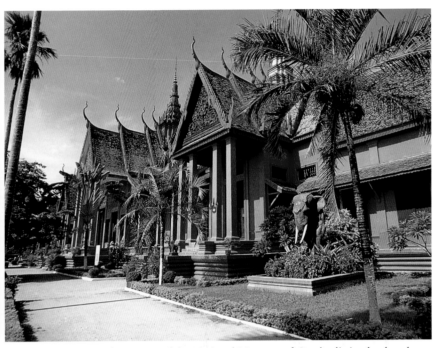

The distinctive red structure of the National Museum of Cambodia is a landmark in the city of Phnom Penh. Photo: John McDermott.

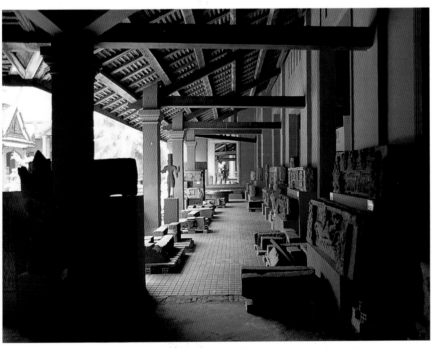

Surrounding the courtyard, exterior galleries house priceless objects from Cambodia's history. Photo: John McDermott.

King has recently been encased in a glass box to protect him from the elements.)

The collections are arranged in chronological order in a clockwise direction around the courtyard. The pre-Angkor period, that time before the full flowering of the civilization, dates from the second century through the beginning of the ninth century. The Angkor period, with its many stylistic subdivisions, began in 802 with the reign of Jayavarman II. The earliest objects in the museum are from the pre-Angkor period and include representations of both the Buddha and the many varied deities of the Hindu Pantheon in both sandstone and bronze. The works are astonishingly fine and varied given that they belong to the earliest known phase of the history of Khmer art.

The early objects from Angkor seem less elegant, but are quite masterful, and by the time of the Koh Ker style in the second quarter of the tenth century, the works have become massive and almost overwhelming. The figural groups of the headless Wrestlers, and the Monkey Kings, Valin and Sugriva, are outstanding examples of this style. This tendency toward size and magnitude was brilliantly countered in the later tenth century by the lively and exuberant sculpture of the temple at Banteay Srei. The preserved objects from Banteay Srei and the works from Angkor in a related style are among the highlights of the museum. The small, exquisite sculpture of Shiva and Uma (whose head disappeared sometime in the 1970s) is particularly affecting.

Rounding the corner brings the visitor to galleries filled with objects from the Baphoun style of the second half of the eleventh century, the Angkor Wat style of the twelfth century, and the Bayon style of the late twelfth and early thirteenth centuries.

With the exception of the large bronze reclining Vishnu in the entrance gallery, the art of the Baphoun style was markedly smaller in scale and more attenuated than the art of the previous period. The relief sculpture of this period shows the influence of the Banteay Srei style in its *horror vacui* and its deeply undercut decoration, as illustrated by a panel from Prasat Pen Chung, Kompong Thom. The freestanding sculpture of the period is particularly graceful and solid.

While much of the greatest architecture of the Khmer Empire was created during the Angkor Wat period, much of the sculpture is curiously archaic and static, lacking in the fundamental grace and liveliness that characterized earlier works. There are a number of examples of sculpture of this period in bronze and stone. The Bayon style, represented here by many heads of King Jayavarman VII, is characterized by simple modeling of facial features with an emphasis on mass rather than on line.

The last galleries of the museum are devoted to ethnographic objects and popular arts, and the more recent, pre-1975 history of Cambodia. There are Khmer shadow puppets made of cowhide, and examples of royal paraphernalia, such as nineteenth-century palanquins, a large wooden boat cabin, and the huge gold funerary urn of King Sisowath, the founder of the museum, who died in 1927. There is also a wonderful, funny wooden elephant of unknown date or provenance.

The courtyard of the National Museum of Cambodia is a delightful place to sit and think. Surrounded by lovely lily ponds and the wonders of ancient Angkor, however, it is difficult to contemplate certain aspects of the history of the museum and the fate of some who worked there. Many staff members of the National Museum of Cambodia from 1975 to 1979 lost their lives during the years referred to by Cambodians as "Pol Pot time." The more recent stability and inklings of prosperity in Cambodia may augur well for the future of this treasure trove of the splendors of the past and of the irreplaceable cultural heritage of Cambodia.

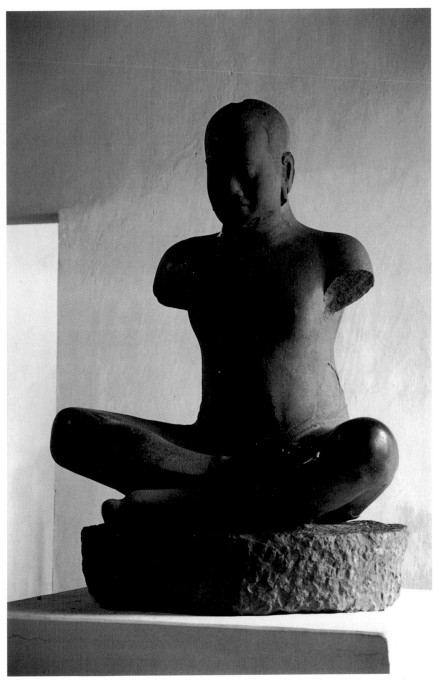

Jayavarman VII, the builder of the walls of Angkor Thom and the Bayon temple, is depicted in this sandstone sculpture. Photo: John McDermott.

TUOL SLENG GENOCIDE MUSEUM

103 STREET JUST NORTH OF 350 STREET
PHNOM PENH

OPEN: EVERY DAY FROM 8:00 A.M. TO 5:00 P.M.

The ghosts seem to think this old schoolhouse belongs to them, thumping and moaning, crying out for help, offering themselves for sex, turning themselves into white cats. People who work here say the ghosts are the restless souls of victims of the Khmer Rouge, and their forms are as varied as the imaginations of the people who describe them.

—Seth Mydans, *The New York Times*, June 30, 1999

You must answer according to my questions. Don't turn them away. Don't be a fool for you are a chap who dare [sic] to thwart the revolution. Don't tell me either about your immoralities or the essence of the revolution. Do nothing, sit still, and wait for my orders. If there is no order, keep quiet. When I ask you to do something, you must do it right away without protesting.

—Some of the "Security Regulations" posted in the courtyard of the Tuol Sleng Genocide Museum

The Tuol Sleng Genocide Museum does seem to be a haunted place, and it is perhaps one of the most poignant monuments in a region that doesn't lack for sad and tragic places. Originally constructed as a high school, the campus became Security Prison 21 (or S-21) in 1975 and soon became a focal point for a campaign of extermination, indeed genocide, that resulted in the deaths of at least 750,000—and probably far more—Cambodians between 1975 and 1979. It has been left virtually untouched and unrestored since the Vietnamese invaded Cambodia in 1979 and drove the Khmer Rouge back into the countryside where they still remain, although their ranks are dwindling rapidly as the old guard dies off and modernization slowly comes to Cambodia.

In April 1975, coinciding with the victory of the Communists in Vietnam, the Khmer Rouge (or Red Cambodians, a phrase coined by then Prince Norodom Sihanouk in the 1960s) marched into Phnom Penh. Almost immediately, the borders of the country, renamed Democratic Kampuchea, were sealed and for the next four years the only information that trickled out was that brought to Thailand by desperate refugees. The 1984 film, *The Killing Fields*, is a gripping account of what Cambodians now refer to as "Pol Pot time," after the late leader of the movement. Pol Pot and his followers wished to return the country to "Year Zero." They set out to exterminate everything and everyone who would not support their vision—the isolation of the country, the creation of a virtually Stone-Age agrarian economy, and a return to what they envisioned as the great Khmer past. Tuol Sleng became a center of this extermination effort and is preserved today as a reminder of the potential inhumanity of humankind.

The courtyard of the museum is a true oasis in the noisy, dirty anarchy of present-day Phnom Penh. Palm trees sway in the breeze under bright blue skies and

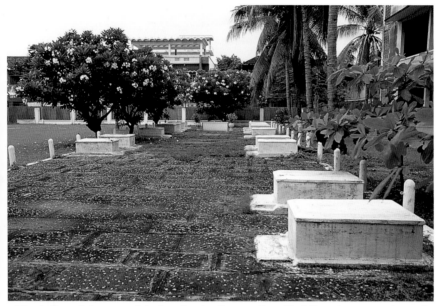

The well-tended graves of the last Cambodians to die at Tuol Sleng in 1979 are located in the courtyard of the museum. Photo: John McDermott.

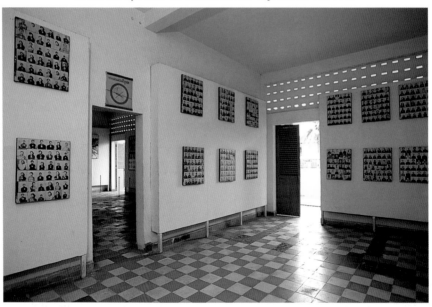

Haunting photographs of those who died here stare at the visitor from the walls of the museum. The Khmer Rouge were obsessed with photographing their victims. Photo: John McDermott.

shaded benches provide resting places and a respite for the visitor from the relentless sun of Southeast Asia. The grass is properly tended and school playground equip- ment is incongruously anchored next to the fourteen well-kept tombs of the last prisoners to die there. One hardly notices the barbed wire on some of the second-

floor balconies and windows and, from the outside, the Tuol Sleng Genocide Museum presents itself as an undistinguished and innocuous collection of structures that would seem not to merit a second glance. The place almost seems to be an embodiment of the concept of the "banality of evil."

But inside the former classrooms there is a different perspective on the events that transpired here in the late 1970s. The four buildings grouped around the courtyard house contain photographic documentation, interpretive material, and the remains of the cells in which the prisoners were held and tortured under the direction of a former schoolteacher named Duch.

Building A was the site of the torture rooms, and they have been left virtually as they were found in 1979. All have the tile floors typical of Southeast Asian buildings, virtually empty walls, bare metal bed frames to which the victims were tied, various instruments of torture, and a photograph of the scene as it was discovered by the Vietnamese in 1979. The last Cambodians to die in Tuol Sleng are pictured in these photographs. The dried blood remaining on the tile floors of these former classrooms in which the city's intellectuals—doctors, lawyers, professionals, museum staff, and even those who spoke foreign languages or wore glasses—were tortured may or may not be original. But, like the interpretive centers now set up at Dachau and Auschwitz in Europe, these rooms are preserved as a lesson to humankind and the message is overpowering.

Building B is filled with documentary evidence of the events at Tuol Sleng. The Khmer Rouge were meticulous about recording their activities, and the photographs of victims displayed in these rooms bear witness to their work. Photographs of two of the six Westerners who died in Tuol Sleng are exhibited here, as are pictures of women, children, and mothers with their babies. The clothing of a few of

the estimated 20,000 Cambodians tortured here lies in a haphazard pile. Only seven sculptors, who were employed full-time here creating busts of Pol Pot, escaped torture and were allowed to live. Some of their handiwork is on display as well.

Building C is filled with brick and concrete holding cells on three floors. The cells were small, about four feet by eight feet, and had brick walls up to about six feet. Some have chains cemented into the floor or a brick removed at eye level. The walls of one cell have toppled to the floor and been left as they fell. All are precarious and seem to have been constructed in a casual and random manner. It is only from close up that the visitor becomes aware of the barbed wire across the two upper balconies of Building C. Suicide would have been preferable to the torture awaiting the prisoners, but they were denied even this option.

The photographs to be found in Building D are among some of the most chilling in the museum. The camera captured the smiling men who ran the prison and their happy families, as if they were posing for a souvenir party photo. There are also photographs of an eerily deserted Phnom Penh, of instruments of torture, and of the Killing Fields of Choeng Ek just outside the city (these are also well worth a visit). In the final room of the museum is a crude but startling map of Cambodia created from human bones, primarily skulls, with the Mekong and Tonle Sap indicated as rivers of blood.

The museum has remained basically unchanged since it opened. And because it was set up by the Vietnamese with the assistance of the East Germans (who had a certain amount of experience in dealing with the presentation of this kind of history), the political content and the message of this museum are quite obvious. The purported statistics of 1,968 Buddhist temples and pagodas, 144 mosques, and 796 hospitals destroyed, and over 3.3 million people dead or missing, are most probably

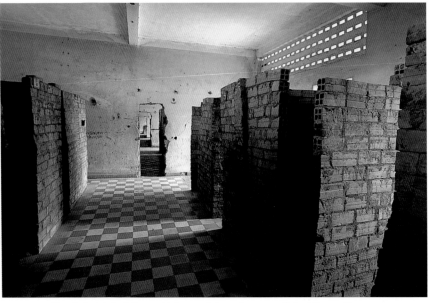

Crude brick holding cells housed the prisoners of the Khmer Rouge.
Photo: John McDermott.

Several individuals in charge of Tuol Sleng are depicted here with their families,
seemingly oblivious to the horror around them. Photo: John McDermott.

not accurate. But the inaccuracies and the exaggerations found in the interpretive material in this museum pale into insignificance beside the message it delivers.

The material presented here is horrific. And yet the overwhelming impression the visitor comes away with is that of the continuation of life, and even the

23

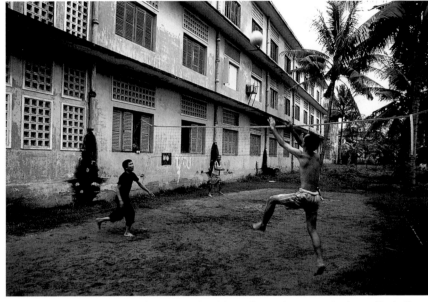

As if to emphasize that life goes on, local boys from Phnom Penh play volleyball in back of the museum. Photo: John McDermott.

triumph of humanity over its own inhumanity. The grounds of the museum are far from sacred to the local population of Phnom Penh. Schoolgirls sit on the benches in the courtyard and giggle. The museum guides will, in a matter-of-fact manner, talk about the deaths of their families and—in the next breath—ask questions about contemporary rock stars. Street vendors hawk aromatic food just outside Tuol Sleng's gates. As Henry Kamm wrote in *Cambodia: Report from a Stricken Land*, "Now its chamber of horrors are a stop on the conducted-tour circuit. The pigsties of its neighbors encroach on the grounds of the memorial." Seth Mydans has reported seeing joggers on the grounds of the museum. The events of the 1970s have become part of history.

Like the museums at the former Nazi death camps, and like the United States Holocaust Memorial Museum, and the Museum of Tolerance, the Tuol Sleng Genocide Museum exists as both a warning and a plea to humanity to remember a horror of history in the hope that it will not have to happen again. It is a place that resonates with the ancient reminder: *Memento Mori* (Remember the Dead).

ROYAL PALACE MUSEUM

PHOTHISARATH ROAD, OPPOSITE THE STEPS TO
THE TOP OF MOUNT PHOUSI
LUANG PRABANG

TEL: 212–470

OPEN: EVERY DAY FROM 8:00 A.M. TO 12:00 NOON AND
FROM 1:00 P.M. TO 4:30 P.M.

Laos was always the sleepy backwater of French Indochina. While Cambodia held stunning art and archaeological treasures and Vietnam possessed massive natural resources that were exploited by the French, landlocked Laos was largely ignored and the lovely city of Luang Prabang is a happy result of that benign neglect. Over 1,000 years old, the city was the capital of the Kingdom of the Million Elephants during the fourteenth and fifteenth centuries. Although it was abandoned as the capital city in the mid-sixteenth century, it remained a center of civilization, culture, and religion through the eighteenth century. The city that exists today is a languid place comprised of dozens of traditional Lao Buddhist temple compounds and many well-preserved French colonial buildings. It also has very little traffic or signs of modernization. In 1995, Luang Prabang was declared a World Heritage Site, and the preservation and conservation of a number of its most important buildings, as well as the whole of the urban fabric, have now begun.

The building that houses the Royal Palace Museum was constructed to be the Royal Palace by the French colonial government during the first decade of the twentieth century. It was intended to mark the beginning of the modernization of Laos by the French, although little of this modernization ever materialized. The building was designed in a hybrid style, part traditional Lao and part French colonial. This is well illustrated at the entrance, where a large gold elephant, the traditional symbol of Laos, presides over the door,

and fleurs-de-lis, the symbol of France, grace the column capitals. The steps are made from Italian marble. The building was refurbished in the first half of the 1970s, at which point the extensive glass mosaics in the throne hall were added.

The Royal Palace fared better than did its royal inhabitants after the Pathet Lao seized control of the country in late 1975. The King was unceremoniously dethroned, after which he and his family were sent to re-education camps where they all died. The building was converted into the Royal Palace Museum and opened as such in March of 1976. Much of the interior remained as it was during the residence of the royal family.

The museum is arranged in thirteen galleries, and the tour path through them is pleasantly—but firmly—enforced by the charming, but insistent, staff. The living quarters of the royal family, located toward the back of the building, have been left untouched—although they seem somewhat sterile—and serve as a sad reminder of the former lives of their occupants. The rooms at the front of the palace, which originally constituted the public rooms of the palace, contain objects from the royal history of Luang Prabang and Laos, and gifts given to the country by foreign governments.

The most important historical object in the museum is the Prabang, the namesake of the city. Visible from the exterior arcade on the far right side of the museum, the Prabang is a Buddha image weighing some 120 pounds and cast in gold, silver, and bronze. (In all probability, the original

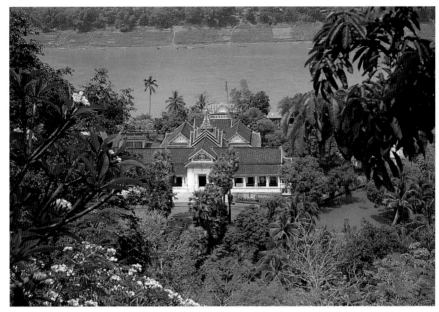

Situated on the bank of the muddy Mekong River, the Royal Palace Museum in Luang Prabang houses a wealth of objects from the past of the Kingdom of the Million Elephants. Photo: Kristin Kelly.

is hidden away in a vault somewhere, but the visitor can't get close enough to the Prabang on display to be sure.) Along with the Phra Keo, or Emerald Buddha, formerly housed in Wat Phra Keo in Vientiane and now housed in the Grand Palace in Bangkok, the Prabang was one of the most revered objects in Laos. It had been a source of spiritual protection for the country since it was brought to Luang Prabang from Cambodia in the fourteenth century. The image is of the Mon-Khmer style. Legendarily, it was made in Sri Lanka and later passed to the King of the Khmer Empire at Angkor. In 1396, the image was given to the ruler of the Kingdom of the Million Elephants.

The King's Reception Hall, to the right of the Entrance Hall, holds a number of Dong Son drums, the ubiquitous remains of the very early civilization of northern Vietnam. The wonderful murals of daily life in Laos on the walls here have been sited to be best viewed in the light appropriate to the scene depicted. The scenes of traditional morning activities can be best appreciated in the morning, and those of late afternoon in the light of the late afternoon.

Many of the objects on display here are from the temples in Luang Prabang and the surrounding area. Those from That Mak Mo, a local temple that collapsed in the early part of the twentieth century, are particularly interesting. This collection includes objects in gold and bronze with lavish decorations of precious stones. An interesting stele dating to 1527 describes in Pali script the contributions of land and money intended to fund the construction of a new monastery. A drawing of the alignment of the planets at the top dates it precisely. There are countless figures of the Buddha in all his various postures, including the typically Lao Buddha praying for rain in which he holds his arms slightly away from his side with fingers pointing straight down. Well-crafted *howdahs* (the passenger seats placed on top of elephants), sedan chairs, and other

pieces of royal furniture vie for the viewers' attention with Buddhist sculpture from as early as the twelfth century in the eclectic arrangement of objects. Carefully crafted betel-nut boxes and gold monks' alms bowls and water vessels are exhibited next to bronze figures of the Buddha. Many of these objects date to the sixteenth century, just before Luang Prabang's abandonment as the capital city.

The visit to the royal apartments falls about half-way through the tour and these rooms are, in some ways, the most interesting part of the Museum. The locally made furniture and the European mirrors remain, although the spaces have been scrubbed clean of all personal traces of the inhabitants. The beds are without linens, the wardrobes without clothing, and the rooms lack any human touches. (The Chinese and French carpets have been moved to storage.) There is, however, an eerie sense of the presence of the royal family. They don't appear to have been royalty who lived in a lavish manner, and they did cede their palace to the state as a museum. But they didn't survive the end of their world and the beginning of another.

Little remains in the King's Library, and since the visitor is not allowed in and all the books appear to be in Lao, it's difficult to tell what the King and his family might have been reading prior to being marched off to the re-education camps in 1975. The King's and Queen's bedrooms are both simply furnished with heavy Art Deco furniture. The motif of the three elephants carved on the King's bed was the emblem on the pre-revolutionary Lao flag.

The children's bedroom now serves as an exhibition space for traditional Lao instruments and for masks and costumes related to the performance of the *Ramayana*, as well as for royal ivory stamps that have been inked and stamped onto paper to show what they actually looked like. The dining room is as simply furnished as the rest of the royal quarters.

The most interesting fact about this royal suite is that none of the rooms has a window to the outside. All the windows face onto corridors. This is an anomaly in a country where traditional architecture always features cross ventilation and where adequate air circulation can make the difference between comfort and abject misery.

Most of the gifts displayed in the reception rooms are of passing interest and importance, although the beautiful Thai niello desk set, a selection of silver from Cambodia, and a decent mini-survey of Indian art in reproduction are worth a perusal.

Included among the gifts received by the royal family from foreign governments are a number of what must be the most incongruous objects exhibited in a museum in Southeast Asia. These are four fragments of moon rocks from the journey of *Apollo 11*, a fragment of a moon rock from the *Apollo 17* mission in December of 1972, and a flag of the Kingdom of Laos, all of which were given by Richard Nixon to the people of Laos in early 1973. The inscription reads:

This fragment is a portion of a rock from the Taurus Littrow Valley of the Moon. It is given as a symbol of the unity of human endeavor and carries with it the hope of the American people for a world of peace.

This flag of your nation was carried to the Moon aboard the spacecraft America during the Apollo XVII mission December 7–19, 1972

Presented to the people of the KINGDOM OF LAOS From the people of the United States of America Richard Nixon 1973

In February of 1973, a cease-fire was declared in Laos, bringing to an end

almost two decades of war. The agreement called for a cessation of the secret war that was being fought in Laos, for the formation of a coalition government in the country, and for the end of American air support. It also signaled the end of American relief for the many—particularly Hmong—supporters of the American efforts in Laos. But before this cease-fire, over two million tons of bombs had been dropped on Laos, more bombs than were dropped on Germany during World War II. In February of 1973, Richard Nixon's White House was already heavily embroiled in the growing Watergate scandal, although the American public would not learn the full extent of it until later that year. In retrospect, these five pieces of moon rock and the flag seem startlingly representative objects of their time. They may also be considered, however, small compensation for all the destruction that rained down on this poor country.

The grounds of the Museum are lovely. The view from the front of the Museum toward Mount Phousi is particularly good, and the view from Phousi looking back down on the museum and the Mekong River is spectacular. The small Prabang Temple, the "Ho Prabang," to the right of the entrance gate, the lovely peaceful lotus pond, the enormous statue of King Sisavangvong, and the dilapidated shelter that houses the royal barges to the left of the entrance all invite the visitor to wander through the grounds and contemplate this now peaceful setting.

WAT PHRA KEO (HO PHRA KEO)

MAHOSOT ROAD, BETWEEN SETTHATHIRAT ROAD AND FA NGUM ROAD

VIENTIANE

OPEN: WEDNESDAY THROUGH SUNDAY FROM 8:00 A.M. TO 12:00 NOON, AND FROM 1:00 P.M. TO 4:00 P.M. CLOSED MONDAY, TUESDAY, AND PUBLIC HOLIDAYS.

Wat Phra Keo, one of the most beautiful and historic buildings in Laos, functions today as both a Buddhist temple and a national museum. It also lends a new dimension to the phrase "temple of the arts." It is probably one of the few museums in the world where the visitor can absorb the cultural heritage of a country while watching devout Buddhists shake fortune sticks out of a cylinder in front of a large figure of the Buddha. Lao kip (the national currency) and incense sticks are placed by worshipers in front of and even in the cracks of objects in the museum. This place is both a repository for antiquities and a living center for Buddhist worship. The collections, though sparse, are interesting, but it is the building, its history, and its current dual usage that may be most fascinating to the visitor.

As is true with many buildings in the region, Wat Phra Keo has a long and colorful history. Constructed in 1565 by King Setthathirat of the Kingdom of Lan Xang, one of the greatly revered figures of Lao history, the Wat was built to house and honor the famous Emerald Buddha (the Phra Keo), which had been brought to Vientiane from the Kingdom of Lanna in northern Thailand. (For the record, the object is probably jade, and is definitely not emerald!) The Phra Keo is an object that has spent a great deal of time in transit around Southeast Asia, and has left in its wake a number of namesake buildings built to house it and dedicated to it. (Karen Schur Narula has written an informed account of the travels of the Emerald Buddha in which she traces the background and the history of the object.) The figure is considerably less than three feet high. Its origins are mysterious. Legendarily it is from India or Sri Lanka, but it seems to be of the northern Thai Lanna style of the thirteenth or fourteenth century. The first record of its existence is in Chiang Rai (a city in northern Thailand) in the fifteenth century, where it was found covered in stucco after a *chedi* had been struck by lightning. Some of the stucco flaked off and the green object underneath was revealed. It was then moved to Lampang, another northern Thai city, by elephant, and from there to Wat Chedi Luang in Chiang Mai. The figure was taken to the city of Luang Prabang in northern Laos in the mid-sixteenth century and later moved south to the city of Vientiane, then known as Wieng Chan, the "City of the Moon." It was at this point that King Setthathirat built this structure of Wat Phra Keo for the statue. In the mid-eighteenth century, Thai invaders under the leadership of King Taksin reclaimed the image, together with that of the Prabang (now in the Royal Museum, Luang Prabang), which was later returned, and took the Phra Keo back to Thonburi, then the capital of Thailand. When the capital city moved just across the Chao Phraya River to Bangkok, Rama I, the first king of the current dynasty of Thai kings, moved the Phra Keo to the new palace. The tiny image, swathed in layers of seasonally appropriate garb, is still on view in the final Wat Phra Keo inside the grounds of the Grand Palace in Bangkok, where Thai Buddhists pay homage to it. A replica is housed in the Vientiane temple.

29

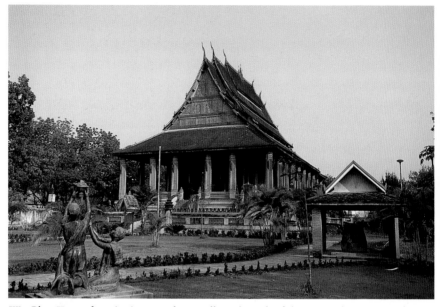

Wat Phra Keo, a functioning temple as well as a branch of the national museums of Laos, sits amid beautifully landscaped grounds in Vientiane. Photo: John McDermott.

The sixteenth-century Wat Phra Keo in Vientiane was destroyed in the 1820s by the occupying Thai army. (With the exception of Wat Sisaket, located across the street from Wat Phra Keo, all the existing temples of Vientiane were destroyed at this time.) The building lay in picturesque ruin until the 1930s when it was restored and transformed into a branch of the National Museum. The restorers carefully reconstructed the architecture and exterior carving of a sixteenth-century temple, and the result is a pleasing and faithful—if not completely authentic—Vientiane *wat* of the time. The main sanctuary, or *sim*, sits atop three tiers and is accessed by steps with wonderful *naga* handrails. The two striking doors on either end of the structure are the only remaining parts of the original temple, and are outstanding examples of early Lao carving. The exterior arcades surrounding the *sim* are filled with a virtual encyclopedia of Lao Buddhas. The oldest known Buddhist image in the country (no. 698) is exhibited in front of the temple and dates sometime between the sixth and the ninth centuries. There is a series of stele with inscriptions in Lao arranged here as well.

The current building is surrounded by a lovely tropical garden in which is exhibited a 2,000-year-old jar from the Plain of Jars in the northeast part of the country. Probably used for funerary and burial purposes, these jars are only now being studied in detail by archaeologists. About three hundred of them survive, most still in situ on the Plain of Jars.

Inside the single-room building, the collections are displayed in glass cases around the perimeter. There are also a number of freestanding Buddha figures in the center of the gallery. The caretaker at the door may have a dog-eared copy of the English edition of a guidebook to the *wats* of Vientiane that contains some useful information about the objects housed here. This guidebook can be particularly helpful, since few of the objects are labeled in English. Although in need of conservation, much of the material presented here is magnificent, and the dearth of objects as

Elaborate *naga* heads form the ends of the balustrades of the steps leading up to the *sim*, or main chamber of the temple. Photo: John McDermott.

The wooden doors of the building are all that remain from the original temple, destroyed by marauding Thais in the 1820s. Photo: John McDermott.

Seated bronze Buddhas in the calling the earth to witness posture surround the terrace of Wat Phra Keo. Photo: John McDermott.

The Buddha praying for rain is also a characteristic Buddha of Laos.
With long arms extended at his sides, the elegant figure appears otherworldly.
Photo: John McDermott.

33

compared with the number to be found in the national museums in other capital cities of the region painfully underscores how much of the cultural heritage of the country has been lost.

Landlocked Laos has been a cultural crossroad—not to mention a geographical doormat—for most of its existence, and influences from Khmer, Burmese, Indian, and Thai cultures are clear in the objects exhibited here. But it is also obvious that a distinctive style was developed in their religious sculpture. Lao Buddhas are very ethereal, elegant, and otherworldly. The figures are characterized by a thin, aquiline nose, curly hair, and flat extended earlobes and they are very different from the graceful Buddha figures of northern Thailand as well as the jolly, chubby Buddhas of China and the Chinese-influenced regions of Vietnam.

Both of the two typical Buddha figures of Laos are represented in the collections here, together with many other manifestations. The Buddha praying for rain, a posture in which the standing Buddha's arms are held stiffly at his sides with his long fingers pointing directly at the ground, is the archetypal Lao Buddha and is unique to Laos and to regions that came under Laotian influence. (One wonders, actually, if this long straight figure staring straight ahead with the extended arms and the long fingers may be a source for the archetype of intelligent aliens that appear in many American movies and television shows.) There are also examples of the other typically Lao Buddha, the Buddha contemplating the tree of enlightenment, in which the standing figure's hands are crossed in front of him. Most of the standard types of both seated and standing Buddhas are well represented in the collection here.

Most of the objects on exhibition in the Wat Phra Keo are from the *wats* of Vientiane, and most date to the eighteenth and nineteenth centuries, although there are earlier objects as well. There is an excellent example of a Dong Son drum,

wonderful walking Buddhas influenced by the style of the Kingdom of Sukhothai in northern Thailand, and a series of Khmer objects that includes some later copies of the famous Angkor *apsaras*. The beauty of the objects that have survived in this museum only underscores the loss that must have occurred.

Across the street from Wat Phra Keo—and worth a visit as well—is Wat Sisaket, an early-nineteenth-century monastery that was one of the few important buildings in Vientiane to have survived the sacking by the Thai army in 1827. Stylistically similar to the reconstructed Wat Phra Keo, the arcades and *sim* of Wat Sisaket house thousands of unlabeled (and in many cases broken) figures of the Buddha in all shapes and sizes. Most date to between the sixteenth and the nineteenth centuries. The piles of shattered and cracked Buddha figures at Wat Sisaket, in combination with the small number of objects housed in Wat Phra Keo, provide sobering material for thought. In the sixteenth century, Vientiane was the prosperous capital of Lan Xang, the Kingdom of the Million Elephants. Located on the banks of the Mekong River, the great highway of Southeast Asia, it was a thriving center of trade and agriculture. Sacked by the Thais in the early nineteenth century, the city was abandoned and fell into disrepair until it was reconstructed by the French at the end of that same century as a city of broad boulevards and colonial architecture. The city that survives today is a pleasing combination of French colonial city planning and eclectic Eastern and Western architecture (and is, incidentally, one of the few cities in Southeast Asia wherein walking hasn't become an undertaking fraught with danger). But the remains of the great early civilizations of Laos are hauntingly elusive. The precious remnants at Wat Phra Keo are a reminder of the ofttimes delicate balance between what may be saved and what may be lost in any culture.

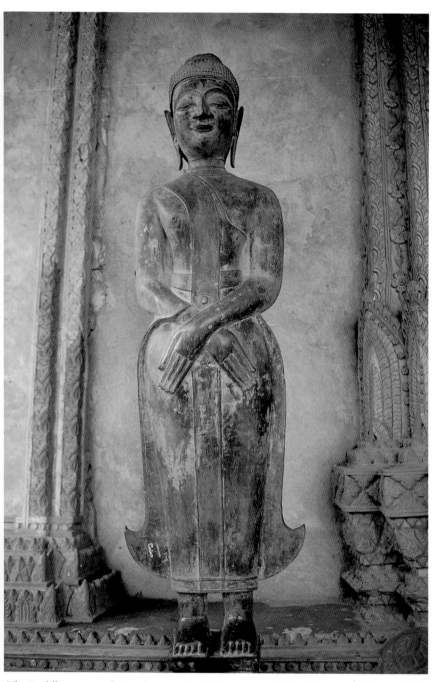

The Buddha contemplating the tree of enlightenment, with hands crossed in front of his body, is another one of the characteristic Buddha figures of Laos. Photo: Kristin Kelly.

NATIONAL MUSEUM

JALAN DAMANSARA

50566 KUALA LUMPUR

TEL: 03-228-26255

OPEN: EVERY DAY FROM 9:00 A.M. TO 6:00 P.M.

The visitor enters the National Museum in Kuala Lumpur by walking through a replica of the late eighteenth-century Malim gate of Kota Kuala Kedah (the only surviving brick Malay fort in Malaysia), and into a courtyard filled with delightful examples of past methods of transport. The traditional bullock carts, rickshaws, and early fire and steam train engines displayed here set the stage for an entertaining and educational trip through the cultural, historical, and natural worlds of Malaysia.

The National Museum is a very popular institution, thronged routinely with Malaysians of all ages from the variety of ethnic backgrounds that make up the multicultural population of the country. In addition, it is an important research institution. The staff of the museum conducts significant investigations in fields related to their collections, ranging from studies on textiles and costumes to expeditions to Sarawak to work on medicinal plants in tropical forests. As one of the federal museums of the very well organized Malaysian Department of Museums and Antiquities, the National Museum states as its objective to be "a repository of Malaysia's rich cultural heritage and the focal point for imparting knowledge on the country's rich historical and national heritage." Since there are substantial state museums around the country as well, the treasures of Malaysia have not been concentrated in this museum and the highlights of regional collections remain basically in their own areas. Rather, this museum is a teaching and educational institution that presents an excellent—and eclectic—overview of the world of Malaysia.

There has been a museum at this location since the early twentieth century. The original Selangor Museum, a Victorian structure established in 1907, occupied the site until it was destroyed (together with most of its contents) in 1945 by a stray bomb meant for the nearby railway yards. Kuala Lumpur was without a museum from 1945 to 1952, a time of intense political struggle in the country during which communist insurgents, in what was then British Malaya, undertook a crusade against the colonial government and the Federation of Malaya. The situation improved somewhat in 1952 when a small museum was erected on the site in that year and served as the National Museum until it was demolished in 1959. The current museum opened in 1963, and houses a comprehensive collection of ethnological and archaeological objects as well as natural history specimens. The current building incorporates characteristic elements of Malay palace architecture into its modern architecture, and is embellished with Malay designs and motifs.

A collection of "early land transport" vehicles is housed in the courtyard. A traditional Melaka bullock cart, with a passing resemblance to the Conestoga wagon from the American West, sits next to an example of a rickshaw. Melaka is a historic city on the west coast of the Malay peninsula about halfway between Kuala Lumpur and Singapore. A fire engine dating to 1958 and two steam train engines that were in use until the 1960s are particularly worthy of note. Inside the repro-

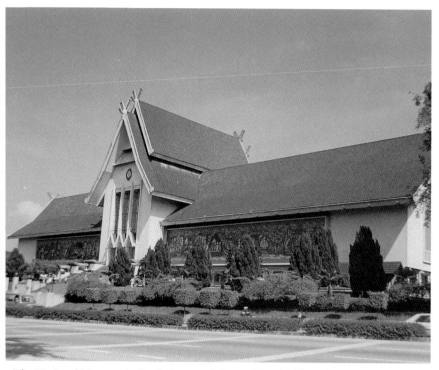

The National Museum in Kuala Lumpur is housed in a building that has incorporated elements of traditional Malay palace architecture into its modern design. It was opened to the public in 1963. Photo: Courtesy of the Department of Museums and Antiquities, Malaysia.

duction of a Malay house, raised above the ground and divided into sleeping and eating rooms, are photographs of the palaces of Malaysia. Two burial poles from Sarawak, thought to be about 200 years old, are displayed near the house.

Inside the museum, the main entrance hall is a great, two-story space with a grand staircase at one end, overhanging balconies on three of its four sides, and wonderful blue and white floor tiles. The museum's galleries lie on either side of this hall. The cultural gallery and the gallery space devoted to rotating exhibitions are on the first floor; the natural history and traditional weapons, ceramics, and musical instrument galleries are on the second floor.

In the cultural gallery, the visitor can observe the wide variety of influences that have contributed to the formation of pre-sent day Malaysia. These are illustrated by displays on wedding customs in Malaysia, an amusing and informative display on the various types of footwear worn by the peoples of Malaysia, and explanations of children's games and toys. The melting-pot nature of Malaysia is perhaps best illustrated by its adaptation of *wayang kulit*, or shadow puppetry, an art found in some form or another throughout much of Asia. The oldest shadow puppets are thought to be from India, Indonesia, and China.

In shadow puppetry, puppets are manipulated behind a white cotton screen and in front of a light source so that the shadows of the puppets are cast onto the screen. Viewers sit in front of the screen. The entertainment has evolved differently in different regions, as have the figures themselves. Chinese figures are smaller

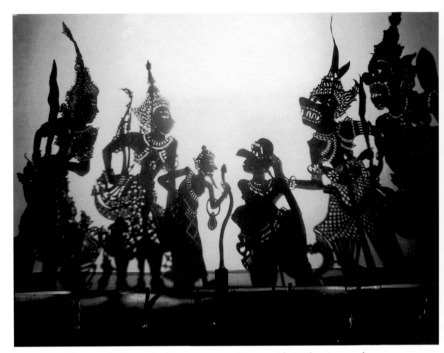

Wayang kulit, or shadow puppetry, is a notable Malaysian art form.
Stories are drawn from both religious and traditional sources. Photo: Courtesy of the
Department of Museums and Antiquities, Malaysia.

and more delicate than those of the Southeast Asian regions. Khmer shadow puppets can weigh as much as 30 pounds. In India, the puppets are held up to the screen so that the viewers can see the colors of the puppets. Shadow puppetry in Malaysia is closely related to that of Indonesia, featuring leather figures of characters primarily from the *Ramayana*. Shadow puppetry is still occasionally performed today in Malaysia, although television and other electronic forms of diversion have largely supplanted it as a mass entertainment.

Everyday clothing and festival costumes are also exhibited here, and given the recent closure of the Textile Museum on Merdeka Square, this is the best place to view these materials. Particularly spectacular are the costumes and props from the Lion Dance, a Chinese and Tibetan ceremony that was imported into Malaysia. Two men support the brightly colored and massive lion's head, and the cloth body. The Lion Dance is still performed around Malaysia at festivals and is, indeed, remarkably similar to the dances performed at Chinese New Year's celebrations around the world.

Models of traditional Malay, Straits Chinese, and Indian (the three major cultural influences on present-day Malaysia) homes, and tableaux of their characteristic ceremonies, have been reconstructed in these galleries to more fully illustrate the richness of the Malaysian heritage.

Of the traditional weapons of Malaysia, the *kris*, or *keris*, is particularly intriguing. A wicked-looking dagger with either a straight or an undulating blade, the *keris* was frequently thought to be imbued with magical powers. The handles were often elaborately decorated with inlay and jewels. The *keris* is probably an import from insular Southeast Asia and has been documented as early as the four-

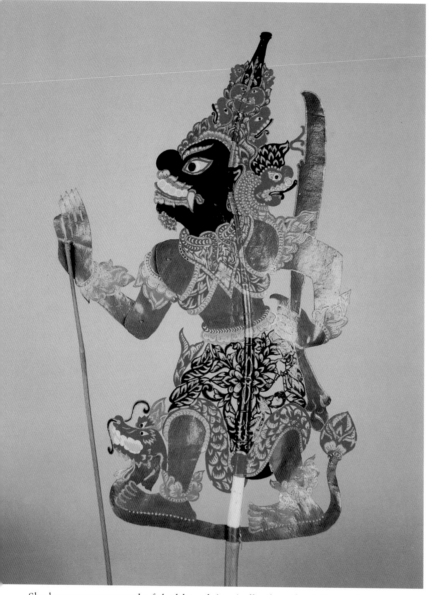

Shadow puppets are colorful, although ironically, the color is lost as they are projected onto a cotton sheet and seen only in shadow. Photo: Courtesy of the Department of Museums and Antiquities, Malaysia.

eenth century on temple reliefs on Java. Many of the weapons on display here are rom Sabah and Sarawak, the island egions of Malaysia. As a combat weapon, he *keris* was a central element in the *mok*, a wild—and frequently suicidal—

charge by Malay warriors armed with the weapon into the ranks of the enemy. (The expression "to run amuck" is based on the Malay verb *amok.)*

The gallery of musical instruments is located behind the weapons gallery and

The installations devoted to the matrimonial celebrations of Malaysia are a highlight of the museum's galleries. Photo: Courtesy of the Department of Museums and Antiquities, Malaysia.

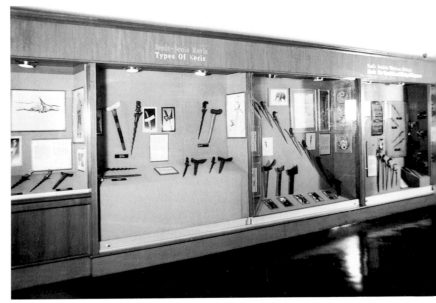

Displays of fearsome traditional weapons, such as the *keris* (or *kris*), are prominent in the National Museum. Photo: Courtesy of the Department of Museums and Antiquities, Malaysia.

Intricate decorative metalwork characterizes the historical weapons of Malaysia.
Photo: Courtesy of the Department of Museums and Antiquities, Malaysia.

features showcases with displays of Indian, Indonesian, and Thai instruments, in addition to the traditional instruments of Malaysia. Instruments such as the *gendang*, the double-headed drum, and the *tawak*, a large gong, used in shadow puppet performances, are displayed here, as is an instrument composed of a circle of small gongs in the center of which a musician would sit. Not to be missed in this gallery are the slightly loopy dioramas of Malaysian court dances, in particular the examples in which the dancers imitate the movements of chickens and goats. This gallery has become, *de facto*, an interactive display as the instruments are in a constant state of use, albeit unauthorized, by children on museum visits.

In the adjacent ceramic gallery, the showcases of early cross-hatched pottery from Sarawak, and the collection of "Nonya" or Straits Chinese special occasion tableware, are of particular interest. For those not familiar with the general history of ceramics and pottery in Southeast Asia, this museum offers a good introduction to the topic.

Malaysia lies completely within the tropics and the flora and fauna of the country are incredibly diverse. The natural history halls of the museum feature the sea- and land-dwelling creatures of Malaysia. Especially riveting are the dioramas and cases devoted to the bats, flying squirrels, and flying lemurs of Malaysia, creatures the average visitor to the country is not likely to encounter. For those with strong stomachs, the insect displays are surreal. The top visitor attraction here is a fiberglass model of the Puchong crocodile that died in 1997 in Melaka. The original weighed some 275 pounds, and was about 18 feet long and over 3 feet wide. On the balcony outside the natural history galleries are cases devoted to the endangered and extinct species of Malaysia, of which there are a depressing number.

The National Museum is a multipronged institution with something for everyone. Its well-organized and thoughtful exhibits and interpretive materials provide the visitor with a broad and stimulating overview, as well as an excellent introduction to the country and people of Malaysia.

BAGAN ARCHAEOLOGICAL MUSEUM

LOCATED IN THE BAGAN ARCHAEOLOGICAL ZONE

TEL: 062–70271

OPEN: TUESDAY THROUGH SUNDAY FROM 9:00 A.M. TO 4:30 P.M. CLOSED MONDAY AND HOLIDAYS.

Bagan, or Pagan as it was known before 1988, is one of the great archaeological sites of Southeast Asia, and indeed, of the world. Founded in the ninth century A.D., the site today consists of nearly two thousand stone, brick, and plaster stupas and temples littered across a flood plain of the Ayeyarwaddy (formerly known as the Irrawaddy) River about 90 miles south of Mandalay in central Myanmar. The vast majority of the temples at Bagan were built in the approximately 200 to 250 years between the middle of the eleventh century and the end of the thirteenth century, when Kublai Khan and his men swooped down from China and overran the city. The city was virtually abandoned at that point, and the site has been in ruins ever since. Even the multitude of temple structures that have survived cannot fully convey the glories of Bagan. As was true at Angkor and most other sites in Southeast Asia, domestic architecture—including what must have been spectacular palaces and dwellings—was made of wood and, in Southeast Asia's humid climate, all such traces have disappeared.

Still, the remains of Bagan are spectacular, and the proximity of its monuments to one another makes it possible to view the overall development of the architecture and its painted and sculpted decoration. As the *Lonely Planet* guide to Myanmar points out, "it's as if all the mediaeval cathedrals of Europe had been built in one small area, and then deserted, barely touched over the centuries." It is undeniable that the forsaken nature of the site does impart a certain element of romance to the entire experience.

The Archaeological Museum at Bagan is a good place to begin any visit to the site. The collections of the museum were moved in 1998 from a temporary location near the Gawdawpalin Temple to a huge new building visible from virtually everywhere in the archaeological zone. The new museum is an unusual and startling place, filled with a combination of priceless and important objects from the site displayed next to modern paintings of temples, and sculptures of historical figures, which may be of marginal interest to the visitor. A selective visit to the museum is highly rewarding and informative, while an attempt to see and study it all can be tiring and even overwhelming.

The Archaeological Museum's collections are arranged on two floors around an enormous—and virtually empty—entrance hall with contemporary sculptures of the important kings of the Pagan period and sculptures from the Pagan period. The best place to start a visit to the museum is in the gallery to the left of the entrance hall labeled "Showroom of Bagan Period Architecture." Inside this gallery is a large relief map of the site and models of many of the major temples. Although the visitor would have to be suspended in midair over the relief for it to be completely comprehensible, it does provide reference points and gives the visitor a clearer vision of the layout of the site than any flat map could. Several of the temples represented here in models are key to understanding the various architectural styles of the site: Ananda (1090), Bupaya (now a reconstruction after the 1975 earthquake; the original was thought to be one of the earliest of the Bagan temples),

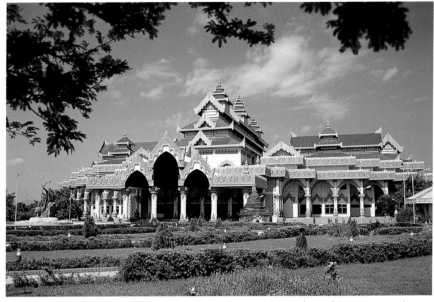

The new Archaeological Museum in Bagan houses objects from this enormous site, consisting of thousands of temples and stupas on a flood plain of the Ayeyarwaddy River. Photo: John McDermott.

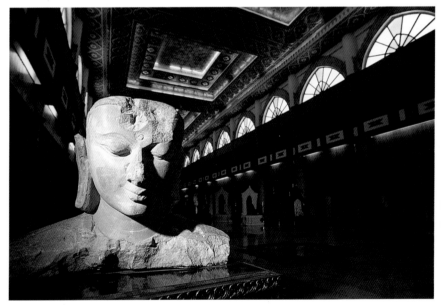

A sandstone head of the Buddha dating to the eleventh century greets the visitor in the Great Hall of the museum. Photo: John McDermott.

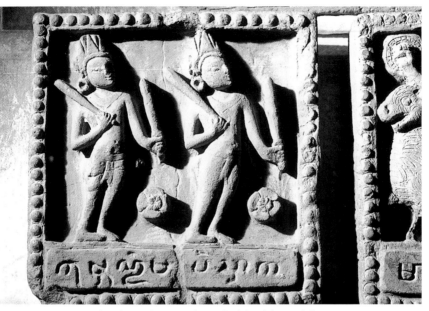

Terra-cotta *Jataka* tiles with scenes from the life of the Buddha were common decoration on the temples at Bagan. This example dates to the eleventh century. Photo: John McDermott.

Dhammayangyi (1167–1170), Thatbyinnyu (1144), and Mahabodhi (1211–1234).

Also on the left side of the entrance hall is the "Showroom of Bagan Period Arts and Crafts," a gallery that features good reproductions of Pagan period mural paintings, and a wealth of objects from the site, including architectural fragments from some of the temples. Particularly interesting in this gallery are some of the few remaining *Jataka* tiles from the Bagan temples, and some of the eleventh-century sandstone sculpture from the Ananda temple. The museum staff has helpfully reconstructed the placement of a perforated window from one of the temples of the Wutthanataw group so that the visitor can appreciate how the original must have appeared. This is a fine place to learn about the iconography of the footprint of Buddha, as its meaning and the 108 auspicious symbols arranged on the bottom of his foot are explained here in a very well-organized didactic panel.

Several display cases hold examples of sculpture—Bodhisattva and Deva figures, heads of children and ogres, and Kinnara and Kinnari figures—that give a sense of the artistic quality for which many Bagan sculptors were known. A wooden sculpture of the earth goddess Vasundari from the seventeenth or eighteenth century conveys an embodiment of the afterlife of that style.

The "Showroom of Bagan Period Literature" on the right side of the entrance hall is well worth a visit. In this gallery are exhibited many stele that record actions ranging from the donations of slaves and lands to the consecration of temples. One particularly interesting stele details a parents' donation of their daughter to a monastery in 1229 because they had no cows or buffalo for a dowry. Two of seven pillars that recorded information about the construction of a new royal palace (now lost) erected by King Kyanzittha (1084–1113), and pillars erected at the Shwezigon Pagoda during his reign are exhibited here as well.

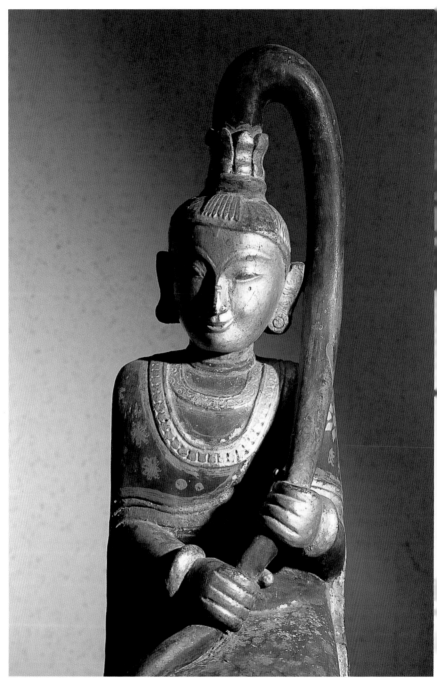

This charming wooden sculpture of the earth goddess Vasundari with her incredibly long topknot dates to the seventeenth or eighteenth century. Photo: John McDermott.

The Myazedi Pillar is one of the most important objects in the history of the country. With inscriptions in Pali, Pyu, Mon, and Burmese, it enabled archaeologists to translate previously incomprehensible texts. Photo: John McDermott.

The most important object in the gallery is the Myazedi Pillar, the so-called "Rosetta Stone" of Myanmar. On its four sides is the same inscription in four languages, Pali, Pyu, Mon, and Burmese (labeled "Myanmar" in the gallery). Pali is the language in which the original Buddhist texts were written. The Indian-influenced Pyu Kingdom predated the Kingdom of Pagan, and ultimately fell to Chinese invaders in the ninth century. (There is evidence that some survivors of this invasion may have settled in the area around Pagan, which constituted the roots of this new kingdom.) Mon is the language of the peoples who had moved from Cambodia into the southern part of Myanmar in the middle of the first millennium. The armies of Pagan defeated them in 1057. Burmese is the language of the country today. The deciphering of the writing on this stone has enabled scholars to interpret a wide variety of documents.

Upstairs on the right side of the museum is a large gallery filled with Bud-dha figures of varying quality from the temples and stupas of Bagan, dating from the eleventh through the eighteenth centuries. This is a good place to master the various mudras, or established sets of hand gestures, postures, or "attitudes," of the Buddha. In addition to the physical characteristics—such as having legs like a deer, a chin like a mango stone, and arms like an elephant's trunk—that were defined in the texts of Theravada Buddhism, every figure of Buddha is depicted in one of the forty mudras. Each has a particular meaning. The standing Buddha with one hand or both hands raised with palms toward the viewer is in the Abhayamudra, and is dispelling fear or giving protection. A seated Buddha with his hands in the same position, is in the Vitarkamudra, and is teaching. The seated Buddha with left hand in his lap and fingers of the right hand pointing down, is in the Bhumisparcamudra, and is calling the earth goddess to witness his enlightenment and victory over Mara, the king of the demons. Buddha seated in

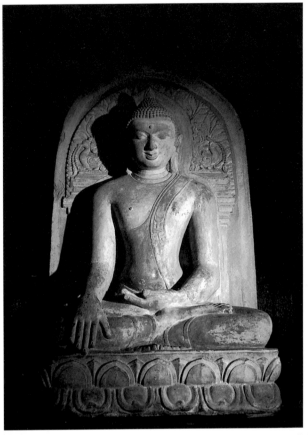

The serene figure of the Buddha is one of the typical figures of the art of the Pagan period. This sandstone example dates to the eleventh century. Photo: John McDermott.

a full lotus position with both hands in his lap is meditating in the Dhyanamudra. The Buddha with his alms bowl in his lap is in the Patramudra. A close look at the figures will prove helpful during a later visit to the site. These mudras have not changed appreciably over the centuries. The Buddha figures on display were objects of worship and were very much in the tradition that had been established centuries ago.

The "Art Gallery of Pagan Period Ancient Monuments" on the left side of the second floor features hundreds of contemporary landscape paintings of the temples at Pagan with floor plans and reconstructions where appropriate. There are also copies of wall paintings from the various temples. The assortment of temple paintings does convey an impression of how these temples and stupas looked prior to falling into ruin.

Travelers to Myanmar are usually aware and tolerant of the glitches common when traveling in the developing world. Visitors to the Bagan Museum should be aware, however, that it is subject to occasional power outages, particularly during and following tropical rainstorms. In a significant blackout, it may be best to leave and return later, since there's not enough natural light inside to make a visit worthwhile.

LACQUERWARE MUSEUM

ADJACENT TO THE AYE YAR HOTEL
(THERE ARE SIGNS ON THE MAIN ROAD)

BAGAN

OPEN: TUESDAY THROUGH SUNDAY FROM 9:00 A.M. TO 4:00 P.M.
CLOSED MONDAY AND THE MONTH OF APRIL.

B urmese lacquerware ranks among the finest in the world, and the lacquerware of Bagan is the finest in modern Myanmar. The National Lacquerware Institute in Bagan is a major training center for contemporary artists in lacquer. On the grounds of the Institute is the small, but informative Lacquerware Museum with installations devoted to the history of the medium in the country, and to the various forms and uses of objects made from lacquer sap.

Lacquerware has been produced in Burma for at least nine hundred years, and the museum houses objects from as early as the twelfth century during the Pagan period. It was frequently used at monasteries and at the royal court, and its survival as a distinct art form is due, in part, to the isolation of the country over the centuries. Burmese lacquerware is unmistakable, and its unique, elegant nature has been well preserved.

The creation of a piece of lacquerware is a long and involved process. The armature on which the liquid lacquer is applied can be one of three materials: wood, bamboo, or horsehair. The wood and the bamboo are relatively rigid, whereas pieces made from horsehair—primarily objects such as cups or bowls with curved surfaces—are flexible. Wood, bamboo, and horsehair are all available in Myanmar, although the traditional bamboo comes only from the northern part of the country. The base materials are shaped into the desired form. A mixture of lacquer sap and ash is spread over this base, allowed to dry, and buffed. Then black (the natural color) or colored lacquer (most frequently some

variation on red) is applied to the object, allowed to dry again, and rubbed and polished. This process is repeated until the object is adequately coated. If the piece is to be decorated, the artist then incises delicate and intricate designs on the surface of the lacquer (which is still somewhat pliable even after it dries), using a sharp metal tool. Pigment mixed with lacquer is then applied to the entire surface of the object to fill in the grooves created by these incisions. The excess pigment is wiped off and the object is allowed to dry. It is then coated with a clear, lacquer-like substance, which is then incised and filled in with a different pigment color. The artist repeats this process with different colors until he or she has completed the design on the surface. Many of these designs are traditional and date back hundreds of years. Frequent motifs include birds, flowers, dragons, elephants, and fanciful mythological beasts. More contemporary work can incorporate more Western and abstracted motifs. Lacquerware production can be seen today in many places in Myanmar, especially in the arcades of temple precincts in Mandalay and Bagan. There are also a number of lacquerware production studios in Bagan.

Most objects in the Lacquerware Museum have either a wood or a bamboo base, although there are some examples of lacquer on a horsehair base as well. Burmese lacquerware tends to take the form of household objects and various kinds of food containers. Many of the objects exhibited here date from the nineteenth century, though there are much older examples.

The Lacquerware Museum in Bagan houses examples of Burmese lacquerware from nine centuries. Photo: John McDermott.

Recently excavated in Bagan, these twelfth-century lacquerware fragments are evidence of this art form from the height of the Pagan period. Photo: John McDermott.

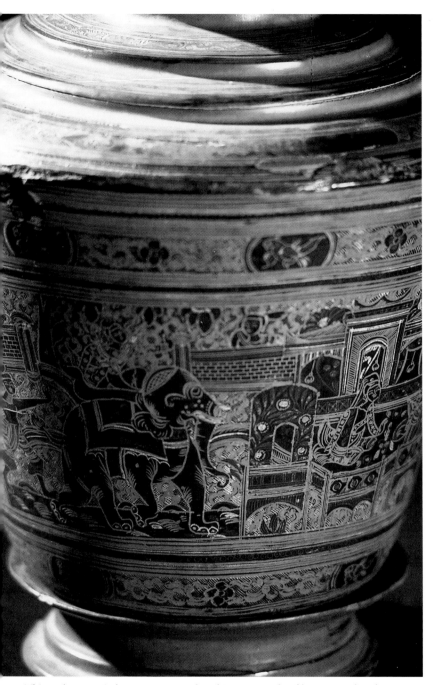

This early-twentieth-century water bowl is an example of lacquer on bamboo.
Photo: John McDermott.

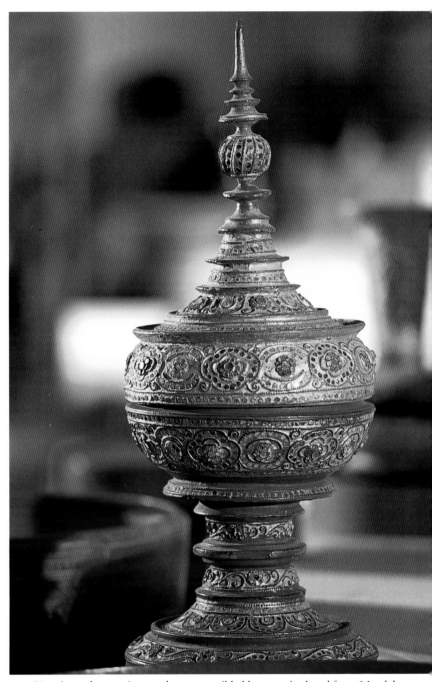

Here is an elegant nineteenth-century gilded lacquer rice bowl from Mandalay.
Photo: John McDermott.

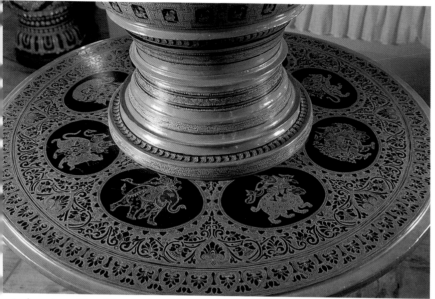

A charming table with a rice bowl features animals from the Burmese birthday zodiac, based on the day of the week that one is born. Photo: John McDermott.

Lacquerware, such as this beautiful tea set, continues to be produced by students at the school with which the museum is affiliated. Photo: John McDermott.

Legendarily, the earliest piece of Burmese lacquerware was found in Bagan in the middle of the eleventh century. The earliest objects exhibited are fragments of brown and black lacquer from an excavation site in Bagan and date to the twelfth century. A gold box and some alms bowls and a betel-nut box date to the sixteenth century. The nineteenth- century collection includes many of the traditional "decked" food containers in which each type of food had a separate container stacked in diminishing sizes on top of one another. There are also several nineteenth-century betel-nut boxes. Some lovely contemporary tea sets (one can actually drink from lacquerware cups) are on display as well.

Even if it is small, and will not involve a long visit, this museum is a good introduction to an intriguing and venerable Asian artistic medium. The time it will take the visitor to appreciate its contents offers a worthy respite from visiting the virtually infinite ruins of Bagan. Although there is no admission charge, a small monetary "gift" should be offered to the minder. The shop adjoining the museum provides an excellent venue for the purchase of high-quality, well-priced contemporary lacquerware, made by the students of the Institute.

NATIONAL MUSEUM (OF MYANMAR)

66/74 Pyay Road
Yangon

Tel: 1–282–563, 1–282–608

Open: Tuesday through Sunday from 10:00 a.m. to 3:30 p.m. Closed Monday and holidays.

A division of the Ministry of Culture of the Union of Myanmar, the National Museum is currently in its third location since 1952. It originally opened on Schwedagon Pagoda Road, then moved in 1970 to a location in central Yangon (then called Rangoon) on Pansodan Road in the British colonial building that had served as the Bank of India. In 1990, construction began on the present modern building, and in 1996, the museum moved once again to its current location, where it opened to the public on September 18. Nine is a particularly auspicious number in Myanmar, and the opening on the eighteenth (nine times two) day of the ninth month was undoubtedly scheduled accordingly.

The museum is extensive and ranges over five floors in its coverage of the artistic, natural, and general cultural histories of the country, with special attention to its musical traditions. (The galleries devoted to musical instruments are the only air-conditioned spaces in the building.) The lighting and presentation are not what one might expect of a new construction, but with perseverance, the visitor will be exposed to an excellent survey of Myanmar's past history and living cultures. The installations begin on the first floor and move upstairs.

By far the most stunning—indeed, almost overwhelming—object in the museum is the huge Lion Throne, exhibited in a ground-floor gallery. The 35-foot high Lion Throne is named for the decorative lions that fill the small niches at the bottom of the throne. As is true of many important objects and relics in this part of the world, the Lion Throne has had a lively history and has traveled around a great deal in its 150-year history. Having been constructed in a manner that allows it to be dismantled, the throne was built between 1856 and 1857, during the reign of King Mindon. Originally the throne was located in Mandalay, the second city of Myanmar to the north of Yangon, and the capital of the Burmese Kingdom just prior to the British conquest of the country. King Thibaw, the last of the kings of Mandalay, became ruler in 1878 after the death of King Mindon. Mindon had managed to balance British influence in the northern part of Burma with that of other foreign powers. Thibaw, however, was simultaneously a ruthless and an ineffective ruler. Not only had he come to power only after executing everyone who stood in his way, but his poor governance of the northern part of the country paved the way for the Anglo-Burmese conflict of 1885, during which the British took control of Mandalay after having encountered only perfunctory resistance.

From 1885 to 1937, Myanmar (then called Burma) was a part of British India. The British took the Lion Throne from Mandalay to the Indian Museum in Calcutta in 1902, and this action probably saved it from destruction since the palace from which the throne was taken was subsequently burned to the ground. This area was the scene of a great deal of brutal action during World War II. In fact, the Lion Throne is the only one of the nine thrones used by the Kings of Burma to

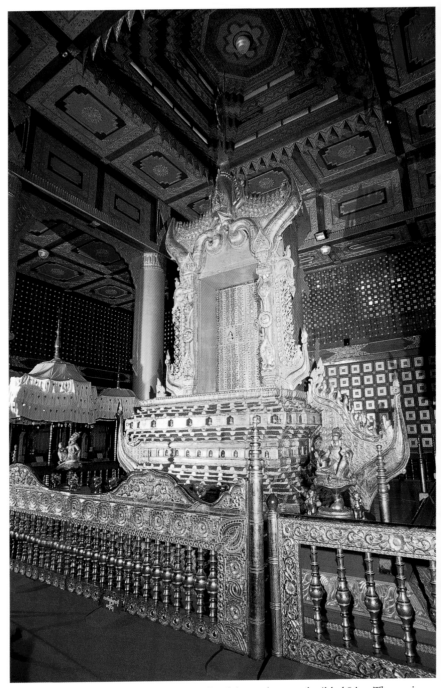

Dating to the mid-nineteenth century, the elaborately carved, gilded Lion Throne is a highlight of any visit to the museum. Photo: John McDermott.

have survived World War II. (Replicas of the other eight thrones, including thrones devoted to elephants, peacocks, conch shells, deer, and bumblebees, are exhibited in the museum.) The throne was returned to Myanmar in 1948, when the independence of the country was declared. In 1957 it was moved to the National Museum, where it has been exhibited in two separate locations.

The throne has a complicated iconography, and illustrates a story from Burmese mythology. The Lokanat, or guardian spirit of the world (figured just below the column capitals on either side of the doors), settled a quarrel between a celestial flying elephant and a flying lion over who would be permitted to eat the clouds in the sky. Because the Lokanat settled the dispute by singing and dancing, the spirit is a symbol of peace. These singing and dancing figures wear bells on their ankles, and hold leaves that represent success and peace. There are other recognizable animals figured on the throne. Rabbits, elephants, and peacocks are found as decorative elements in the areas around the doors, and the patterning on the lower "wings" of the throne is said to be that of a crayfish scale. All in all, the object is far greater than the sum of its parts, and is perhaps best appreciated as an overwhelmingly large relic of Burmese history.

The Lion's Throne is placed in context in the next room, where models of Mandalay Palace and actual examples of nineteenth-century furniture and dress from the northern part of the country are displayed. The original gilded door from Mandalay Palace is here as well. A staggering quantity of gold is in evidence in this room. Although the furniture on exhibit here consists primarily of beds and reclining couches, there is a wonderful huge brass gong supported by two nineteenth-century figures. The most spectacular object here is a nineteenth-century gold leaf manuscript cabinet, originally

from the Hman Kyaung monastery in Mandalay, that would have held Buddhist scriptures. The exhibited state attire that was worn by King Thibaw and his Queen is virtually identical to the garb on the marionettes available for sale in the markets of Yangon.

An installation which traces the development of the Burmese script, a written language that has been described by Tony Wheeler and Joe Cummings, authors of the *Lonely Planet* guide to Myanmar, as looking like "a lot of mating bubbles and circles, very distinctive, and quite indecipherable!" is also housed on the ground floor. With objects as old as fifth-century bricks, the evolution of the Burmese script is traced through manuscripts and photographs of monuments around the country. Two fine examples of inscribed teak pillars from Kanbawzathadi Palace in Bago from the sixteenth century, and a lovely Shan astrological manuscript from the nineteenth century, are highlights of this gallery. Many of these inscriptions, particularly those dating between the thirteenth and fifteenth centuries, are represented in rubbings or photographs. For a Western visitor, the range and variety of these inscriptions, as well as their intrinsic beauty, will be of interest. For the more avid visitor, the small guidebook available at the museum lists the most important objects on display and their dates.

On the first floor are historical galleries devoted to the prehistory and history of the country, and a gallery exhibiting treasures and royal regalia. Some of these treasures are nothing less than astonishing. These objects were used by many generations of Burmese kings to enhance their position and celebrate their reigns. Traditionally, the thirty-five objects associated with the regalia (or insignia) were placed in front of the throne, seventeen of them on the right hand of the ruler and eighteen on the left. A wide variety of forms ranging from large and small candelabra to betel-nut boxes, to an exquisite

Burmese script, consisting of loops and lines, is used here on ivory.
Photo: John McDermott.

The royal treasures of ancient Burma, ranging from caskets to betel-nut containers to trays, are on display in the museum. This pitcher in the shape of a crayfish, dating to the eighteenth or nineteenth century, is one of the most astonishing examples.
Photo: John McDermott.

Music has always played a major role in the lives of the Burmese. A collection of these intricately detailed and decorated instruments is on display in the gallery of musical instruments. Photo: John McDermott.

pitcher in the shape of a crayfish formed part of this golden tableau. When the British conquered Mandalay, many of these articles were removed and taken to the Victoria and Albert Museum in London. Many of them were returned in 1964 (though some of the exhibited pieces are reproductions).

The two other galleries on this floor interpret the natural and cultural history of Myanmar from its origins down to the eighteenth century. The eclectic group of objects exhibited ranges from the teeth of extinct creatures to objects from the Pagan period to paintings depicting life in the country during various periods. The Pyadalin cave from about 10,000 years ago, evidence of Stone Age habitation in the country, is reproduced here in miniature. A stunning silver casket in the form of a Bodhi tree (the tree under which the Buddha was enlightened) dates to the fifth-century Pyu period. There are also outstanding examples of sculpture from the height of the Pagan period during the eleventh and twelfth centuries.

The galleries on the second floor are among the best organized in the museum. Great emphasis has been placed on the performing arts, and the galleries devoted to the display of musical instruments are outstanding and very informative. Traditional Burmese music is believed to date back to the Pyu period, and was played on a variety of elaborately decorated stringed and brass instruments, xylophones, drums, and gongs. The Burmese orchestra, or *saing waing*, requires at least seven musicians, who usually sit in a circle to play.

Also on display here is the full range of marionettes from the Burmese *amyint thabin*, or high stage drama, a ritual during which stories from the *Jataka* and from Burmese history were performed for three nights in a row. Burmese puppets are among the most charming and intricate in this part of Asia. Each drama used at least 28 characters, but usually no more than 36. All are represented here. These large wooden marionettes are spectacular, encompassing types ranging from fanciful dragons and Garudas to richly garbed

Puppetry is an important tradition in all of Southeast Asia. The charming marionettes of Myanmar represent one of the country's most notable and captivating folk arts.
Photo: John McDermott.

kings to more prosaic storytellers and quirky clowns. The animal figures—white elephant, tiger, horse, parrot, and monkey—are particularly appealing. Puppet performances are rare today, although there are still venues in Yangon and Bagan where it is possible to see one.

Folk art—the exuberant physical expression of the beliefs and life of the rural Burmese—fills the other gallery on this floor. The objects include a wide variety of objects of traditional Burmese lacquerware, Buddhist alms bowls, and wooden painted and gilded toys. Elaborately accessorized ship's "eyes" were of assistance in navigating the treacherous waters of the Ayeyarwaddy (formerly the Irrawaddy) River and of the Andaman Sea. Bullock carts form the central display on the floor. There are small carts used only for passengers, and a larger example (to be drawn by four bullocks) that would have been used for carrying cargo. The deer-antler chair looks like something that one might find in rural Montana. The ivory carvings of subjects ranging from

bullock carts to Buddha images are refined and elegant.

The most interesting paintings in the art galleries on the third floor are the scenes of France and Italy painted by Burmese artists. How alien the culture of Europe must have seemed to these artists! Most of the paintings, however, are copies of temple paintings from Bagan, a site that dominates the past of Myanmar as much as Angkor dominates that of Cambodia. There are also copies of paintings from Amarapura and other sites. Many more contemporary paintings, including some of the work of U Ba Nyan, who introduced European painting techniques into Burma, are exhibited here as well.

The two galleries on the top floor are devoted to the minority peoples of Myanmar and to a didactic exhibition concerned with the evolution of the figure of the Buddha in Burmese art. Both are extremely interesting. Beginning with the Pyu period and passing through the subsequent art history of Myanmar, one gallery exhibits objects that allow the visitor to

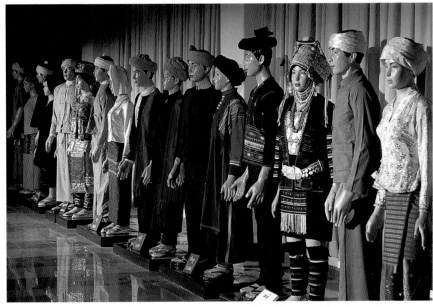

The hill tribes of Myanmar are represented in this assembly of peoples in traditional costumes. Photo: John McDermott.

watch the figure of the Buddha evolve, achieve its most eloquent expression in the art of Pagan, and gradually devolve.

The galleries devoted to the minority peoples of Myanmar feature mannequins wearing the costumes of Myanmar's tribal peoples, as well as musical instruments, artifacts, and books that have been published about these peoples. A model of a boat from Lake Inle, a shallow body of water in the Shan States in east-central Myanmar where boatmen propel and steer their boats with their feet and trap fish with traditional bamboo fish traps, is included as well. The lineup of mannequins in their brightly colored tribal costumes is somewhat eerie, but educational. The Vietnam Museum of Ethnology and the Tribal Museum in Chiang Mai are perhaps more detailed in their interpretive materials, but this gallery is, nonetheless, worth perusing at some length to learn more about the minority peoples of this country.

The National Museum of Myanmar provides an excellent introduction to the long history of what is today one of the most closed and xenophobic countries in the world. The galleries and collections here show the richness and diversity of its art and culture in the past. The visitor can only hope that, in the future, the country may find a way to build upon these traditions.

SINGAPORE
ASIAN CIVILISATIONS MUSEUM

39 ARMENIAN STREET
SINGAPORE 179939

TEL: 375–2510

OPEN: TUESDAY THROUGH SUNDAY FROM 9:00 A.M. TO 5:30 P.M.
CLOSED MONDAY.

The British instilled a healthy sense of history and a respect for material culture in the countries they colonized in Asia, and it is not surprising that some of the most advanced museums in Southeast Asia are those located in former British colonies. The British had a keen desire to learn about countries they were colonizing. In Singapore, the roots of what are now the museums overseen by the National Heritage Board are to be found in the early collecting activities of the British. While all of these museums are being upgraded and expanded, the Asian Civilisations Museum is currently the most highly evolved. Only half complete at this stage, it is arranged thematically and offers an excellent introduction to the civilizations of this part of the world.

Built to "explore and present the cultures of Asia, and to interpret the civilisations that created them, so as to promote awareness of the ancestral cultures of Singaporeans and of the heritage of the Southeast Asian region," this first wing of the Asian Civilisations Museum opened in 1997. It is housed in the former Tao Nan School building, dating from 1912, and is devoted to the Chinese heritage of Singapore. A second branch is slated to open in the Empress Place Building at the south end of the Padang (the large playing field in a bend of the Singapore River near Marina Bay) in 2002. This second wing will house expanded Southeast, South, and West Asian material, as well as additional Chinese objects. Eventually, the Empress Place Building will become the flagship

museum and the Tao Nan Building will focus on connoisseurship, collecting, and on the Peranakan, or Straits Chinese, culture.

The historic building itself is enormously interesting and a highlight of any visit. Built between 1910 and 1912, the school was the first of the Chinese schools to change its language of instruction from dialect (in this case Hokkien) to Mandarin, the language viewed as the unifier of China and of the Chinese people. The colonial government of the Straits Settlements considered this a tentative move toward a politically unified Chinese community and attempted to halt any such development by offering funding to Chinese schools that taught in local dialects. Most refused, and by 1935 all Chinese schools had converted to instruction in Mandarin Chinese. The Japanese used this building during their occupation of Singapore from 1942 to 1945. By the early 1970s, the school administrators had decided to relocate the school out of the central part of Singapore, and in 1982 the building was vacated. Empty from 1982 to 1991, it was renovated in the 1990s and reopened as the Asian Civilisations Museum in 1997.

The original building, now protected by the Preservation of Monuments Board, was designed in a style combining elements of European architecture with façade balconies suggesting tropical colonial architecture. The resulting façade is an absolute delight. Chinese and Straits Chinese objects are displayed on three floors

63

The graceful arcades of this restored building are one of the architectural highlights of Singapore. Photo: Kristin Kelly.

The building that now houses the Asian Civilisations Museum (seen here in an early photograph) was originally the Tao Nan School. The building dates to 1910–1912. Photo: Courtesy National Archives of Singapore.

A light-filled interior stairwell ties the building together architecturally and provides easy access to the galleries on each floor. Photo: Kristin Kelly.

that wrap around a three-story stairwell which forms the heart of the building. Indeed, the principal architect of the renovation, Chu Lik Ren of the Singapore Public Works Department, has stated that "My favourite part of the building is the three-story stairwell. It is the soul of the building, it is its centre. Without it, there is no light within the building." It is the architectural element that holds the building together as the visitor moves from one floor to another. The renovated classrooms and administrative offices make wonderful galleries, and the recycling of the building has been completely successful.

The introductory gallery on the first floor provides a detailed time line of Asian history from 3000 B.C. to the present, as well as an introduction to the key periods of Chinese history and art. The time line traces history and artistic developments in China, India, island and mainland Southeast Asia, and West Asia. The introduction to Chinese history and art notes the development of the civilization from the Neolithic period beginning in 5,000 B.C. through the end of the Qing dynasty in 1911. Trade and commerce have played a key role in the success of Singapore as a nation-state and this fact is never far from the minds of Singaporeans. The role of trade in the dissemination of art and culture throughout Asia is featured on a computer terminal in this introductory gallery.

The displayed collections of Chinese art are arranged thematically on the second and third floors of the building. Galleries devoted to symbolism, religion, the role of architecture and city planning, and ceramics are found on the second floor. The third floor houses galleries explaining the culture of the *literati*, the role of collecting and connoisseurship, and galleries devoted to Chinese painting.

The many homonyms that exist in Chinese created a number of opportunities for auspicious phrases to be rendered in visual form, and the Chinese were masters at creating puns on Chinese words and phrases such as success, happiness, prosperity, and longevity. Likewise, the symbolism of both flora and fauna have played a key role in the iconography of Chinese art. The visitor can peruse examples from many centuries and media to learn about the role that symbolism played in the development of Chinese art.

Many of the world's great religions passed through China at one point or another, and the country became a melting pot for a variety of beliefs. Buddhism came to China along the Silk Road, and although it almost became a state religion during the Sui and Tang dynasties (late sixth to early tenth centuries), it was associated with India and Central Asia and came to be viewed as undermining the Confucionist order. Confucius lived in the Warring States Period (475 B.C. to 221 B.C.), and the tenets of Confucianism that ruled China dictated that an individual should act in accordance with his position in the social context. It emphasized the eight virtues of loyalty, filial piety, kindness, reverence, observance of rites, righteousness, incorruptibility, and propriety. Taoism, the philosophy of "the way," became inextricably interwoven with Buddhism and was derived from early animistic Chinese beliefs. All these religious elements found their way into the artistic environment of the country, and their influences can be seen in many different ways.

Architecture and city planning in China tended to reflect "the beliefs and values in which space at both domestic and urban levels is organized in Chinese society." The gallery devoted to architecture and city planning is filled with historic objects from both China and Singapore. A *duogong*, or wooden bracket, from one of the earliest temples in Singapore, dominates the gallery. Also of interest is a wonderful, large painted map of Beijing kept under a cover to avoid unnecessary light exposure. Much of what is

The Chinese were advanced city planners at an early stage in their history.
This gallery is devoted to the architecture and city planning of early China.
Photo: Courtesy Asian Civilisations Museum.

known about Chinese architecture has been drawn from small surviving models of buildings, many of which were found in tombs from the Han dynasty. There are examples of these small Han building models, in addition to a model of a courtyard house from the Ming Dynasty, which faces south to embrace the summer and its associated warmth and fertility.

In many ways, Chinese art is best represented by its over 7,000-year history of ceramic production and the space devoted to ceramics displays a wide variety of wares. From Neolithic painted coiled pots to greenware and blue-and-white ware, through the enameled wares of the Qing dynasty, Chinese ceramics found their way around the world. Some were traded to the countries of Southeast Asia. Others were created for the European export market. Many were found in shipwrecks.

The *literati* bridged the social gap between the ruler and the common people of China. The *literati* functioned as advisors, policy makers, and itinerant scholars. The study was their most important room, and the simple elegance of a *literati* study with pieces dating from the late sixteenth through the nineteenth centuries is one of the highlights of the museum's third floor. The implements for writing are displayed in an adjacent gallery that chronicles the history of the art of writing in China. The brush was invented for writing, and the technique is explained here. At the end of the Zhou dynasty, the collecting of writing implements became important.

The Chinese came to value greatly the objects of their own past history. They collected Imperial porcelain, snuff bottles, and fascinating objects made from rhino "horn" (actually a solid mass of densely packed keratin). Jade and bronze were also objects of collecting and connossieurship throughout Chinese history. Many of these objects took on an importance beyond their monetary value. Jade was more valuable than gold to the Chinese. Rhino horn was so sought after that the

The culture of the *literati*, the Chinese intellectual class, is displayed and described in the museum. Photo: Courtesy Asian Civilisations Museum.

rhinoceros had become extinct in China by the thirteenth century. Bronze, which had initially been a relatively utilitarian medium, became much prized in the Qing dynasty. The astonishing level of refinement possible in such collectible objects is illustrated here by the displays of many different kinds of luxurious pieces, ranging from imperial porcelain to rich jade.

The visit comes to an end with a small but comprehensive exhibition of Chinese painting illustrating the history of the medium through the many centuries of its development.

While the collections of the Asian Civilisations Museum are young and still growing, its social purpose—to explain to the diverse population of Singapore from whence they came—is undeniable. It is in many ways, however, the most advanced museum in Southeast Asia in its modern approach to museology and, after a visit, the viewer will find himself or herself eagerly awaiting the opening of the Empress Place wing of the Museum. This modern—and very Singaporean—approach to museum attendance includes a wonderful museum shop and café. The main branch of the National Museum shop is located just down the block at 53 Armenian Street.

THE MUSEUMS AT THE NATIONAL UNIVERSITY OF SINGAPORE (LEE KONG CHIAN ART MUSEUM, NG ENG TENG GALLERY, SOUTH AND SOUTHEAST ASIAN COLLECTIONS)

MUSEUM ANNEX, KENT RIDGE CAMPUS

SINGAPORE 119260

TEL: 874-6917

OPEN: MONDAY THROUGH SATURDAY FROM 9:00 A.M. TO 4:30 P.M. CLOSED SUNDAY AND PUBLIC HOLIDAYS.

The wonderful collections of the National University of Singapore are to be housed in a new building scheduled to open in early 2001. Three formerly separate museums, the Lee Kong Chian Art Museum, the South and Southeast Asian Collections, and the Ng Eng Teng Gallery, will be brought together under one roof. One of these museums, the South and Southeast Asian Collection, has not been accessible to the public in the recent past. This new site will provide an important venue for the display of representative objects from these three interesting and very diverse collections.

As is appropriate for a university museum, the NUS museums are committed to "ensuring that the art collections of the University . . . are accurately interpreted, effectively displayed, carefully presented, and conscientiously promoted for the enjoyment and benefit of the NUS community of students and staff as well as the wider community of Singaporeans, and friends and visitors from all over the world." The National University of Singapore Museums were established as a unit in 1997, and their public outreach function is an important one.

The Chinese are the dominant ethnic group in Singapore. While the museums of the National Heritage Board emphasize the multicultural heritage of modern-day Singapore, the city clearly presents itself as Chinese. The Chinese first settled in Southeast Asia in the fourteenth century,

but it wasn't until the nineteenth century that significant numbers of Chinese moved to Singapore and provided the basis for the diverse population that has since propelled Singapore into its current position as a major center of technology and commerce.

The Lee Kong Chian Art Museum, named for the first Chancellor of the University of Singapore, houses some 4,000 objects from 6,000 years of Chinese history, providing a particularly strong representation from the Warring States period (fifth to third centuries B.C.) to the present. The museum was originally opened in 1972 at Nanyang University, the Chinese university in Singapore, and its collections reflect its origins in a Chinese institution of higher education. In 1989, the museum moved to the Kent Ridge Campus of the National University of Singapore, and was re-opened in its first location on this campus in 1990. By the mid-1990s, it had become clear that the museum had outgrown its modest galleries, and the planning process for the new Museum Annex began.

Acquisitions since the opening of the museum have been concentrated primarily in painting and calligraphy and in an excellent and comprehensive collection of ceramics. These have been funded mainly by the Lee Foundation and, to a lesser degree, by the Shaw Foundation. In the new facility, the collections will be displayed thematically and by stylistic

Xu Bei Hong (1895–1953). *Horses*. First half of the twentieth century. Color on paper,
39¾ x 32⅝" (101 x 83 cm). Lee Kong Chian Art Museum. Courtesy National
University of Singapore Museums, National University of Singapore. These lively horses
are one of the masterworks of the Chinese collections.

Red pottery pointed bottom bottle from the Yangshao Culture. 4800 to 4200 B.C., Ceramic, 18½ x 7⅞" (47 x 20 cm). Lee Kong Chian Art Museum. Courtesy National University of Singapore Museums, National University of Singapore. This fifth millennium B.C. bottle is one of the early Chinese wares on exhibit at the museum.

period. By medium, they consist of the aforementioned Chinese ceramics, and more modest—but still excellent—collections of archaic jade and bronze, painting and calligraphy and sculpture.

The objects in the ceramics collection represent a quite comprehensive history of ceramic production in China. Of particular interest are the ceramic models of southern Chinese farmhouses from the Han Dynasty (206 B.C. to A.D. 220). These models were frequently placed in tombs of the period to create an environment that would be familiar to the deceased. Houses similar to these two-thousand-year old models are still built today in southern China.

Green glazed ceramic pillows from the Song Dynasty (960 to 1279) and the Yuan Dynasty (1280 to 1368) are another highlight of the collection. One Yuan example is modeled in the form of a theater with tiny performers on stage below the place where a head would be placed.

The jade collections also span some 7,000 years starting with early pieces from Neolithic cultures. Jade is an expensive medium and these small objects—in particular the rich green "spinach jade"—represented the height of luxury in China. The collection here traces the development of this art form from its beginnings to its heights in the Qing period (1645–1911). The *bi* pendants from the early Warring States Period and the late Spring/Autumn Period (770 B.C. to 221 B.C.) are of special interest. They are frequently found in burial contexts, and the delicate carving, which features dragons and other fanciful beasts, is of the highest quality.

The Bronze Age in China began in the early Shang Dynasty (sixteenth to eleventh centuries B.C.). Unlike jade, bronze was made primarily for everyday use, albeit for the richer classes. Bronze work reached its peak during the period from the mid-Shang to the mid-Western Zhou Dynasty (eleventh to early eighth

Kendi. Thai Sawankhalok ware. Fourteenth to fifteenth century A.D. Stoneware.
5½ x 6¼" (13.9 x 16 cm). South and Southeast Asian Collection. Courtesy National
University of Singapore Museums, National University of Singapore. This lovely
stoneware vessel is an excellent example of the work produced in central
Thailand during this period.

Cheong Soo Pieng. *Pounding Rice.* 1953. Oil on canvas. 36⅝ x 30¾ (93 x 78 cm). South and Southeast Asian Collection. Courtesy National University of Singapore Museums, National University of Singapore. Rice, the staple of the Asian diet, and its production are a common theme in traditional art. In this colorful and slightly abstract composition, women pound the harvest.

Ng Eng Teng. *Mother and Twins.* 1988. Bronze (Western Australia). 20⅞ x 9 x 7" (53 x 23 x 18 cm). One of Singapore's leading modern artists, Ng Eng Teng has developed his version of the classic theme of mother and child by metamorphosing the children into disembodied heads. Ng Eng Teng Gallery. Courtesy National University of Singapore Museums, National University of Singapore.

centuries B.C.) and began a decline after that time. Many examples of weapons, bowls, jars, and other vessels are on display here.

The collections of painting and calligraphy feature the great masters of the Ming and Qing Dynasties (1368 to 1911) and are in the form of hanging and hand scrolls, fans, and albums. The graceful delicate depiction of animals—and particularly birds—in these hanging scrolls is masterful.

The Ng Eng Teng Gallery, established in 1997 with a gift from the artist (later supplemented by a second gift in 1998), exhibits collections of a completely different sort, the most comprehensive collection of a single artist in Singapore. Here, forty years of the work of Ng Eng Teng is on display. He is primarily a sculptor, but his work also encompasses pottery, and early examples of his painting and drawing are exhibited as well. His first works from the 1950s were terra-cotta, fired in kilns in Singapore, although he has worked in a number of media. He studied pottery design in England in the early 1960s.

The work is delightful. Ng Eng Teng has always used the human figure—and is, in fact, passionately devoted to it—as the basis for most of his work, and the more abstract works are frequently variations of this. He also finds inspiration in contemporary events. His *Split* series was inspired by the destruction of the old Chinese section of Singapore. His moving sculpture, *Hostage*, of 1981 commemorates the Americans held captive by revolutionaries

in Tehran for 444 days. The Vietnamese boat people and the plight of children caught up in the horror of war galvanized his *Freedom Child* of 1978. His many round abstract faces are charming and *Modesty* of 1986, in which three arms of a figure are deployed to cover private parts, is both humorous and a commentary on contemporary society. He is probably best known for his series of mothers and children, several examples of which are on display in the gallery.

The South and Southeast Asian Collections belonged to the University of Singapore before its merger with Nanyang University. These collections are broader and more heterogeneous and are comprised of the historical art of Southeast Asia, as well as the work of more contemporary artists. All of these collections have been in storage for many years. They consist of sculpture, textiles, paintings and drawings, and ceramics from the Southeast Asian region, as well as from the Indian sub-continent. Arranged thematically and chronologically, these collections are a welcome addition to the museum scene in Singapore.

The Museums at the National University of Singapore represent one of the great unknown treasures of the city. Just a short MRT ride from the center of the city, they will undoubtedly play a large role in the city's cultural scene once they can be exhibited and interpreted in more spacious surroundings. Future visitors have a wonderful treat in store for them.

RAFFLES HOTEL MUSEUM

RAFFLES HOTEL ARCADE, THIRD FLOOR
328 NORTH BRIDGE ROAD
SINGAPORE 188719

TEL: 337–1886

OPEN: EVERY DAY FROM 10:00 A.M. TO 9:00 P.M.

Few phrases conjure up as many romantic and engaging images of life in the Golden Age of Travel as does that of "Raffles Hotel, Singapore." Named for Sir Stamford Raffles, the Englishman who founded the first trading colony in Singapore in 1819, Raffles Hotel recalled, in the words of Somerset Maugham, "all the fables of the exotic East . . ." (Among the objects in the collection is the short note written by Maugham in February of 1956 to the manager of Raffles, authorizing the use of this quotation by the hotel.) In another quotation, Raffles is noted as, "immortalized by novelists and patronised by everyone." Maugham, Joseph Conrad, Rudyard Kipling, and a host of other literary greats passed through Raffles while in Singapore, and their spirits seem still to be present in this living monument of Singapore history. Indeed, in many ways, the history of Raffles reflects the history of Singapore.

Raffles was not always a world-class hotel. (As Rudyard Kipling wrote, "Providence conducted me along a beach, in full view of five miles of shipping...to a place called Raffles Hotel where the food is as excellent as the rooms are bad. Let the traveler take note. Feed at Raffles and sleep at the Hotel de l'Europe.") Originally a modest establishment comprised of just a bungalow and a small restaurant, Raffles was purchased by the Sarkies brothers in 1885. These legendary innkeepers of the Orient had built the E&O (Eastern and Oriental) Hotel in Penang, Malaysia, and would build the Strand Hotel in Rangoon, Burma (now Yangon, Myanmar) a few years later. These three hotels came to define the essence of British colonial style in Southeast Asia, even though their Armenian owners (who were not considered "white"), were barred from many British colonial functions. All three of these hotels have been renovated recently as if to assert their place in a New Golden Age of Travel at the beginning of the twenty-first century.

The Sarkies brothers significantly expanded Raffles, and in the late 1880s completed the building that forms the core of the present-day hotel. Raffles can truthfully boast of having welcomed travelers for well over one hundred years. Visitors of notable literary, artistic, and political merit as well as just plain rich folks graced its halls. Singapore was the "Crossroads of the East" during the early twentieth century and no knowledgeable world traveler would have felt his trip complete without a luggage sticker from Raffles. By 1939, and the beginning of World War II, the stream of travelers had been reduced to a trickle and during the Japanese occupation of Singapore from 1942 to 1945, Raffles was used as a drill ground by Japanese troops.

By the middle of the 1980s, Raffles had fallen into a state of disrepair that contrasted sharply with the rapid modern development of the city of Singapore. An extensive—and slightly controversial—renovation in the early 1990s cost about $160 million Singapore (about $100 million U.S.) and returned much of the fabric of the hotel to the way it had appeared in

Raffles Hotel, Bras Basa Road, Singapore.

This colored postcard of the main building of the Raffles Hotel (dating to 1910) captures the colonial elegance of the original hotel. Photo: Courtesy Raffles Hotel.

915. While the remodeling altered some of its charming colonial character, the interior courtyard and the breezy arcades remain attractive spots of refuge from sleek, shiny Singapore, and the rooms are lovely.

The role of Raffles in the history of Singapore and of travel in Asia is indisputable, and the hotel itself remains a focal point in the lives of Singaporeans. Indeed, it has been designated as a monument of Singapore's cultural heritage. The teak staircases, the metal cage elevators, the verandas, and lovely trees and plants, as well as the architecture of the Palm Court itself, all serve as reminders of a slower more elegant era.

The small museum on the third floor of the Raffles Hotel Arcade is well worth a visit as a window into a world that has almost disappeared. The museum is located just steps from the legendary Long Bar, the birthplace of the Singapore Sling, that fruity, luscious, and deceptively potent tropical concoction first shaken in 915 by bartender Ngiam Tong Boon, probably the most legendary employee of

Raffles. The safe in which he is believed to have kept his recipes, as well as the 1936 bar bill with the original recipe for the Singapore Sling, are exhibited in the museum.

Opened to the public in November of 1991 after the two-and-a-half-year renovation of the hotel, the museum celebrates the history of Raffles within the context of the Golden Age of Travel, a period defined as having extended from about 1880 to 1939. This period marked the beginning of what would become an ever-expanding wave of popular tourism that has developed into the largest industry in the world. During the closure of the hotel, the staff sought memorabilia and objects from Raffles history from all over the world. The response from former visitors was overwhelming, and the displays here reflect the generosity of past travelers and guests. The collections consist of an excellent assortment of old picture postcards and guidebooks, stamps, posters, advertisements, hotel brochures, and the tableware and flatware used at the hotel. The hotel luggage sticker collection recalls a time when travel to Asia necessitated long

The Seaside Resort of MALAYA

Seaview Hotel SINGAPORE

TENNIS
GOLF
SWIMMING
DANCING
OPEN AIR
CINEMA

Fully up-to-date with every modern convenience

voyages at sea and far more than the 20 kilos of luggage permitted today on many international flights. There is a small, but informative and important collection of documents related to the early history of Singapore, and fascinating letters written to and from Raffles by those who have stayed there, including Maugham, Conrad, and former United States President George Bush. The nineteenth-century photographs of Singapore and other parts of Southeast Asia recall an age long past.

Especially fascinating are reproductions of three newspaper articles about the shooting of a tiger under a billiard table at Raffles in 1902 ("Tiger shot at Raffles Hotel!"). There are also articles about a very large snake and a boar found—and disposed of—on the grounds of the hotel. While the modern visitor is unlikely to find wildlife this exciting at the refined, sophisticated Raffles of today, other delights abound here. Surrounded by the towering skyscrapers of a sleek modern city, Raffles remains an elegant and charming reminder of the graceful world of colonial Singapore.

Hotel luggage labels were works of art during the early part of the twentieth century, as this example from the Seaview Hotel, one of Raffles' rivals in Singapore, illustrates. Photo: Courtesy Raffles Hotel.

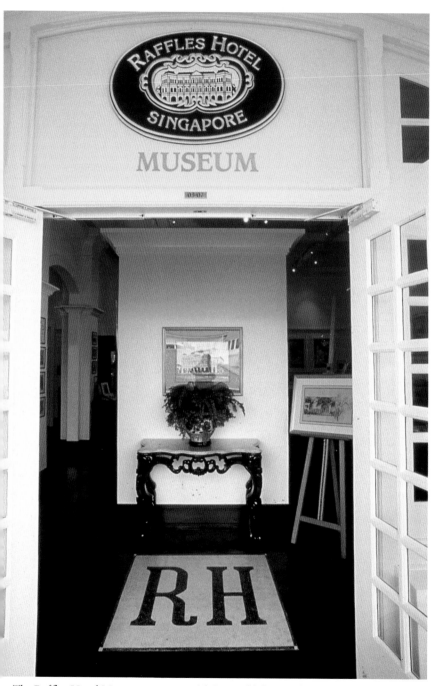

The Raffles Hotel Museum entrance with its world-famous logo invites the visitor to enter and catch a nostalgic glimpse of another world. Photo: Courtesy Raffles Hotel.

RAFFLES HOTEL Ltd.

(INCORPORATED IN STRAITS SETTLEMENTS)

SINGAPORE

$ Ind. No.

RAFFLES GARAGE
SINGAPORE

RAFFLES CAFÉ
SINGAPORE

WINE ORDER

Gin sling mixture

Half Gin
few drops Cherry Brandy
few drops Angostura Bitters
1/4 glass D.O.M. Liqueur
1/4 " Maraschino "
1/4 " Lemon squash
few pieces of ice

Name
(Please sign legibly)

Address in full

273169 Date

First shaken at Raffles, the Singapore Sling—here called a "gin sling"—became a staple on cocktail menus around the world. The original recipe, written on a Raffles bar chit, is on display in the museum. Photo: Courtesy Raffles Hotel.

Memorabilia and ephemera from the Golden Age of Travel fill the display cases and galleries of the Raffles Hotel Museum. Photo: Courtesy Raffles Hotel.

The museum exhibits many items such as these programs, menus, and tableware from the 1940s and 1950s. Photo: Courtesy Raffles Hotel.

SINGAPORE ART MUSEUM

71 BRAS BASAH ROAD
SINGAPORE 189555

TEL: 332-3222

OPEN: TUESDAY THROUGH SUNDAY FROM 9:00 A.M. TO 5:30 P.M. CLOSED MONDAY.

By collecting the traditions of the country and affording the means of instruction to all who visit our stations, we shall give an additional inducement to general intercourse. . . . And shall we, who have been favoured among other nations, refuse to encourage the growth of intellectual improvement or rather shall we not consider it one of our first duties to afford the means of education to surrounding countries, and thus render our stations not only the seats of commerce but of literature and arts?

—Sir Stamford Raffles, quoted in Kwok Kian Chow, *Channels and Confluences: A History of Singapore Art*, page 9

Another of the delightful restorations of a colonial building undertaken to provide a suitable site for a museum, the Singapore Art Museum is housed in the former St. Joseph's Institution in the center of the Arts and Heritage Precinct in old colonial Singapore. It is within walking distance of the Singapore History Museum, the Asian Civilisations Museum, and the Raffles Hotel Museum. As is true of the other museums of the National Heritage Board, it is a work in process as the Heritage Board strives to refine, consolidate, exhibit, and interpret their holdings.

Established in the middle of the nineteenth century as St. John's Institution, the building was the home of one of the leading Catholic schools of Singapore. It was renamed St. Joseph's Institution a few years after its founding. The building is a superb example of colonial architecture. The graceful curved arms of the building that now form the façade on Bras Basah Road, and the wonderful dome were added to the original central rectangular core of the building in the early part of the twentieth century. In 1988, the school relocated out of central Singapore and the government assumed control of the buildings. The complex has been beautifully restored and it now houses Singapore's national collection of modern and contemporary art. The one slightly unfortunate—although clearly necessary—part of the restoration has been to enclose the lovely upper-level verandas in glass in order to provide climate control for the sculpture collections. However, the glass was installed free of the architecture so that the architectural details were not disturbed and are still clearly visible. The cool tiled floors and the restful curves of the architectural spaces are a welcome respite from the heat and humidity of Singapore. A very successful multipurpose room, appropriately called the Glass Hall after both its glass walls and the Dale Chihuly sculpture installed inside, was also created to be transparent. (A very informative pamphlet entitled *Singapore Art Museum at the Old St. Joseph's Institution: Your Guide to a National Monument* is available free at the Museum. It provides a detailed analysis of the history of the building.)

The mission of the Singapore Art

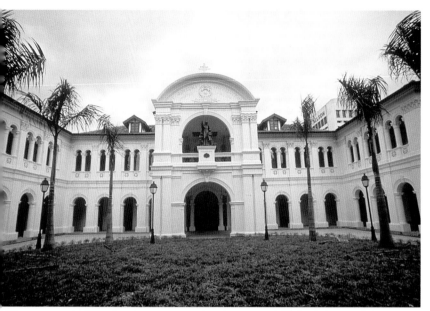

The museum building has been renovated and conserved. Today it is one of the most beautiful of the remaining colonial structures in Singapore. Photo: Courtesy the Singapore Art Museum.

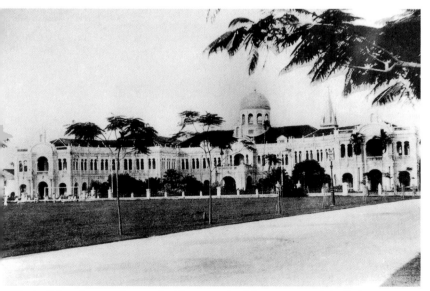

The building that now houses the Singapore Art Museum was originally known as St. Joseph's Institution, seen here in an early photograph. Photo: Courtesy National Archives of Singapore.

The interior spaces of the former school have been adapted for use as galleries.
Photo: Courtesy the Singapore Art Museum.

Museum is "to preserve and present the art histories and contemporary art practices of Singapore and the Southeast Asian region so as to facilitate visual arts education, exchange, research, and development." The successor to the activities of the British Council in the 1950s, and to the National Museum Art Gallery (established as an adjunct to the National Museum, now the Singapore History Museum), the Singapore Art Museum was established twenty-five years ago, in 1976, with a donation of some 93 objects. The collection currently consists of over 4,000 twentieth-century objects with a regional focus on Southeast Asia. It is the largest collection of its kind in the world, and the entire holdings cannot be exhibited at once. The museum usually has three exhibitions on view at any one time—one Singaporean, one regional, and one international—in its thirteen galleries. Through its Collection Exhibition Series, the museum intends, eventually, to show its entire collection in a series of thematic exhibitions (the first of which dealt with images of self and

notions of identity in twentieth century Southeast Asian art). Objects not currently on view are accessible through the art E-mage gallery, a multimedia presentation of the holdings available on terminals in the museum.

The museum is particularly strong in holdings of the work of Singaporean artists of the last fifty years. Although Chinese culture dominates the life of this multicultural city, the formal practice of the arts of painting and sculpture seems to have had its origin in the colonial world. Kwok Kian Chow, Director of the Singapore Art Museum, has argued convincingly, however, that modern art in Singapore is not an obvious derivative of any of the great international art movements of the time, even if the history of Western art does serve as an important reference for its study. Singaporean artists have frequently taken the city of Singapore as an inspiration for their works. From the land, river, and seascapes of Richard Walker in the 1920s and 1930s to those of Georgette Chen in the 1950s and

Georgette Chen's oil-on-canvas painting, *East Coast Vendor*, of 1961, rests firmly in the tradition of Singapore painting by portraying daily life in the city. Photo: Courtesy the Singapore Art Museum.

Lim Cheng Hoe in the 1950s and 1960s, the city has been a muse. Many of these oil paintings and watercolors are in the collection of the Singapore Art Museum. (In the 1980s, Arbour Fine Arts Gallery, a commercial space, mounted a show entitled *Not The Singapore River* as if trying to break free of this provincial inspiration.

This, in turn, resulted in Teo Eng Seng, a contemporary artist, creating a work entitled *The Net: Most Definitely the Singapore River* in 1986. The work is composed of a net covered with "paperdyesculpt," sculpted paper.)

The museum also has important holdings in Southeast Asian regional art.

Bayn Utomo Radjikin's mixed-media work, *Lang Kachang*, of 1991, is a more contemporary vision of modern Singapore. Photo: Courtesy the Singapore Art Museum.

In exhibitions devoted to the art of the region, the Singapore Art Museum would like to break down the traditional barriers between the national arts and styles of the countries of this region and look across borders to common themes and the interpretations of various experiences.

Not only are the collections of the Singapore Art Museum good and growing, but the building itself is lovely. The entire complex, including the café and the National Heritage Board shop here, will provide ample rewards to anyone visiting this delightful museum.

SINGAPORE HISTORY MUSEUM

93 STAMFORD ROAD
SINGAPORE 178897

TEL: 332–2510

OPEN: TUESDAY THROUGH SUNDAY FROM 9:00 A.M. TO 5:30 P.M.;
WEDNESDAY EVENING UNTIL 9:00 P.M. CLOSED MONDAY.

The Singapore History Museum is the original museum in the city. Opened in the colonial district of Singapore as part of the Raffles Library and Museum in 1887 by Governor Frederick Weld, the museum has had a number of reincarnations over the past century. The early history of the museum is quite colorful. The original builder is reported to have gone insane during the construction process, and the original natural history exhibits fell prey to mold, ants, and the dust that entered the building through unglazed window openings. The collections grew rapidly, however, and in 1907 and 1916, the original building was enlarged.

Until the 1950s, the museum continued to focus on the natural history collections. In 1960, the museum was separated from the library, and in 1969 the Raffles Museum was formally renamed the National Museum.

In the 1970s, the institution began to metamorphose from a collection of objects reflecting the natural world into a historical and cultural record of Singapore and Southeast Asia. In the 1970s, many of the natural history specimens were transferred to various institutions in Singapore and Malaysia, including the National Museum in Kuala Lumpur and the University of Singapore. Among the objects donated to the National Museum in Kuala Lumpur was a 42-foot Indian Fin Whale skeleton, the most famous object in the collection up to that point. Every native adult Singaporean remembers the "Whalebone" from his or her childhood. The building offi-

cially became the Singapore History Museum after being incorporated into the National Heritage Board in 1993.

The museum building itself is a fine and elegant example of colonial architecture, both inside and outside. The graceful and stately façade has been beautifully restored, and the entrance rotunda with its arches, classical Greek orders, and lofty airy cupola is one of the great spaces in Singapore. Indeed, the opportunity to appreciate this architecture is one of the highlights of a visit to the museum.

Taking as its mission "to explore and to enhance the national identity of Singapore by preserving, presenting, and interpreting the nation's history and material culture in the context of its multi-cultural origins," the museum today is a charming, eclectic collection of objects and exhibits that is evolving rapidly into a first-rate history museum. Housed on two floors, the collections range from a wide variety of jade objects collected by Aw Boon Haw, the Tiger Balm king, to natural history drawings commissioned by Major-General William Farquhar while he was stationed in Singapore. In addition, the history of Singapore is illuminated in the famous dioramas of the history of the city and in installations illustrating the lives and customs of the various ethnic groups that make up the city's population. Special exhibitions devoted to aspects of history and culture ranging from the Chinese secret societies to the archaeology of Singapore are frequently mounted in the galleries on the second floor.

A highlight of any visit is the rotating

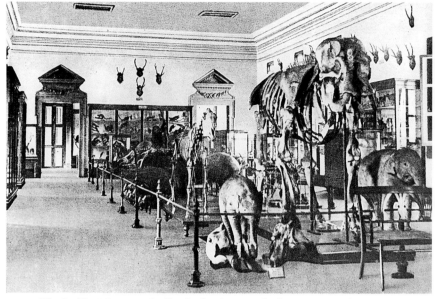

The Raffles Museum, the first in the city, was the forerunner to the current Singapore History Museum. This wonderful early-twentieth-century photograph of the natural history hall at the museum evokes the British colonial atmosphere of the time. Courtesy National Archives of Singapore.

The Raffles Museum was also figured on black-and-white postcards of the early twentieth century. This one wishes the recipient a Glad New Year in English and Chinese. Courtesy National Archives of Singapore.

In one of the most beautiful colonial buildings in the city, the Singapore History Museum houses an eclectic collection related to the history of the city. Courtesy Singapore History Museum, National Heritage Board.

collection of botanical drawings, housed in the Goh Seng Choo Gallery on the ground floor. After serving as the first British Resident and Commandant of Melaka from 1803 to 1818, Major-General William Farquhar was British Resident and Commandant in Singapore from 1819 to 1823, and, with Sir Stamford Raffles, was responsible for the founding of the East India Company factory there. Raffles later dismissed Farquhar as Resident and Commandant over fundamental disagreements concerning the administration of the settlement. A colorful character who survived two attempts on his life (one by a man whom he had sent to jail) and tolerant of both gambling and cockfighting in the colony, Farquhar commissioned local artists to paint the vibrant and varied natural life of the region. The result was almost 500 drawings that Farquhar took with him when he left Southeast Asia to return to London. He donated them to the Royal Asiatic Society in November of 1827, and they were never exhibited as a group after-

ward. In 1993, the Royal Asiatic Society decided to sell them. The drawings were auctioned off in Singapore in 1995, and 477 of the drawings were donated to the Singapore History Museum. Several dozen of them are exhibited on a rotating basis and they are worthy of a visitor's close attention. Reminiscent of an Audubon run amuck in the tropics, each drawing records in colorful and exquisite detail some aspect of the flora and fauna of Southeast Asia. The anonymous Chinese artists combined the kind of scientific accuracy required by European scientists with traditional Chinese techniques. They also resemble paintings done by Indian artists for the English East India Company in the late eighteenth and nineteenth centuries, in the so-called "Company Style."

In all, there are 55 drawings of medicinal plants, 42 drawings of flora from Mt. Ophir, near Melaka in Malaysia, 61 drawings of animals, insects, and reptiles, 108 drawings of birds, 154 drawings of more general plants, and 57 drawings of fish.

Even with modern fixturing and furniture, the museum's spacious entrance hall with its towering dome, is one of the great indoor spaces in Singapore. Courtesy Singapore Tourism Board.

The early-nineteenth-century botanical and natural history drawings commissioned
by Major-General William Farquhar are a highlight of the museum's collections.
This one depicts a Malay apple and a bright yellow Black Naped Oriole. Courtesy
Singapore History Museum, National Heritage Board.

The South Indian neighborhood of Serangoon Rood is depicted in the period of the 1890s in this diorama, one of the most popular exhibitions in the museum. Courtesy Singapore History Museum, National Heritage Board.

The jade galleries on the second floor are filled with fine examples of Chinese carved art from the Haw Par collection of the Aw family. This collection was donated to the museum in 1980. With objects in jade, crystal, lapis lazuli, and other precious stones, primarily from the Qing dynasty, the gallery is a treasury of priceless carvings.

Though Singapore is a melting pot of Asian peoples and western influences, the dominant culture is Chinese, and more specifically "Straits Chinese." The term Straits Chinese refers to those Chinese who had settled in the three port cities—or Straits Settlements—of Melaka, Penang, and Singapore centuries ago, and who owed their loyalties to their cities and to the British colonial government. In many cases the Chinese men had intermarried with local Malay women, creating the Peranakan culture, a lively and unique blend of Chinese, Malay, and British colonial tradition. The terms Straits Chinese and Peranakan are used interchangeably, although the Straits Settlements no longer exist. The home of a wealthy Peranakan family from the turn of the twentieth cen-

tury has been reconstructed on the second floor of the museum. The eclectic furnishings and layout of the house do an excellent job of underscoring the ability of the Peranakan to retain their Chinese essence, while adapting to the cultures around them. The reconstructed rooms of the house, the reception room, the ancestral hall, the living room, the bridal chamber, and the kitchen illustrate the richness and depth of this indigenous culture.

Perhaps the most popular galleries at the Singapore History Museum are those that house the twenty dioramas depicting the history of Singapore from the early nineteenth century to the first parliament meeting in 1965. While there is a small nod to the existence of early ruins (perhaps as early as the fourteenth century) in the area of Fort Canning, just behind the museum, the dioramas mainly provide a striking visual record of the economic, political, and social history of Singapore over the course of the past two centuries.

Singapore was founded as a trading post for the English East India Company in 1819 and has been a thriving center of trade and commerce ever since. This trading

economy was fueled by immigration from China, India, and the Malay Peninsula. Each of these ethnic groups settled in a specific area of Singapore, which is still notable today for its various ethnic neighborhoods. These neighborhoods and the waves of immigration are celebrated in the dioramas. The political history of the city that is exhibited dates primarily from the period between the outbreak of World War II and 1965. The Japanese occupation of Singapore, which they renamed Syonanto or Light of the South, was particularly brutal. Although the entire population suffered, the Chinese population—which had supported the resistance of mainland China against the Japanese

invasion—was singled out. The detailing of Singapore's post-war history centers on the granting of City status to the colony by the British in 1951 and the ill-fated alliance with Malaysia, which lasted only two years. Singapore became independent in 1965.

The National Heritage Board in Singapore is actively developing and refining its three museums: the Singapore Art Museum, and the Asian Civilisations Museum, in addition to the Singapore History Museum—which is a marvelous work in progress. Any additions to its impressive structure or amplifications of its rich collections can only increase its appeal.

JIM THOMPSON HOUSE

6 SOI KASEMSAN 2, RAMA I ROAD
BANGKOK 10330

TEL: 02–216–7368

OPEN: EVERY DAY FROM 9:00 A.M. TO 4:30 P.M.; REQUIRED ENGLISH-LANGUAGE TOURS START AT REGULAR INTERVALS.

During World War II, American architect Jim Thompson was stationed in Thailand with the Office of Strategic Services, the forerunner to the Central Intelligence Agency. Enchanted with the culture and people of Thailand, Thompson returned after the war (and following a divorce from his American wife). He began to work on plans for the renovation of the fabled Oriental Hotel, then a dilapidated shell of a building that had been used as housing for U.S. Air Force personnel during and immediately after the war. When that project foundered, he set his sights on the flagging Thai silk industry and revitalized it by creating fabrics that were appealing to the Western eye and by marketing them appropriately. His success in this enterprise is perhaps best illustrated by the designer Irene Sharaff's use of real Thai silk for the costumes in the original New York production of *The King and I* (a musical banned even today in Thailand for its historical inaccuracies about King Mongkut). He founded the Thai Silk Company, Ltd., became its managing director—and the rest is history. Elegant, brightly colored Thai silk is still highly sought after today and Jim Thompson's silk is the best of the best. His silk empire survives today with shops scattered throughout the city of Bangkok, including a branch at the Jim Thompson House.

The visitor pressed for time may be inclined to skip Thompson's House, thinking it a mere adjunct to the retail business. To do so would be a mistake. Along with the Suan Pakkad Palace, and the Siam Society, Jim Thompson's House can provide the overwhelmed visitor to Bangkok with a nostalgic glance into the world that captivated Thompson and others in the years immediately following World War II. Jim Thompson's House is much visited and with good reason. The house, on the banks of Khlong Saen Saep, one of Bangkok's longest canals, is one of the loveliest spots in all of Southeast Asia.

Thompson fell in love with Thailand, as well as with the art and architecture of Southeast Asia. In 1959, he purchased six traditional Thai houses, one in Bangkok and five from the former royal capital at Ayutthaya, some 60 miles north of Bangkok, and had them assembled at the site of the current house. Insisting on the traditional Thai construction techniques and avoiding the use of nails, he supervised the joining of these six houses together into the graceful amalgam that today houses his small but exceptional collection of Southeast Asian art. The house consists of a stair entrance hall, dining room, living room, terrace, study, master bedroom with bath, two guest rooms each with bath, and a kitchen and pantry.

The architecture of the house can easily be described as elegant. The interplay between the dark teak and the bright silks, and the dramatic presentation of the objects Thompson collected combine to create a harmonious and pleasing interior. As Somerset Maugham wrote to Thompson after a dinner party in 1959, "you have not only beautiful things, but what is rare you have arranged them with faultless taste." The modern visitor is the benefi-

The porch of the Jim Thompson House Museum, overlooking the canal that runs in front of the house, is particularly magical at night when illuminated by candles. Photo: Courtesy Jim Thompson House.

ciary of this faultless taste.

By contrast, the gardens are a lush tropical display of every shade of green under the sun. In the steamy climate of central Thailand, anything can grow. The garden of Jim Thompson's House attests to this. Visitors to the house are required to take a tour (and to remove their shoes as is traditional in Southeast Asian homes) conducted by charming English-speaking guides. But the gardens are freely accessible and worth strolling through, especially down to the now unpleasantly pungent canal that fronts the house.

Thompson was a master of the reuse and retooling of objects and architecture. He juxtaposed buildings in a new and different way; he also used furniture in an untraditional manner. In Thompson's house, walls are turned inside out, Chinese mah-jongg tables become dining tables, and Carrara marble floors comfortably cohabit with seventeenth-century Ayutthaya-style Buddhas.

Thompson's collection is especially rich in early Thai and Khmer sculpture and in Chinese furniture. On the ground level, below the traditional Thai house raised on stilts, are exhibited two Buddha figures from the Lopburi period. The first, dating to the sixth century A.D. is one of the oldest representations of the Buddha in Southeast Asia. The other dates to the seventh century. There are also fine sandstone lions from Angkor, in present-day Cambodia, and an impressive wooden lintel with the Buddha and figures of animals from Ayutthaya. Small but choice displays of the characteristic Thai five-color Bencharong ware are exhibited here as well. The original five colors were eventually supplemented with other colors. The Chi-

Bencharong ware, originally made in China to Thai specifications, and later made in Thailand, and Chinese enamelware are well represented in Thompson's collection. These examples date to the eighteenth century. Photo: Courtesy Jim Thompson House.

nese executed the original Bencharong-ware —such as these—after Thai designs. Now the Thais themselves produce the ware. There is also a good display of blue and white fifteenth-century pottery from Vietnam. A lovely Chinese Qing dynasty dining table with a blue-and-white top depicting scenes of trading with the West is displayed on this ground level as well.

A small gallery on the same level is filled with drawings and paintings by Thai artists from the 1860s, illustrating scenes of daily life. The drawings of market scenes and the gathering of coconuts are particularly charming. Dr. J. J. Chandler, an American missionary in Thailand, originally collected these paintings in the nineteenth century. Jim Thompson believed strongly that these drawings should be in Thailand and he procured them in the United States and brought them back to

Thailand. There are also interesting renderings of buildings in Bangkok.

Thompson broke with traditional Thai architectural tradition by building a room on this ground level with stairs that access the house rather than incorporating the more usual freestanding staircase design. This room provides an elegant entry to the house and boasts a marble floor from Carrara, an Italian cabinet, the figure of a Burmese gong holder, and a seventeenth-century Ayutthaya-style Buddha.

The upstairs foyer contains two sixteenth-century paintings from Surat Thani in southern Thailand featuring scenes from the life of Buddha. There are also several nineteenth-century paintings done by monks showing scenes of the life of the Buddha and the life of Siddhartha, the prince who was to become the Buddha.

Many pieces of nineteenth-century Chinese blue-and-white porcelain made for the export market found their way to Thailand. Photo: Courtesy Jim Thompson House.

There is a Vishnu figure and figures of Kali and Shiva in niches, all dating to the Angkor Wat period of Khmer art.

In the dining room, the beautiful wooden walls are complemented by lovely wooden interior-closing shutters. Thompson used two adjoined mah-jongg tables with Chinese porcelain inlays as his dining-room table. In this room, as in all the others throughout the house, vents at the top of the walls allow the air to circulate around the house to keep it cool. The house is narrow at the top and wider at the bottom so that the heat in the house will rise to the top of the room and be expelled from the house. The common high barriers between the rooms serve several functions. They keep babies in; they also keep snakes, floods, and bad spirits out.

The living room is a harmonious configuration of objects from around Southeast Asia displayed in a room that is, literally, turned inside out. It is this part of the house that originally came from Bangkok, and the far wall is actually reversed so that Thompson and his guests could view the elaborately carved exterior teak walls as they sat in the room. The window shutters that open and close from the outside, and not from the inside as they do in a typical Thai house, are one of the eccentricities of the house. The eighteenth-century wooden Burmese figures of good spirits and a traditional Thai bed used as a coffee table are all examples of Thompson's ability to visualize and use an object for a purpose other than that for which it was originally intended. The three claws on the foot of the bed/cocktail table indicate that it must have been a bed made for a commoner. (The more claws, the higher the rank of the occupant.) A tenth-century Cambodian head and cases with bronze work that once served as elephant decoration complete the decor.

Thompson's study is in a section of the house that formed a connection between two other houses. It was the one air-conditioned part of the dwelling, although the unit was subsequently

Thompson joined two Chinese mah-jongg tables, which bear the royal insignia of
King Chulalongkorn (Rama V), to form his dining room table.
Photo: Courtesy Jim Thompson House.

removed to allow air to circulate more freely throughout the house. On one wall are prints of the first Thai ambassadors to the court of Louis XIV. Dressed in the bright robes of Thai nobility of the time with elaborate headgear, these ambassadors must have made quite an impression, even at the opulent courts of eighteenth-century France. A copy of the first map of Siam, the old name for Thailand, hangs on the same wall as the prints of the Thai ambassadors. On the opposite wall, a seventh-century Lopburi Buddha receives offerings in a fourteenth-century celadon bowl from Sukothai.

The adjoining guestroom has a small bed (perhaps Thompson did not want his guests to overstay their welcome!) and contains a small dresser originally built for a Thai princess, as well as a charming Chinese chamber pot in the shape of a cat. Traditional Thai houses did not have indoor plumbing and the well-to-do utilized chamber pots for middle-of-the-night needs.

Jim Thompson himself slept in a large bed with five clawed legs, originally built for a member of Thai royalty. Thompson's bedroom is filled with first rate and quirky art objects. Rich Chinese children played with mouse houses, elaborate dollhouse-like structures set in boxes behind a piece of glass—the ancient equivalent of a television set and an endless source of entertainment when live mice ran up and down the stairs and in and out of the elaborately decorated house. There is also a large eighteenth-century screen from Ayutthaya with 450 images of the Buddha and a thirteenth-century Khmer sculpture. Perhaps the most striking object in the room is the head of a sun god from the pre-Angkor period of Khmer art. The head bears a close resemblance to heads of the Egyptian

The living room of Jim Thompson's house is the oldest part of the structure, dating to about 1800. With its dark inside-out teak walls, jewel-tone Thai silk furnishings, and outstanding Southeast Asian art objects, the room delights the visitor with its harmony and restful design. The figures in the niches are from Amarapura, in modern Myanmar. Photo: Courtesy Jim Thompson House.

sun god Ra and is strikingly different from much of Khmer art.

The kitchen, which was originally the sixth of the Thompson houses, is now used as a storage area but is fronted by a meditating Buddha with the figure of a *naga*.

In life, Jim Thompson was a successful entrepreneur and an astute collector of the art and architecture of his adopted country. In death, he has become a legend. During Easter weekend of 1967, while vacationing with friends in the cool Cameron Highlands of Malaysia, Jim Thompson just vanished. Theorists have explained his disappearance as everything from providing lunch for a hungry tiger to

falling victim to the ultimate payback for some of his OSS activities during World War II. But no trace of him has ever been found, and no completely plausible explanation of the events of that afternoon has yet been proposed, although mystics, detectives, and friends have certainly tried. There are those who are still trying to explain the disappearance over thirty years later. As Thompson's biographer William Warren wrote, "It is some measure of the first Jim Thompson legend that it could leave behind such a rich variety of possibilities." This house is a testament to his passion, his taste, his love for Thailand, and ultimately, to his life. It is the enduring legacy of a remarkable man.

This nineteenth-century mouse house—which inspired a children's book—is a particularly charming object in Thompson's bedroom. An elaborate miniature structure designed to hold small mice, it could have provided hours of entertainment for privileged Chinese children. Photo: Courtesy Jim Thompson House.

NATIONAL MUSEUM

Na Pha That Road, north of the Grand Palace between the Sanamluang and the Chao Phraya River

Bangkok 10200

Tel: 02–224–1404, 02–224–1333

Open: Wednesday through Sunday from 9:00 a.m. to 4:00 p.m. Closed Monday and Tuesday and on national holidays.

The sprawling complex of the National Museum in Bangkok is devoted to a survey of the art of Southeast Asia with a special emphasis on the arts and cultures of Thailand. It is arguably the most comprehensive museum in the region. The antiquities collection of King Mongkut (Rama IV, 1851–1868, the king made famous in *The King and I*) forms the core of the museum's collections. The first museum was founded on the grounds of the Royal Palace by his son, King Chulalongkorn (Rama V) in 1874 and moved to this site, the former palace of Wang Na, in 1887. In 1926, it became the Bangkok Museum. In 1933 it was placed under the Department of Fine Arts and became the National Museum.

Located between the Sanam Luang and the Chao Phraya River, a short walk north from the Grand Palace and Wat Pho in the historic center of Bangkok, the museum complex comprises a number of historical buildings, as well as the more modern galleries that opened in the 1960s. The visitor will be asked to remove his or her shoes before entering the historical buildings. The small brochure available at the entrance is helpful in placing oneself within the complex, as all parts of it are not immediately apparent to the first-time visitor.

The museum is most easily grasped as a series of historic buildings and several exhibition structures, of which two—the North and South Wings—are modern. The other buildings were part of the original palace, although many of them have been greatly modified. Much of the charm of the National Museum lies in the graceful traditional galleries and the pavilions, even if the modern galleries that embrace the original buildings are better suited to the display of objects.

The museum is housed in part of the Wang Na, or Front Palace, that was built at the same time as the nearby Grand Palace. It was the residence of the Deputy Kings of Thailand from 1792 to 1885 and during this time played an important role in the cultural life of the Kingdom. The palace has been subdivided now. The central or middle court of the palace forms the National Museum. Thammasat University occupies another part of the grounds. The original palace faced east and backed onto the Chao Phraya River. Several of the structures on the museum's grounds were part of this palace.

The Phutthaisawan Chapel was built in 1787 to house a mid-fifteenth-century gilded bronze figure of the Buddha brought from Chiang Mai and still on view in the chapel (although the image—like many images of the Buddha in this part of the world—has been housed in several different locations in Bangkok). The chapel itself is an outstanding example of monastery architecture of the early Bangkok period. The black-ground murals in this chapel are among the oldest in Bangkok and depict lively scenes from the life of the Buddha, as well as from the life of the common people of the day. The complete absence of perspective in these paintings adds to their quirky charm.

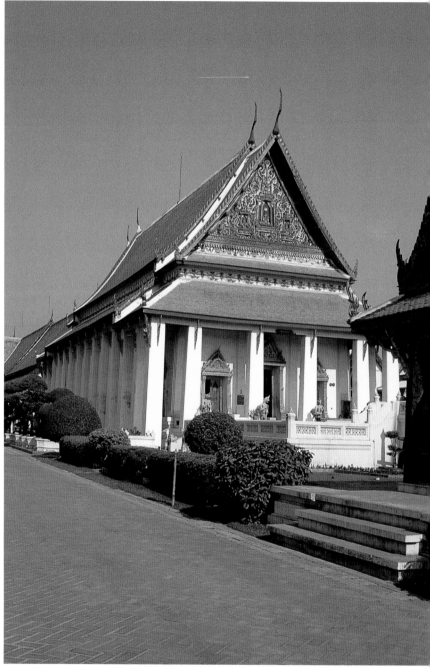

In addition to many of the country's material treasures, the grounds of the National Museum in Bangkok house historic buildings and temples that have been moved here. The Phutthaisawan Chapel dates to the late eighteenth century. Photo: Kristin Kelly.

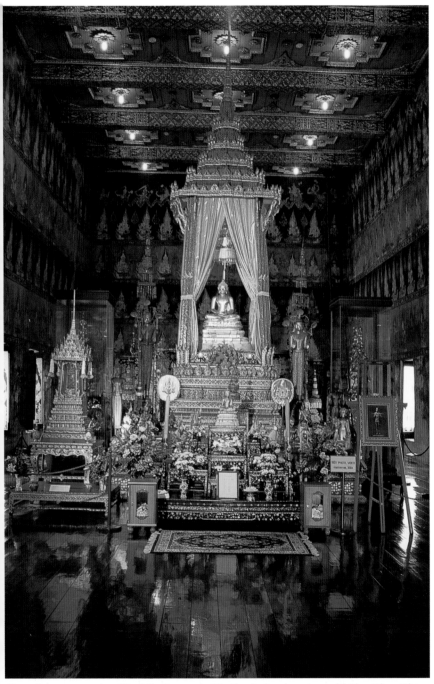

One of the most revered Buddha images in Thailand, the gleaming gold Phra Phut Sihing in the Phutthaisawan Chapel, may date to the Sukhothai period. Photo: John McDermott.

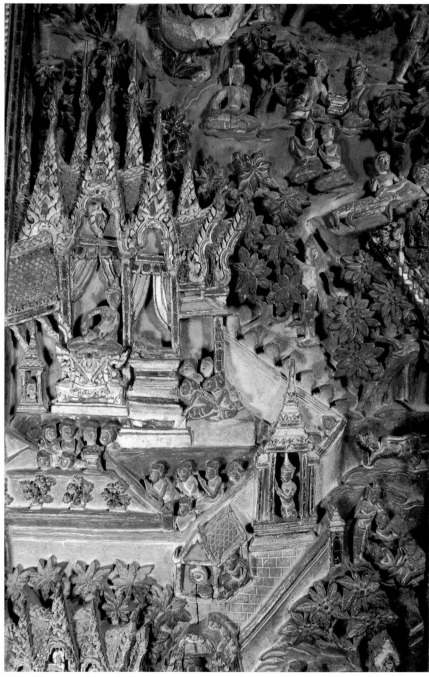

The Thais have historically been master wood-carvers, as evidenced by their buildings and furniture. This eighteenth-century cabinet depicts scenes from the life of the Buddha. Photo: John McDermott.

The Red House, or Tamnak Daeng, which was the private living quarters for Princess Sri Sudarek, one of the sisters of Rama I (1782–1809), was built of golden teakwood in the Ayutthaya style. Even in Bangkok's steamy climate, the house is cool inside and offers a respite from the relentless sun and heat. The house has been moved several times. Originally in the palace in Thonburi, on the far side of the Chao Phraya River, it was relocated to the Grand Palace and from there to its current location. Half common room and half sleeping room, it is furnished today in the style of the early Bangkok period.

The residence of King Pin Klao (1851–65), who originally lived in this palace, is an East/West hybrid from the time. The King lived on the second story of the structure and his living quarters included a library, living room, dining room with a shrine, bedroom, dressing room, bathroom, balcony, and pantry.

Of the remaining historical structures, many are small pavilions. Three of them are open to the air in traditional Thai style. The Samranmukhamat Pavilion was part of the Dusit Palace in the northern part of Bangkok, and was moved here in the time of Rama VII. The Patihantasanai Pavilion and the Sala Longsong Pavilion (near the entrance to the museum) were moved here from the palace of King Vajiravudh (Rama VI, 1910–1925) in Nakhon Pathom, the oldest city in Thailand. The Mangkhalaphisek Pavilion was part of the original Wang Na Palace and was used on ceremonial occasions.

The first two exhibition galleries are housed in one of the palace buildings and are devoted to Thai prehistory and history and set the historical stage for the remainder of the museum. These spaces are filled with objects from important excavations at Ban Chiang in Northeast Thailand and other prehistoric sites in the country, and with historic photographs and objects of everyday life from all periods of Thai history up to the 1960s. The material from

Ban Chiang, near Udon Thani, dates primarily to the first millennium B.C. and consists of both pottery with its typical reddish whorl patterns, and bronze and sandstone molds.

The history galleries reveal both the deep reverence the Thai feel for their history and their royalty and the fact that Thailand is the one country in Southeast Asia that was never colonized by Europeans. Thailand means "home of the free people."

The majority of the National Museum's collections are displayed in the historical buildings of the Phra Wiman group, and in the two modern wings. This is the national collection of Thailand, and the emphasis is on the art and cultural patrimony of Thailand with art and archaeological objects dating from prehistory to the modern Bangkok period. Comparative objects from both mainland and insular Southeast Asia are included where appropriate.

The buildings of the Phra Wiman group house galleries arranged by either medium or function, as well as galleries displaying temporary exhibitions. These galleries are devoted to gold and royal regalia, ceramics, the famous Thai Khon masks and puppets, mother-of-pearl, ivory, stone, wood, textiles, Buddhist religious objects, musical instruments, forms of transportation (including the varied ways in which elephants were dressed), enamels, and weapons. Among the most interesting of the objects displayed is an ivory *howdah*, or elephant seat, presented to Chulalongkorn (Rama V) by the Prince of Chiang Mai in the early twentieth century. The gallery devoted to ceramics details the history of Thai stoneware, primarily from the Ayutthaya and Sukhothai periods. Recordings of traditional Thai music can be played in the gallery with the musical instruments, including gamelans, drums, flutes, and brass instruments. Just walking from gallery to gallery is an experience here, since the architecture is of

interest as well. The two small interior courtyards are among the most peaceful places in Bangkok. The tropical flowers, small ponds, and shade trees provide a welcome respite from the relentless heat, noise, and dirt of the city.

Adjacent to these older galleries is the gallery housing motorized vehicles used for funerary purposes. Many of these are very large and are gilded and inlaid with glass mosaics. There are also a number of beautiful palanquins on view here.

The two modern wings display religious sculpture and cultural objects from different periods and describe the various influences that were brought to bear on Thai culture and civilization from its earliest recorded beginnings through the Bangkok period. The objects in the South Wing date to the Dvaravati and Lopburi periods. Those in the North Wing are Lanna, and from the Sukhothai, Ayutthaya, and Bangkok periods.

The South Wing galleries greet the visitor with a general selection of Asian art, including Cham sculpture and a number of representations of the Buddha, as well as the members of the Hindu pantheon. Informative didactic material related to the interactions between the various countries of Southeast Asia, and galleries devoted to large-scale temple sculpture, ceramics, and metalwork provide an introduction to the art and archaeology of the region. The Indian influenced Dvaravati art of central and western Thailand, the art of the Srivijaya Kingdom, and the art of the Lopburi period, also in central Thailand, are both exhibited and explained here. Of particular interest are the Dvaravati Buddha heads, and other stucco and stone sculpture, including a stone Wheel of the Law found at Nakhon Pathom, and dating to the seventh or eighth century. Srivijaya sculpture from the peninsula of Thailand dates between the seventh and the thirteenth centuries. This art is highly decorative and shows the influence of both Indian and Javanese art.

The art of the Lopburi period is, in essence, the colonial art of the Khmer Empire in Thailand and the examples displayed here clearly exhibit their Khmer roots.

The North Wing galleries are filled with objects from the Sukhothai and Ayutthaya periods and the more contemporary Bangkok, or Rattanakosin, period as well as objects from Lanna, or northern Thailand. The galleries on the lower floor are primarily devoted to the Bangkok period, with musical instruments and minor arts, as well as models of palaces, furniture, teapots, painted scrolls, and the characteristic Thai spirit houses, meant to placate the spirits of the place. This is the Thai art that may be most familiar to the visitor, and its influence survives today in Thai temple architectural and its decoration. Stamps, coins, and other paper objects might be of somewhat less aesthetic interest, but they are historically interesting. The Lanna sculpture exhibited here is of some interest, particularly the charming figures of animals—deer, elephants, and the *hamsa*, or sacred goose.

Not to be missed are the galleries on the upper level devoted to the art of the Sukhothai and Ayutthaya periods. A lovely Sukhothai-style head from Thonburi on the opposite side of the Chao Phraya River dates to the fourteenth or fifteenth century. Other Sukhothai sculpture—Buddha feet, a figure of Uma, and a monumental bronze figure of Vishnu—attest to the primacy of this period in Thai art. (The Phra Phut Sihing Buddha in the Phutthaisawan Chapel may date to the Sukhothai period, since it displays some of that period's stylistic characteristics. The hand position, however, is unusual.)

The Ayutthaya period is known for its elegant and serene bronze and sandstone sculptural figures of the Buddha, many of which are on view here. The sophisticated lacquerware of the Ayutthaya period—particularly the cabinets—is also elegant, and a highlight of this museum.

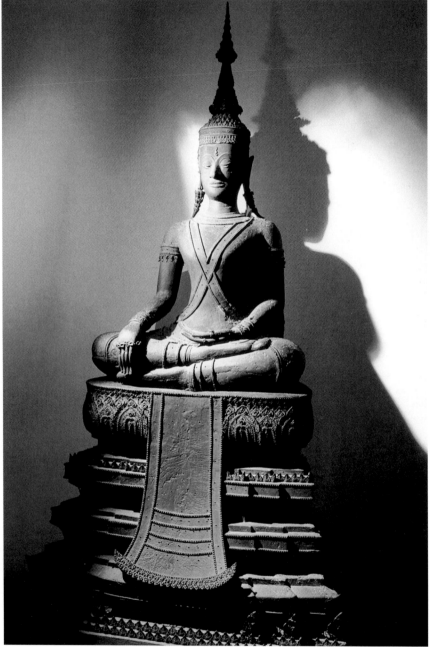

This regal seated Buddha in the calling the earth to witness posture dates to the Ayut-thaya period of the seventeenth or eighteenth century. Photo: John McDermott.

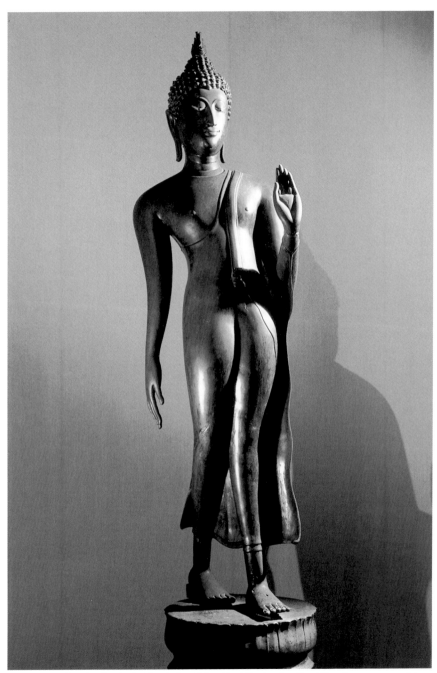

An example of a classic Sukhothai walking Buddha in the dispelling fear posture, this sculpture dates to the fourteenth or fifteenth century. The slight curve of the body evident in this Buddha figure is typical of this period. Photo: John McDermott.

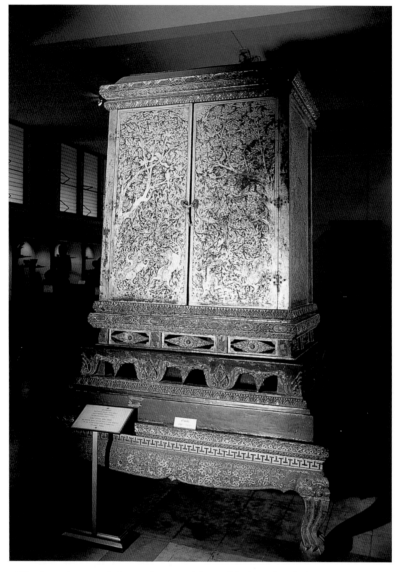

The Ayutthaya period was also noted for its black-and-gold lacquer work, an
example of which is this exquisite cabinet. Photo: John McDermott.

The National Museum can be an
overwhelming place, perhaps best ab-
sorbed in a series of visits rather than all
at once. The visitor with limited time
might wish to concentrate on the architec-
ture of the historic buildings, on the gal-
leries inside the Phra Wiman group of
buildings, as well as on the galleries

devoted to the art of the Dvaravati and
Lopburi periods in the South Wing and to
the art of Ayutthaya and Sukhothai in the
North Wing. But as a survey of the art of
Southeast Asia, and in particular that of
Thailand, the collection of the National
Museum is unsurpassed and will amply
reward the attentive visitor.

PRASART MUSEUM

9 SOI KRUNGTEPKREETHA 4A, KRUNGTEPKREETHA RD.
BANGKAPI, BANGKOK

TEL: 02–379–3601

OPEN: FRIDAY THROUGH SUNDAY, BY APPOINTMENT ONLY,
FROM 10:00 A.M. TO 3:00 P.M.

The discoveries from various archeological sites in Thailand have made it clear that civilization has flourished in this area since prehistoric times. It is unfortunate, however, that many of our most precious objects have been taken abroad and have thus been lost to the country. I strongly believe that such priceless reminders of our heritage do not belong to anyone in particular but to the whole nation and that they should be kept in Thailand where they can be cherished by future generations who wish to study what our ancestors achieved. The Prasart Museum is the realization of my dream to house in one place prehistoric artifacts, Buddha images, statues of Brahman gods, pottery, Thai furniture, Thai paintings and Thai and Chinese porcelain as well as objects from other parts of Asia and elsewhere.

—Khun Prasart Vongsakul, 1990

The wondrous collection of art and archaeological material assembled by Khun Prasart Vongsakul is housed in a serene five-acre compound on the edge of the ragged urban fabric of Bangkok. This museum is truly unique, and by any measure one of the most delightful places in Thailand. From the first glimpse of the entrance gate, created in imitation of a pavilion in the eighteenth-

century Bangkok style, it is clear that this is a museum unlike any other in the region.

Like the Suan Pakkad Palace or Jim Thompson's House in the heart of the Thai City of the Angels (as part of Bangkok's name translates), the Prasart Museum is a physical manifestation of the personal vision of its founder. In this case, Khun Prasart has dedicated much of his time and money since the museum was founded in 1981 to the realization of his dream as described above. The complex is an extraordinary and eclectic combination of the natural and human worlds—old and new, found and created. The visitor is guided by members of a knowledgeable staff through the Prasart Museum and even those who are accustomed to exploring museums on their own will be grateful for such expert assistance. The unescorted visitor would miss a great deal of the hidden riches here.

As is also true at the Suan Pakkad Palace and at the Jim Thompson House, the architecture and the gardens are an integral part of a visit to the Prasart Museum. On the site are a number of new buildings constructed in traditional Thai style, and inspired by the architecture of the country. The Tamnak Daeng at the National Museum in Bangkok, built in the eighteenth century, inspired the "Red Palace"—constructed of rare golden teak—which holds objects from the Ayutthaya and Bangkok periods.

The teakwood library, known as the Hor Kaeow, is set on stilts in a lily pond, as was historically typical for monastery

The elegant and superbly maintained grounds of the Prasart Museum are one of the highlights of any visit there. Photo: John McDermott.

In the bedroom of the Red Palace, this bed dates to the reign of Rama II. The large collection of Chinese blue-and-white porcelain comprises an impressive installation. The disciple figure is Burmese, of the nineteenth-century Mandalay period. Photo: John McDermott.

This elaborately carved, Chinese-influenced room dividing screen, which dates to the early Rattanakosin (or Bangkok) period, is another of the furnishings in the Red Palace. Photo: John McDermott.

libraries in Thailand as placement in water minimized the danger from termites to both the structure and the sacred texts inside. The library now holds manuscripts, books, and photographic materials.

The small Buddhist chapel was inspired, in part, by Wat Suthat in Bangkok. The carved gable depicting Vishnu astride his vehicle, Garuda, is particularly wonderful.

During the Bangkok period and especially during the reign of King Chula-longkorn (Rama V), who traveled extensively abroad, European architectural styles came into vogue. One of these European-style buildings, constructed with marble floors and high ceilings, displays objects and furnishings from the late eighteenth century through the present. In addition to these buildings in which the collections are housed, there are reconstructions of a Chinese temple, a Lanna style pavilion from the north, a traditional Thai house, and a Khmer chapel from the Lopburi area of central Thailand. Ancient architectural fragments from around the country are on display as well.

The brilliant gardens, tended by twenty-five gardeners (half the staff of the museum), also contribute to the overall pleasure of the visit. They are a blend of traditional and contemporary Thai garden design. The traditional is represented by the rigidly pruned trees and shrubs around the site, by the old gnarled trees (primarily moved here from their original sites), and by the fruit trees found in every Thai garden. The more contemporary aspects include the dense multihued plantings surrounding the brick pathways that wind through the museum. Sixty different species of palm trees grace the grounds, as do a number of outdoor sculptures ranging from huge ancient Thai water jars to Khmer stone carvings. Some of the large-scale Chinese objects originally came to Thailand via sea as ballast in the holds of trading ships. The combination of fragrant and vivid plantings and priceless objects

may lead the visitor to want to spend most of his or her time outdoors. To do so would be a mistake, for there are superb treasures on display in the three major exhibition buildings—the "Red Palace," the Library, and the European-style building.

Khun Prasart's collections range from very early Ban Chiang pottery with its typical reddish brown whorl patterns and prehistoric metalwork to late-nineteenth- and early-twentieth-century royal household objects. The later Bangkok period is very well represented, although some of the true treasures of the collection are the objects from the Sukhothai and Ayutthaya periods and from the Kingdom of Lanna (as northern Thailand was known). In particular, the elegant pottery and sculpture of the Sukhothai period exhibited here are of very high quality.

Inside the "Red Palace" are collections of art from the Ayutthaya and Bangkok periods, including a wonderful eighteenth century opium bed that Khun Prasart purchased from the royal family. Also on display, are a number of pieces of mother-of-pearl furniture. Khun Prasart collects Chinese art enthusiastically. A pair of late-nineteenth-century doors, which were pierced to allow air circulation through them, an eighteenth-century gold screen, and a rosewood bed with a marble base are three of the Chinese objects on display in this building. Many nineteenth-century Burmese and Lanna-style objects influenced by Burmese art are exhibited here as well. A sandalwood mirror embellished with a five-clawed dragon would have originally been made for the Thai royal family. A Buddhist manuscript cabinet with slightly sloping sides in the traditional Thai shape is displayed on the porch of this building.

The Library building in the pond holds some of the treasures of this collection, including a superb Buddha subduing Mara from the Sukhothai period. The attenuated proportions of this figure, as

A reconstruction of a sandstone temple from the Lopburi area in the Khmer style is set into a great lawn at the museum. Photo: John McDermott.

Numerous guardian figures, such as this elegant example, dot the landscape of the Prasart Museum. Photo: John McDermott.

well as the excellent craftsmanship mark it as a masterwork. A *howdah* (or elephant seat) of ivory and wood with a rattan seat made for the royal family is also exhibited here.

The open-air Lanna pavilion and the Chinese temple building at the far end of the museum site are both worth visiting. The Lanna-style pavilion is frequently the temporary location of Khun Prasart's newest acquisitions and is the setting for a large late-nineteenth-century footprint of the Buddha with the 108 auspicious signs, and a Mandalay period bronze Buddha figure. The Chinese temple is a wonderful and wildly colorful reconstruction.

The European-style building is dedicated to the memory of King Chulalongkorn, or Rama V. (Western visitors may know Rama V as the oldest of the many children of King Mongkut, Rama IV, of *The King and I* fame). Like his father, Rama V was progressive and saw the value of integrating Thailand into the outside world. He founded the major university in Bangkok, and abolished slavery

in Thailand. He owned many of the objects exhibited in this building. In 1897, Rama V went to Europe, and his travels there strongly influenced his view of art and architecture. Many of his personal possessions and those of his queen are on view here.

A number of smaller scale objects, particularly ceramics, are exhibited in this European-style building, the top floor of which is used today for storage. Small cases hold Khmer bronzes, and small Chinese terra-cottas from the Han dynasty. There are pieces of early pottery from Ban Chiang in northeast Thailand, and from the Kanchanaburi province to the west of Bangkok. Celadon, a traditional Thai medium, and a number of Khmer ceramics are also shown here. The Prasart Museum boasts one of the finest collections of Bencharong, that five-color (blue, black, green, red, and yellow) ware first produced in the eighteenth century during the Ayutthaya period, and which has continued as an important Thai art form to the present. Many early examples in a wide

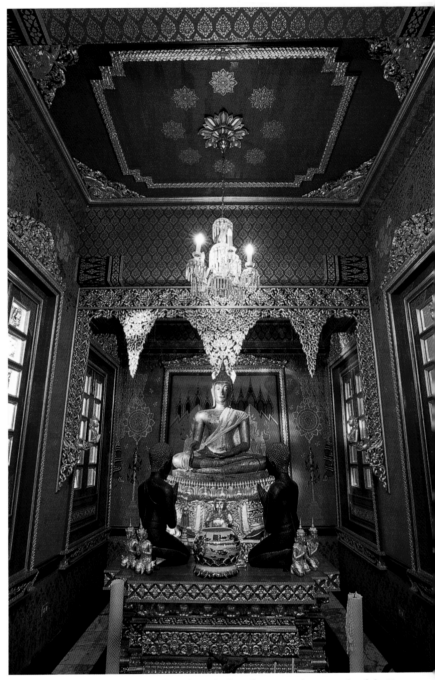

This golden Buddha figure is found inside the Library on the grounds of the Prasart Museum. Photo: John McDermott.

The interior of the Red Palace features a variety of objects from the many cultures of Thailand. Photo: John McDermott.

variety of shapes are exhibited here.

Khun Prasart is considering the foundation of a second museum outside Chiang Rai in the north of Thailand. This museum would house the collections from Lanna and the north in a setting more appropriate to their origins. Given the delights that greet the visitor at every turn at the current Prasart Museum, one can only hope that this project will soon become a reality.

On a practical note, the Prasart Museum is on the outskirts of Bangkok, a city almost incomprehensible in its size and reach. It is not readily accessible by public transportation, and renting a car without a driver would be an act of lunacy, given the chaos in Bangkok's streets. Hotels can arrange quite reasonably priced cars with drivers, and most are familiar with the location of the Prasart Museum.

SIAM SOCIETY AND KAMTHIENG HOUSE

131 Asoke Road, Sukhumvit Soi 21

Bangkok 10110

Tel: 02–661–6470, 02–661–6471

Open: Tuesday through Saturday from 9:00 a.m. to 12:00 Noon and from 1:00 p.m. to 5:00 p.m. Closed Monday.

The venerable and respected Siam Society safeguards an extensive repository of information and documents related to the history, customs, and culture of the amazing country of Thailand, formerly known as Siam. Founded in 1904 under royal patronage by a group of concerned Thais and foreign residents in Bangkok, the Society was established for "the purpose of investigating and encouraging the arts and sciences of Thailand and examining the ways in which they relate to those of the neighboring countries." Their motto is "Knowledge Produces Friendship."

The tranquil grounds of the Siam Society, with their lush tropical plantings, are one of the last remnants of the old Siam. Surrounded today by nondescript skyscrapers and subject to the noise and pollution of the city of Bangkok, the Siam Society survives as a memory of those aspects of traditional Thai culture that have, in large part, been lost.

The Siam Society is far from being a stagnant organization, however. As of this writing, the Kamthieng House, one of the major components of the Siam Society complex, is undergoing a major restoration. Intended to assist in better interpreting the life of northern Thailand in the late nineteenth century, this renovation work will improve an already wonderful institution, and it will help rectify some of the decay attributable to the pollution, humidity, and heat to which it has been subjected. The renovated building will utilize appropriate new technologies that will enhance the interpretation of the collec-

tions. Historical objects will be better protected from the environment as well. The museum is scheduled to open in early 2001, in time to celebrate the Society's hundredth anniversary in 2004.

The history of the Siam Society is, in many ways, the history of Thailand in the twentieth century. (Bonnie Davis has assembled the history of the Siam Society in a well illustrated book.) The Society began its existence as an itinerant organization with no permanent residence. After World War I, it moved into the first of several temporary quarters. Through various historical and financial troubles—during World War II, the Society's funds were frozen in the Hong Kong and Shanghai Bank—the Council of the Siam Society persevered, and by 1944 the Society was headquartered in the current complex on Asoke Road, Sukhumvit Soi 21. The library was opened by King Bhumipol, the current reigning monarch, in 1962, and the Society has continued to collect books and sponsor lectures on topics generally related to life in Thailand, ranging from orchids to archaeological sites to tropical disease. During its history, the Siam Society has forged links with other foundations and societies both in Thailand and abroad. The John D. Rockefeller III Foundation provided funds in 1965 to acquire artifacts, develop the library, and create "an archive of the visual and performing arts of Thailand not already maintained in other cultural institutions in Siam."

It had been one of the original objectives of the Society in the early twentieth century to create an ethnological museum,

The northern Thai architecture on the grounds of the Siam Society evokes the disappearing world of Lanna-style architecture. Photo: John McDermott.

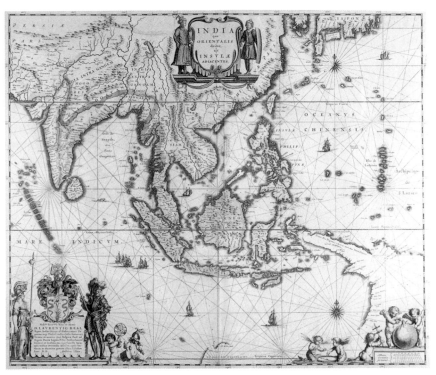

In 1635, the Europeans who had begun to travel to Southeast Asia drew intricate—if somewhat inaccurate—maps of the region. Photo: John McDermott.

The Siam Society is dedicated to the arts and sciences of Thailand as well as to examining how they fit into the region. The library is filled with both books on Thai topics and art works from the country. Photo: John McDermott.

but it was not until 1964 that this goal was realized. In that year, the Kamthieng House, one of the major public attractions of the site, was moved to the grounds of the Siam Society from the east bank of the Ping River in Chiang Mai in northern Thailand. The project was financed by the Asia Foundation. Today, it is a well-preserved example of a house of a well-to-do northern Thai family from the second half of the nineteenth century. The donor, Nang Kimhaw Nimmanhaeminda, gave the house of her mother, Nang Kamthieng Anusarasundara, to the Society. (In northern Thai tradition, the family house becomes the property of the eldest daughter in the family.) To this day, the spirits of Nang Kamthieng and Nang Saed, the builder of the house, are said to wander the structure. The family was wealthy, and gained their wealth from the taxation of betel-nut sellers who passed the house on a daily basis. (This taxation was understandably the root of some dissatisfaction among betel-nut sellers and Nang Kamthieng and her family were forced

to seek refuge inside the walled city of Chiang Mai for a time during a tax revolt.)

The two buildings that make up the Kamthieng House complex are worth a close look. The house is unusually large for a private home. It is solid teak and was originally supported by 36 octagonal teak pillars. The area below was used for storage and other activities. As a living museum of northern Thai culture, the house is designed to show life in Chiang Mai during the later nineteenth century. The traditional components of a northern Thai house were the living quarters, a kitchen, a well, a granary, and a rice pounder, and the Kamthieng House is considered "complete" as it has all these, in addition to a porch between the main living space of the house and the kitchen and granary areas. The architectural decoration of the house, with its crossed upper gable decorations said to represent a pair of buffalo horns, is typical of northern Thai buildings of the time.

The living quarters included the private area of the home where the owner

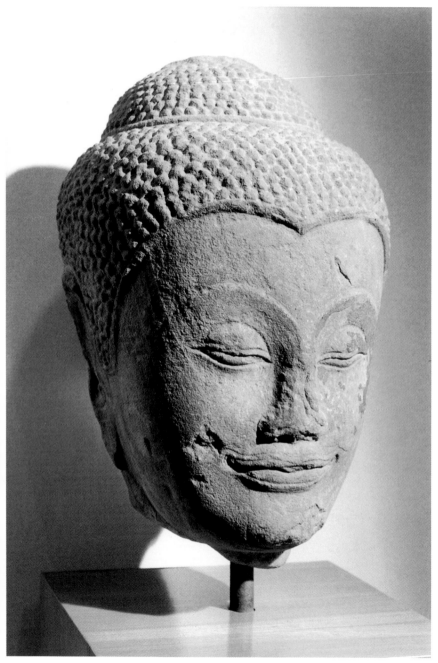

This substantial Buddha head from the Ayutthaya period is a wonderful example of its stone sculpture. Photo: John McDermott.

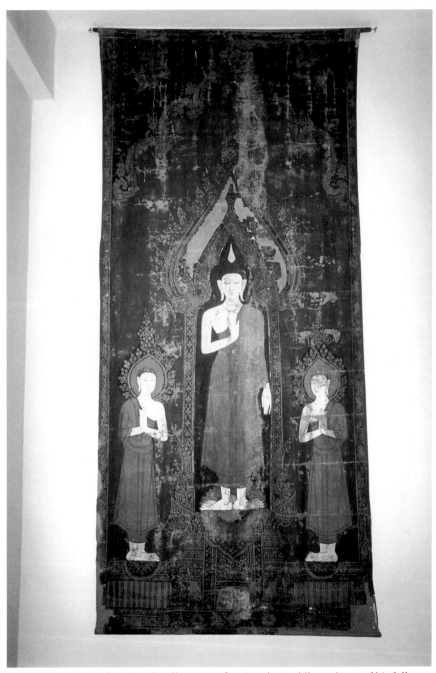

A large and intricately painted wall tapestry figuring the Buddha and two of his followers dates to between 1825 and 1850. Photo: John McDermott.

and the family members would sleep. Occasionally, guests might be invited to sleep there as well. This inner room is home not only to the ancestral spirits of the family, but also to the perceived strengths of the inhabitants. Over the doorway, the *ham yon*, translated into English as "magic testicles," or perhaps more politely, "potent charm," were carved to ward off evil. (It has been suggested that northern Thai buildings were constructed to look like buffalo, and that the *ham yon* were part of this conceit.) It has also been suggested that the house shape was adapted from Burmese models.

The cool, graceful porch was the daytime living area. On it, the family would cook, do the washing, grow plants for food and medicinal purposes, and take baths. In addition, it served as a dining area and an outdoor foyer where visitors and guests would be welcomed. As is customary, the kitchen—in this case not from the original Kamthieng House—is a separate building located next to the main building. The northern Thai raised sand-filled cooking platform is typical of the area around Chiang Mai. Kitchens were the storage houses for staple foods and also the location where the servants slept. The kitchen is the seat of many firmly held superstitions. Pestles left in mortars will result in illness to a family member. The supports to the cooking platform must not bump up against each other or disharmony in the house will result.

The well is also typically northern Thai. Unlike the areas of central and southern Thailand where rainwater was captured in large vessels, the northern Thais relied on well water. Traditional northern Thai wells were lined with brick, and water was drawn up from them in a bamboo basket lined with resin. Drawn water was segregated by purpose and drinking water was consumed in coconut shells. Bathing water and, lowest of all, foot-washing water, were kept in separate basins.

The nearby two-story granary, adjacent to the kitchen, usually held rice, the staple food of Southeast Asia, and is near the rice-pounding shed. Here the older daughters of the family would pound only the quantity of rice needed for the day. The granary was only filled or accessed on auspicious days in order not to offend the rice spirits. The granary is normally constructed above ground and can be reached from the main house by a raised walkway. The second floor is high enough to allow a man standing in a bullock cart to pass a basket full of raw rice to someone standing on the upper floor. Large granaries were symbols of the wealth of the resident. Because granaries are so important to the culture, they are typically covered with high-quality wood carving.

A Thai spirit house is displayed on the grounds as well, although this is a custom more affiliated with the central and southern regions than those of the north.

The building itself is important, as are the objects displayed inside. On display are objects used by both the farmers and the lake and river fishermen of northern Thailand, as well as rice sickles and rice knives used in the growing and harvesting of wet rice. Northern Thais eat "sticky rice," which is formed together into balls and eaten with the fingers after being dipped into various condiments. Also on display are lacquerware objects used to eat rice, and bamboo tools used to harvest it.

Bits and pieces of architectural decoration, particularly carved wooden objects and panels from both houses and monasteries in northern Thailand, are on view here. (Many of these were purchases resulting from the Rockefeller donation of 1965 at a time when a number of older buildings were being demolished to make way for more modern structures—a convenient pairing of money and available objects.) A number of the *ham yon*, or large carved wooden panels from the living quarters of other homes, were acquired at this time. Many of these are

Henri Mouhot, one of the first Westerners to visit the mainland of Southeast Asia, made Europeans aware of the wonders of the region by publishing *Travel in Siam, Cambodia, and Laos, 1858–1860*. Photo: John McDermott.

religious objects carved from a single piece of teak, although their provenance and original usages are, unfortunately, still unknown, and they are the subject of on-going research. There are wooden panels with fanciful animals, as well as lions, birds (including the sacred *hamsa*), floral motifs, and stylized clouds, elephants, dancing human figures, and other elements drawn from nature. Some panels depict figures from the *Ramakien*, the Thai ver-sion of the *Ramayana*. Large boxes and cases for palm leaf manuscripts are exhib-ited here as well.

The Siam Society houses a collection of many colorful costumes attributed to the hill tribe peoples of northern Thailand, although this collection is not as extensive as that of the Tribal Museum in Chiang Mai.

In the mid-1980s, a traditional house from the central plains of Thailand was dismantled at its original location and moved to the Siam Society site. This Saen-garoon House should also prove of inter-est to the visitor.

In addition to interpreting the mate-rial culture of northern Thailand, the Siam Society plans to host northern Thai cul-tural performances. The Siam Society is an institution where the whole is infinitely greater than the sum of its parts. The tran-quil grounds, the graceful old northern Thai architecture, and the collection of ethnographic and agricultural objects are all the somewhat melancholy echoes of a more relaxed time and place that now seem very far removed from modern life.

The traffic in Bangkok is frequently daunting, and the visitor should be aware that the Siam Society is located just a short walk—with no major thoroughfares to cross!—from the new Asoke BTS station. The interesting shop at the Siam Society, with objects from many areas of the region, is worth a visit as well.

SUAN PAKKAD PALACE MUSEUM

352 SRI AYUTTHAYA ROAD
RATCHATHEWI, BANGKOK 10400

TEL: 02-246-1775

OPEN: MONDAY THROUGH SATURDAY FROM 9:00 A.M. TO 4:00 P.M.
CLOSED SUNDAY AND NATIONAL HOLIDAYS.

The lovely gardens and traditional Thai wooden architecture of the Suan Pakkad Palace (Lettuce or Cabbage Farm in English) provide an oasis amid the noisy chaos of modern Bangkok. Although surrounded by high-rise buildings and the concrete jungle of Thailand's ultramodern capital, the visitor feels instantly transported back to the nineteenth-century Thailand represented by those buildings that comprise the Palace grounds. The collections are excellent and well worth a visit. But it is the place itself that is the most evocative. The tame pelicans that wander the grounds, the seductive scents of the flowering trees, the well-tended grass, and the serene and simple architecture represent a way of life no longer typical in one of Southeast Asia's most developed countries. Suan Pakkad Palace recalls this near past.

Assembled over an extended period beginning in 1952, the Suan Pakkad Palace is sited on the grounds of a former commercial vegetable garden, hence its somewhat odd name. It embodies the vision of the Prince and Princess Chumbhot of Nakhon Sawan, a province in central Thailand. They began with a reception pavilion on the grounds and soon after decided to gather their collection of Thai art and antiquities together there and allow the public to visit. Admission fees collected were donated to the promotion of Thai cultural activities. Today, the proceeds from admission fees to the museum still support the work of the Chumbhot-Pantip Foundation, which provides opportunities for underprivileged students, supports medical institutions that serve the less fortunate, and which continues to promote art and cultural activities in Thailand. The Foundation is responsible today for the operation of the Palace.

Like the Prasart Museum, and others that represent the idiosyncrasies of their founders, the Suan Pakkad Palace houses an eclectic, diverse, and delightful collection ranging from historic photographs of Thai royalty and aristocracy to superb Khmer sculpture to geodes from central Thailand. As the late Princess herself stated in her introduction to a book on the collections, "It [the collection] makes no pretense at being comprehensive in any of the fields of study it represents; though we have aimed always at quality, we have mainly been guided by what appealed to us for one reason or another."

Seven historic buildings set within the Palace grounds were moved here from other sites around Thailand and have been reassembled to allow ease of access for the visitor. A number of them belonged to the Prince's great-great-grandfather, one of the two Regents in the time of King Mongkut (Rama IV, reigned 1851-1868), the learned and forward thinking King of Siam whose fame among Westerners is linked to the autobiography of Anna Leonowens and its many cinematic interpretations. The structures are splendid examples of traditional Thai architecture. The contrast between the wood, green grass, blue sky, and the cool of the interiors on a hot day will charm any visitor. The roofs of these buildings are sharply pitched with wide overhangs to allow for fast drainage of

The traditional Thai architecture of the buildings at the Suan Pakkad Palace Museum makes the complex a delightful refuge from the noisy chaos of Bangkok. Photo: John McDermott.

When lit with tiny white lights at night, the grounds—and in particular the historic Lacquer Pavilion—are magical. Photo: John McDermott.

tropical rains away from the building. All the structures are raised above ground level to keep the living quarters above the monsoon runoff and to allow whatever cooling air there might be to circulate freely around the house. The six primary houses have teak-paneled walls and the customary architectural detailing, including soaring gables at each end of the house. Houses I through IV are grouped near the entrance to the grounds. Houses V and VI are slightly beyond this and to the right. The Lacquer House from the Ayutthaya or Early Bangkok period stands alone at an angle in the main garden.

Princess Chumbhot was the creative force behind the gardens at the Palace, which are more informal than most Thai gardens and which contain many plants imported from other countries. She was an inveterate traveler and frequently brought back plants, many of which have adapted well to the steamy tropical climate of Bangkok. The main garden incorporates a large lawn dotted with a wide variety of flowering trees and plants and a lily pond. A long teak royal barge used by King Chulalongkorn, the son of King Mongkut, (ruled 1868–1910) is displayed along the back wall of the main garden. The rock sculpture garden near the entrance consists of unusually shaped stones culled from the islands of southern Thailand. Plant and garden enthusiasts will want to explore in the back section of the Palace grounds where a nursery and exotic plant collection are housed. William Warren, a leading scholar of Thai art and culture, wrote of the gardens that "they play an important part in the creation of its (the Palace's) total effect, offering an ideal setting for the various buildings and also a restful contrast to the busy city just outside the walls."

The collections are exhibited as the Prince and Princess wished rather than in chronological or geographical order. House I presents fascinating early photographs of Thai royalty and a choice collection of Khmer and Thai art. House II contains a number of more contemporary objects from the Bangkok period. House III holds objects belonging to the family and a series of amusing French drawings of Siamese royalty from the seventeenth century. House IV exhibits Buddha images from a variety of cultures. House V is devoted to the prehistoric art of Thailand. House VI displays a wide variety of art from Thailand, including ceramic ware, axes, and sculpture from Sukhothai. House VII is the Khon Museum and displays delightful examples of puppets, masks, and other Thai folk art. Objects from the excavations at Ban Chiang are exhibited in the new Chumbhot-Pantip Center of Arts.

Most of the art objects and archaeological materials shown in the Suan Pakkad Palace are from Thailand. The collections thus comprise a short course in Thai art history. The earliest objects are prehistoric examples of the famous pottery from Ban Chiang in Udon Thani province in the Northeast of Thailand. Ban Chiang is a relatively recent "find" in the archaeological world, having been first discovered in the 1960s and excavated by the Fine Arts Department of the Thai government and the University of Pennsylvania in the mid-1970s. Most frequently characterized by red geometric and whorl patterns, the earliest Ban Chiang pottery dates to the fourth millennium B.C. Many of the wares from Ban Chiang are strikingly modern in appearance and quite varied. Some have feet and some need to be supported by a modern stand; some are painted and some plain. Some have surface hatching and some are smooth. There is a small but comprehensive collection displayed here.

History in Thailand begins with the Dvaravati period, dating from the seventh through the eleventh centuries. Primarily stone, stucco, and terra-cotta—the latter two being architectural decoration from temples—the surviving objects from this

The Suan Pakkad Palace Museum has strong collections of material from Ban Chiang, an archaeological site in Northeast Thailand. These new galleries display intriguing remnants from that civilization. Photo: John McDermott.

This piece of pottery from Ban Chiang dates between 300 B.C. and A.D. 200, and exhibits the red-whorled pattern typical of much of that period's pottery. Photo: John McDermott.

This figure of Uma, the consort of Shiva in Hindu mythology, may date to the seventh century A.D., and is a masterpiece of early Khmer art. Photo: John McDermott.

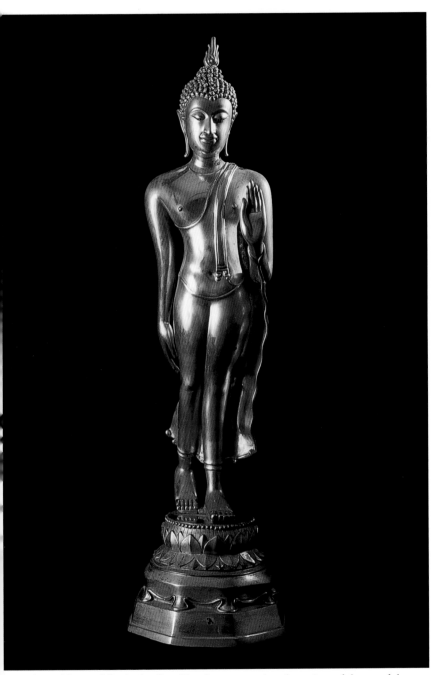

This golden Buddha in the dispelling fear posture is a showpiece of the art of the Sukhothai period, dating to the fourteenth century. Photo: John McDermott.

This delightful Sawankhalok bowl from central Thailand dates between the fourteenth and sixteenth centuries. Photo: John McDermott.

period are almost exclusively images of the Buddha, represented in the collections of the Suan Pakkad Palace by several seated figures of the Buddha in various mudras. Each of these mudras, or symbolic postures, represents an aspect of the life or character of the Buddha.

Art of the Lopburi period from the seventh through the fourteenth centuries is also represented in the collection and is characterized in the early centuries by the influence of the Khmer art of Cambodia and in its later manifestations by an evolving Thai character. An outstanding exam-ple of Khmer-influenced art of this period is a torso of Uma, the consort of Shiva, from Aranya Prathet on the Thai-Cambodian border, due west of Angkor. This is one of the masterpieces of the collection and may date to the seventh century. The collection houses a small, select number of Khmer sculptures from this same period.

Thai art reached its apogee during the Sukhothai period, in the thirteenth and fourteenth centuries. Sukhothai, now a World Heritage Site in central Thailand, was the short-lived capital of an empire that stretched from Lampang in the north

The gold-on-black lacquer paintings of the interior of the Lacquer Pavilion illustrate tales from Buddhist and Hindu mythology, as well as from the daily lives of the Siamese in the late seventeenth and early eighteenth centuries. Photo: John McDermott.

to the Malay peninsula in the south. The Kingdom of Sukhothai established friendly relations with many of its neighbors and absorbed influences from other art and architecture into their canon. The Buddha figure from this period is characterized by a flame topknot, broad shoulders, a narrow waist, elegant proportions and a mysterious and gentle smile. The most recognizable figures from this period are the graceful curved figures of the walking Buddha with hand raised in the Abhayamudra for dispelling fear, and with one heel raised off the ground.

Capitals of Thailand have moved successively south. In the middle of the fourteenth century, the capital of Thailand moved from Sukhothai to Ayutthaya where it remained until the new capital at Bangkok was founded in 1782. Thai art of the Ayutthaya period was not as stylistically unified as that of the Sukhothai period and took its artistic influences from the earlier art of Thailand, as well as from Khmer and even Chinese art.

The collection is rich in objects from the Bangkok (or Rattanakosin) period, particularly lacquerware furniture and artifacts such as food containers, boxes, and trays inlaid with mother-of-pearl, as well as in household objects such as tea sets, spittoons, and bowls of niello silverware. Examples of Bencharong ware, either made in China after Thai designs or made in Thailand itself, are well represented in the collection.

French drawings of Thai kings and queens from the late seventeenth century offer the visitor a humorous interlude in the galleries of House III. The Reine de Siam (Queen of Siam) is portrayed as a bare-breasted Junoesque figure clad in European clothing and what appears to be an ermine cape. The watercolor of Chaou-Haraye (King Narai; ruled 1656–1688) is even more imaginative. He appears to wear a part of a building on his head. He also looks African and sports the same ermine-trimmed cape as the Queen. Presumably these artists had not visited Siam,

as the renditions of the Siamese are completely fanciful.

The highlight of a visit to the Suan Pakkad Palace is the Lacquer Pavilion. This late Ayutthaya or early Bangkok period building, dating to the seventeenth to eighteenth centuries, was moved to the site from the Ban Kling monastery on the east bank of the Chao Phraya River (which divides the city of Bangkok) between the former capital of Ayutthaya and Bang Pa-in, the site of a number of royal palaces. The current Pavilion is a conflation of two buildings and now consists of a central room surrounded by a narrow corridor. The gold-on-black lacquer paintings are eclectic and illustrate events from the life of the Buddha, scenes from the *Ramayana* (the Hindu epic), and charming vignettes of everyday life in Thailand. Some of the historical scenes show the arrival of early foreign visitors to the capital city of Ayutthaya. The depictions of traditional Thai architecture and gardens are particularly charming. The exterior relief carving on the pavilion is of

interest as well—dragons, mythical beasts, and half-human, half-bird creatures are tied together with foliage and interlace to form elaborate and decorative forms.

Princess Chumbhot also collected shells, minerals, and fossils. These are primarily from Thailand, but the collection has been enriched with gifts that have broadened its scope. These are exhibited in Houses IV and V and are of interest to those with a bent toward the natural world. The geodes in the mineral collection, many of which are from the area around Lopburi, are quite unusual.

Despite the fascinating quality of the collections, however, it is the setting of the place itself that may prove the most captivating to the visitor. Only faint echoes of the lost elegant world of Siam and early Thailand still exist today. It is in places such as the Kamthieng House at the Siam Society, the Jim Thompson House, and the Suan Pakkad Palace that the fortunate visitor may catch a glimpse of a world not long gone, but one that seems far, far away.

VIMANMEK MANSION MUSEUM

DUSIT PALACE GROUNDS, OFF RATCHAVITHI ROAD
BEHIND THE PARLIAMENT BUILDING

DUSIT, BANGKOK 10300

TEL: 02–280–5928

OPEN: EVERY DAY FROM 9:30 A.M. TO 4:00 P.M. (THE LAST ENTRY IS AT
3:15 P.M.) REQUIRED GUIDED TOURS — IN ENGLISH AND LASTING
ABOUT AN HOUR — LEAVE APPROXIMATELY EVERY THIRTY MINUTES.

Vimanmek Mansion, or the "Celestial Residence," is part of the larger complex of buildings in the Dusit Palace and is probably the largest teakwood building in the world. King Chulalongkorn (Rama V, reigned 1868–1910) built this mansion as a summer residence and a retreat from the rigid formalism of the Grand Palace, and he lived here for a period of five years from 1901 to 1906. The building itself was the first and largest permanent residence in the Dusit garden, a piece of land personally purchased by the King in the early part of the twentieth century. Although elegant, it appears quite informal when compared to the buildings of the Grand Palace. It also looks as if it were influenced by European architectural tradition, and, in fact, Rama V was the first Thai King to visit Europe at the very end of the nineteenth century. With its painted and plain paneled-wood walls, the interior of the building looks like a cross between a hunting lodge and an upscale beach house. The warm teak exterior walls and many windows make Vimanmek Mansion one of the most attractive buildings in Bangkok, and a visit here is a trip back into Thai history at the turn of the last century. Teak is a uniquely suitable construction material, given the heat, humidity, and bug-laden climate of Thailand, and it was one of Thailand's great natural resources until well into the twentieth century. Rampant logging, however, has led to the disappearance of the majority of the natural teak forests.

The Vimanmek Mansion had been partially constructed on Si Chang Island in the Bight of Bangkok just off the coast of Chon Buri beginning in 1893. Construction had been stopped, though, due to a French blockade of the Gulf of Thailand and the building was abandoned. On seeing it in 1900, the King ordered it dismantled and reconstructed in its current location on the grounds of the Dusit Palace. The reconstruction and finishing touches took only seven months, and it was occupied in 1901. On Rama V's death in 1910, the mansion was used by two of his successors briefly, and was then closed in the mid 1930s for a period of almost fifty years. In 1982 the mansion reopened as a museum in celebration of the bicentennial of the move of the capital of Thailand to Bangkok from Thonburi across the river. The mansion is surrounded on all sides by water, bordered on three sides by three of Bangkok's famous klongs, or canals, and on the other by a small (and very bright green) pond called the Jade Basin.

Although the Palace's 81 rooms on three floors are filled with treasures of Bangkok period art and memorabilia of old Siam, it is the overall impression rather than individual objects that has the greater impact. The detailed decorative carving on the walls, ceilings, and staircases of the interiors is of the highest quality and ties together the spaces within. Over thirty of the rooms are open to the public, and may be visited on a tour guided by

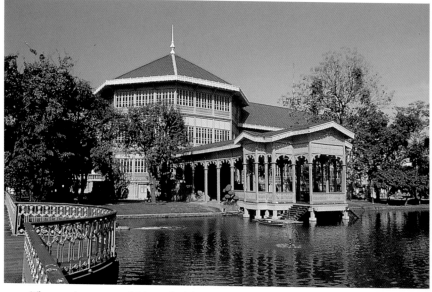

The royal quarters of King Chulalongkorn were housed in this octagon of the Vimanmek Mansion overlooking the waters of the Jade Basin. Photo: John McDermott.

delightful Thai hosts and hostesses.

The building was constructed, in essence, in the shape of an L with each side measuring some sixty meters. An elegant, enclosed veranda, which allowed for air circulation while keeping out the direct rays of the run, runs around the entire building with the exception of the octagon at the north end that has its own separate balconies. This four-story octagon was the personal residence of Rama V, the rooms of which have been restored to their original 1905 appearance. The King's bedroom, private study, and bathroom on the top floor are furnished quite simply, but elegantly, and the exhibited objects from his life, including his books and two writing desks, suggest a king who looked to many sources for inspiration. The bathroom features a tub with the first shower head installed in Thailand. The holding tank was filled manually. The living room and audience hall on the lower floors are filled with European—or European inspired—furnishings. The Queen's quarters were located in the north end of the mansion. Other parts of the mansion housed members of the royal family, consorts, and friends.

The lovely dining room is set as if for a formal dinner. Royally commissioned portraits fill the throne room, still used at times for state occasions. There are entire rooms given over to the exhibition of silver, glass, ivory, and various kinds of traditional ceramics. The collections are rich, but are housed in a building that is surprisingly simple and graceful.

As the authors of the *Passport Guide to Thailand* have recognized, Vimanmek Palace is in some ways the reverse side of the Jim Thompson House. The traditional arts and cultures of Thailand fascinated Thompson, a worldly American who chose to live in Bangkok. Europe and the many other cultures of the world entranced Rama V, who managed to open up Thailand to influence from Europe and the West while retaining Thai independence by staving off the advances of the French and British colonial powers as they annexed neighboring countries. The mansion reflects the taste and the interests of an extraordinary king.

This graceful sun-filled veranda runs around the exterior of the mansion.
Photo: John McDermott.

The exquisite carved-wood detailing in the interior of the building is seen at its best in this spiral staircase, one of two that connect the second and third floors. Photo: John McDermott.

The King's private bathroom boasts the first showerhead to be used in Thailand. The holding tank was filled manually. Photo: John McDermott.

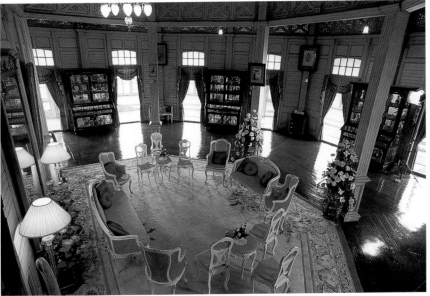

The royal family used this space on the third floor of the octagon as a living and sitting room. Cabinets filled with objects from the royal collections alternate with large windows in this part of the building. Photo: John McDermott.

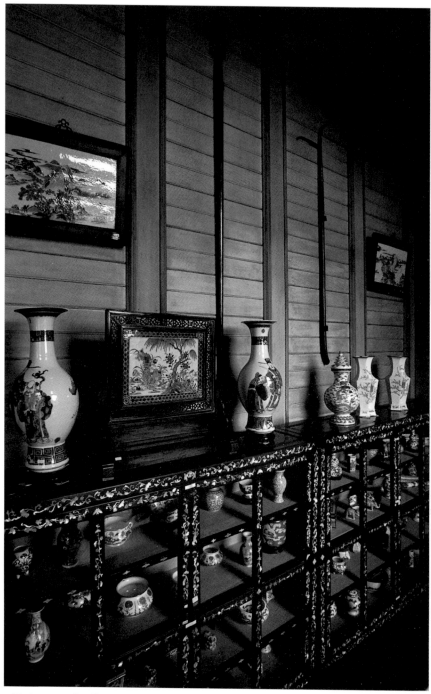

Various royal collections, including this display of Chinese blue-and-white porcelain, are on exhibit in the Mansion. Photo: John McDermott.

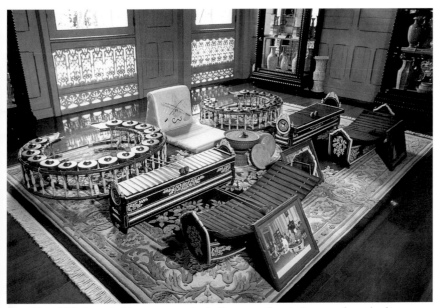

Traditional Thai musical instruments, including several variations on the xylophone, are arranged in the Mansion's music room. Photo: John McDermott.

The visitor should note that because Vimanmek Mansion, like the Grand Palace, is the property of the Thai royal family, appropriate dress is required and strictly enforced. Shorts, sleeveless tops, and mini-skirts are not permitted, although cover-ups are available on site.

There are several other museums worth visiting in the lovely, park-like grounds whose broad expanses of grass, trees, and wide avenues form an open space that provides a welcome respite from Bangkok's relentless urbanism. Several small facilities devoted to photography, and museums with collections of traditional textiles, old clocks, and carriages — as well as one treating the history of the royal elephants — are all on the grounds of Dusit Palace and well within walking distance of Vimanmek Mansion. Traditional Thai dances are performed daily at 10:30 A.M. and 2:00 P.M. along the canal near the Mansion.

NATIONAL MUSEUM, CHIANG MAI

CHIANG MAI-LAMPANG ROAD
MUANG, CHIANG MAI 50300

TEL: 053–221–308

OPEN: WEDNESDAY THROUGH SUNDAY FROM 9:00 A.M. TO 4:00 P.M.
CLOSED MONDAY AND TUESDAY.

As the second major city of Thailand, Chiang Mai is a highly accessible place with historic temples and lovely examples of traditional northern Thai wooden architecture, Chiang Mai (or the "New City") was founded in 1296 by King Mengrai. Traces of the original city walls built by Mengrai in the last decade of the thirteenth century are still visible today. In the fourteenth and fifteenth centuries, Chiang Mai became an important center in the Lanna (or "Million Rice Fields") Kingdom. It was during this period that many of the major *wats*, or monastery temple complexes, of Chiang Mai were founded, including Wat Chiang Man (1296), Wat Phra Singh (1345), Wat Chedi Luang (fifteenth century), and the unearthly, surreal forest temple, Wat Umong (late fourteenth century), located just outside the city. Wat Jet Yod, an unusual temple within walking distance of the National Museum, was built in the fifteenth century to host a meeting of the World Buddhist Council in 1477. Many of the doctrines of this Eighth Tripitaka are still the norm today. Numerous objects displayed in the National Museum came from these temples, which date back to the time of the Kingdom of Lanna (also spelled Lan Na).

Chiang Mai was conquered by the Burmese in 1556, and was only returned to Thai control in 1775. It was during this second Thai period that the massive extant brick walls around the city were constructed. Today Chiang Mai is a major center for both Thai and hill tribe arts and crafts, as well as the hub of the trekking and tourism industries in northern Thailand.

The National Museum, Chiang Mai is housed in a graceful white building that represents an adaptation of traditional northern Thai architecture. Founded in 1954 as a very small center with only a few objects, the current building was opened in 1973, and the museum now boasts a collection of about one million items. As the major regional museum in the north, the National Museum, Chiang Mai also oversees the operation of the branch of the National Museum in Chiang Sean, the Nan Museum, and the Hariphunchai Museum in Lamphun.

The museum's installations cover six major areas. On the ground floor are displays related to the natural and early cultural background of the region, the history of the Lanna Kingdom, and the art and culture of the city of Chiang Mai after the Burmese occupation in the sixteenth century. The galleries upstairs are devoted to trade and the economy of the north up to the beginning of World War II, modern Chiang Mai, and the development and evolution of Lanna art.

The exhibits begin even before one enters the building. Displayed outside are two kilns, early evidence for the manufacture of ceramics, an art form for which both central and northern Thailand have long been famous. A cross-draft kiln excavated in 1970 is from Chiang Rai province and is dated between the fourteenth and the seventeenth centuries.

Though much of the art of Lanna is exhibited on the upper floor, the visitor is

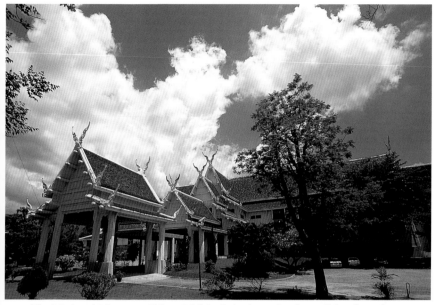

The National Museum, Chiang Mai, built in the style of a traditional northern Thai building, is located on the outskirts of the city and is surrounded by parkland. Photo: John McDermott.

This kiln that greets the visitor outside the museum's entrance was used in the period from the fourteenth to the seventeenth century to create the famous ceramics of northern Thailand. Photo: John McDermott.

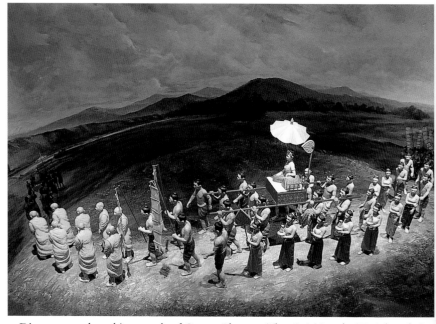

Dioramas, such as this example of Queen Chamma Thewi visiting the Hariphunchai Kingdom in the eighth century, are among the most popular exhibits in the museum. Photo: John McDermott.

immediately confronted on entering the building with an overpowering fifteenth-century Lanna-style head of the Buddha, just to the left of the entrance hall. The tightly curled hair, elongated earlobes, and the forceful lines around the eyes, as well as its massive scale, mark this as an important work of the period. Large, elegant manuscript boxes that originally held Buddhist scriptures surround this imposing head.

The galleries begin to the right with a detailed installation about the geological history of the Chiang Mai area. An informative relief map of the region showing major cities, archaeological sites, and geographic features is a very useful orientation tool. Photographs of prehistoric archaeological sites—many of which have only been excavated during the last fifty years—and displays of simple tools illustrate the early civilization in this area, possibly dating as early as 500,000 years ago. The Lua (or Lawa) people of northern

Thailand still live in a manner not too far removed from that of these early peoples, and their simple clothing and jewelry are featured in this area as well.

Some of the ceramic arts of the Hariphunchai Kingdom, the first state of northern Thailand, are exhibited nearby. With an economy based on trading and agriculture, this Buddhist Kingdom was founded in the seventh century, and flourished during the eighth and ninth centuries with a capital city at Lamphun, south of Chiang Mai. The art of the Hariphunchai Kingdom was heavily influenced by Dvaravati art.

As is true with all National Museum branches in Thailand, the Chiang Mai museum is primarily devoted to the art of its immediate area, that is to the history of the Kingdom of Lanna. King Mengrai, who founded the city in the late thirteenth century, laid it out in a rectangle similar to that of the city of Sukhothai to the south, and it was during the period between 1355

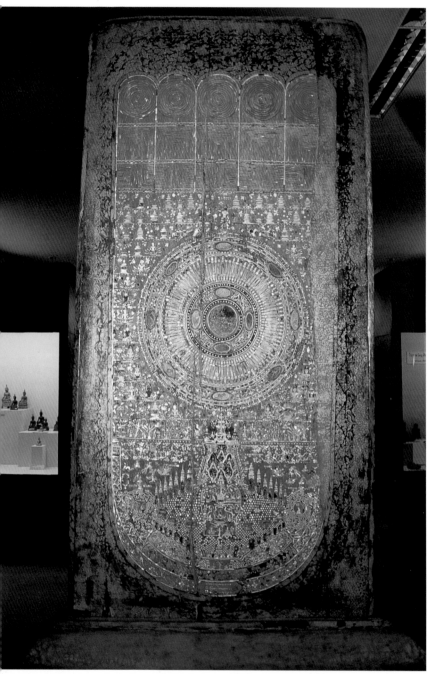

This footprint of the Buddha from Wat Phra Singh in Chiang Mai dates to the late eighteenth century and is a beautiful example of the temple art of the period.
Photo: John McDermott.

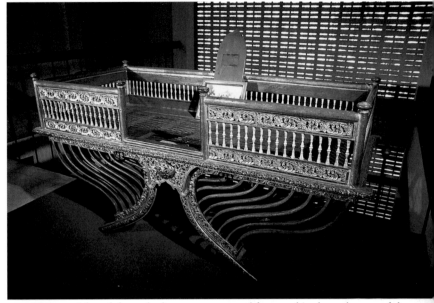

This royal *howdah*, or elephant seat, was used for travel in the early part of the twentieth century. Photo: John McDermott.

and 1525 that the Kingdom of Lanna reached its apogee. Extensive trade networks around the region assured the continuing wealth of the kingdom, and Buddhism flourished in this environment. Most of the figures of the Buddha exhibited here are seated representations of the Buddha subduing Mara, left hand in his lap and right fingers extended to the ground, a favorite northern Thai subject. Photographs and models of the many temples and monasteries in and immediately around Chiang Mai are exhibited in the introductory section to the art of Lanna, as are examples of pottery, and weights and measures. Light brown and sage green ceramics—many of which are remarkably modern in appearance—are also exhibited here. They were fired in kilns such as the one exhibited outside the museum.

The clear highlight of the introductory galleries devoted to the art of Lanna is a large footprint of the Buddha from Wat Phra Singh, dating to 1794. Though it dates far after the decline of the kingdom, the inlay of mirrors, mother-of-pearl,

black lacquer, and gold leaf is astonishing. In the eighteenth century, Chiang Mai once again fell under Thai influence, and the relationship between the court of Siam (as Thailand was formerly known) and Chiang Mai began under the rule of Rama I. The robes of Chao Kaew Nawarat, the last King of Chiang Mai, are exhibited here. After his death, Chiang Mai became part of a unified Thailand. There are also wonderful old stereographs of scenes from Italy given to Phra Rajchaya Chao Darasasmi, the King's consort, by King Chulalongkorn, the Thai Rama V.

Upstairs, the galleries display objects and provide information concerning the trade and economy of Chiang Mai, the nineteenth- and twentieth-century history of the area, and the development of the art of Lanna.

Before 1921, the city—and, indeed, the entire north of Thailand—were effectively isolated from the development of the southern part of the country. In that year, the rail line between Chiang Mai and the south was opened. As a number of

This serving dish is typical of lacquerware in the Lanna style, featured in the
National Museum. Photo: John McDermott.

photographs in these galleries make clear, elephants were used as a means of transportation well into the twentieth century and a wonderful *howdah* (elephant seat) of red-and-gold lacquer is exhibited here. Ox carts and old plows, as well as wooden wheels and shovels, illustrate how "low-tech" was the life of the people of northern Thailand just one hundred years ago.

To a certain degree, the economy of northern Thailand has always been linked to the production of arts and crafts, and the industries devoted to weaving, lacquerware, metalwork, and wood are highlighted here. A loom and a detailed illustration of the process of lacquerware production are featured in this area of the museum.

In addition, there are quite humorous photographs of Western missionaries who came to Chiang Mai in the second half of the nineteenth century. The missionaries seem to have been a rather dour lot. The Reverends McGilvary, Dan Beach Bradley, and Jonathon Wilson stare unsmilingly back at the visitor from formal black-and-white photographs.

The final galleries in the museum are devoted to the development of the art of the Kingdom of Lanna and northern Thailand. After the founding of Chiang Mai in 1296, the art of the region was broadly influenced by the other artistic traditions of this part of the world—the art of India, the Mon and Burmese art of Myanmar, Khmer art, and the artistic traditions of Sukhothai and Ayutthaya. The art of the Bangkok (or Rattanakosin) period was an important later influence.

The art of northern Thailand went through five, clearly defined, stylistic stages. The very earliest influence was that of the Dvaravati and Hariphunchai kingdoms, themselves in turn influenced by Mon art. The Hariphunchai state existed from the mid-eighth to the late-thirteenth

century and its center was the city of Lamphun to the south of Chiang Mai. The period from the mid-fourteenth to the mid-fifteenth centuries shows the influence of the Kingdom of Sukhothai, at that time the dominant influence in central Thailand. The so-called "Golden Age" of Lanna art occurred during the reigns of King Tilokkarat and Phra Muang Keo from 1441 to 1525. This was followed by a "decadent" period from the mid-sixteenth to the late-eighteenth centuries, during which Chiang Mai was abandoned, and the area came under increasing Burmese influence. The late-eighteenth century brought about a revival of Lanna art, which is still underway to a certain extent as Chiang Mai leads Thailand in the production of the high-quality arts and crafts that remain very much in evidence today.

A number of wonderful Buddha figures on display here illustrate the development of these artistic styles. These include several standing Buddhas of the Lanna style from the nineteenth and early twentieth centuries, and a large red banner from a temple in the environs of Chiang Mai.

The galleries conclude with a room that provides a broad overview of the arts in Thailand from the Neolithic ceramics of Ban Chiang in the northeast to objects from the Rattanakosin or Bangkok style of the nineteenth century. While not as comprehensive as the collections of the National Museum in Bangkok, this room does provide a framework and context within which the displayed objects can be placed.

Visits to the National Museum, Chiang Mai, and to the Tribal Museum can offer the visitor to Thailand's north an excellent introduction to the natural and cultural histories, the art, and the people of this charming and diverse part of Thailand. Each of these museums is quite compact and both can be visited in half a day.

TRIBAL MUSEUM

RATCHAMANGKLA PARK, CHOTANA ROAD
MUANG, CHIANG MAI 50300

TEL: 053–210–872

OPEN: EVERY DAY FROM 9:00 A.M. TO 4:00 P.M.

The startling Akha gate, or Lok-kah, that greets the visitor to the Tribal Museum in Chiang Mai represents a spiritual barrier similar to those found in all Akha villages. Passing through it, one leaves the menacing and unsafe world of the forest spirits and enters the domain of human beings. The star-shaped straw decorations on the gate prevent any evil spirits from entering the village, and the construction of a new gate every year in April ensures that the village will continue to be protected. Welcome to the animist world of the hill tribes who see spirits in trees, rocks, streams, and even in the hills themselves. The Lahu version of the creation of the earth bears out the importance of the natural world and its spirit inhabitants to the hill tribes:

> The earth was created a little too large and the heaven was a little too small. Strings were attached to the four corners of the earth and were drawn, forming hills and valleys. Rocks and stones were put in. Seeds of trees and plants were sown to make the birds happy and sing for joy. The hills in their beauty sang.

A division of the Tribal Research Institute of the Department of Public Welfare of the Ministry of Labor and Social Welfare of Thailand, the Tribal Museum in Chiang Mai was originally established in 1965 to assemble a range of tribal objects of material culture for study and research and, secondarily, for public education. The visitor is fortunate that such a public education component exists, since this museum provides a compact, succinct, and comprehensible introduction to the rich cultures and practices of the hill tribes of northern Thailand and the Golden Triangle, both for those who plan to trek through the area to visit the tribal villages and those who just plan to shop in the Night Bazaar in Chiang Mai.

The museum was originally shoehorned into a small room at Chiang Mai University with poor lighting and handwritten labels. Having outgrown that space, the museum moved to its new location in Ratchamangkla Park in 1997 and is now able to present the tribal cultures in a more engaging and informative manner. The Tribal Research Institute fills up the entire building, but the second and third floors are devoted to the development work done with the hill tribes by the Thai government, the various NGOs working in Thailand, and the Thai royal family. It is the first floor that is of greatest interest to the visitor.

In Thailand, the term "hill tribe" refers to the minority peoples who live primarily in remote areas of the country and whose languages and ethnic origins differ from those of the majority people, the Thai. The hill tribes have historically been migratory people, and in the past they did not recognize the borders between countries, although this has recently changed. These tribes are relative newcomers to the area of the Golden Triangle. Many of them migrated from southern China and Tibet less than two hundred

An Akha gate, or Lok-kah, greets visitors to the Tribal Museum. Similar gates are found at the entrance to all Akha villages in Southeast Asia. Photo: John McDermott.

The Tribal Museum is housed in a modern building on the outskirts of the city of Chiang Mai. Photo: John McDermott.

The museum utilizes mannequins, in addition to more traditional displays, to convey the feeling of a tribal village in northern Thailand. Photo: John McDermott.

years ago. Since the Yao are the only tribe with a written language, the histories of these groups have been passed down through an oral tradition, making it difficult to pinpoint origins and early migrations. (The Akha claim to have had at one time a written language that was eaten by a dog; this may partially explain the consumption of canines by the Akha on special occasions.) Spoken language does provide clues that indicate origins further north.

It has been the Thai government's stated policy since 1976 to attempt to integrate the hill tribes into the mainstream of life in Thailand. While there has been some progress in this regard, the hill tribes still lack adequate education and access to health care, and their traditional methods of slash-and-burn agriculture (not to mention their opium crops) have hindered a fuller integration. At the same time, the unique cultures and languages of the hill tribes are in very real danger of extinction. Like the Vietnam Museum of Ethnology and its affiliated research facility, the Tribal Research Institute and its museum provide a means of preserving and interpreting the complex cultures of these peoples of the hills.

The Hmong are perhaps the most familiar of these groups to the Western visitor because of the large number of Hmong (or Meo) who settled in the United States after the end of the American involvement in Southeast Asia. In addition to the Hmong, the Tribal Museum exhibits and interprets objects from the other five major hill tribes, the Karen, Lahu, Lisu, Akha, and the Yao (or Mien) as well as many smaller ethnic groups. Of these, the Karen comprise by far the largest group.

The museum's collection consists of practical or functional items such as agricultural tools, household utensils, musical instruments, ceremonial objects, and wicker baskets, and more decorative objects such as jewelry and handicrafts. The objects in the collection are explained in labels and photographs and in the stories passed down through the oral tradition.

Today, the hill tribes create arts and crafts both for themselves and for the growing tourist market. A selection of these crafts is displayed in the museum.
Photo: John McDermott.

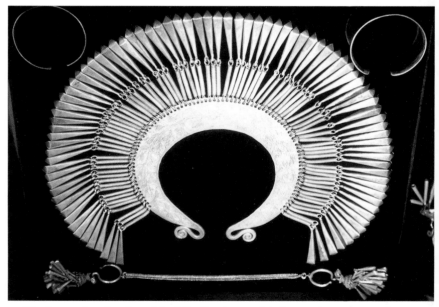

The heavy silver jewelry of the hill tribes is one of their most important art forms.
Photo: John McDermott.

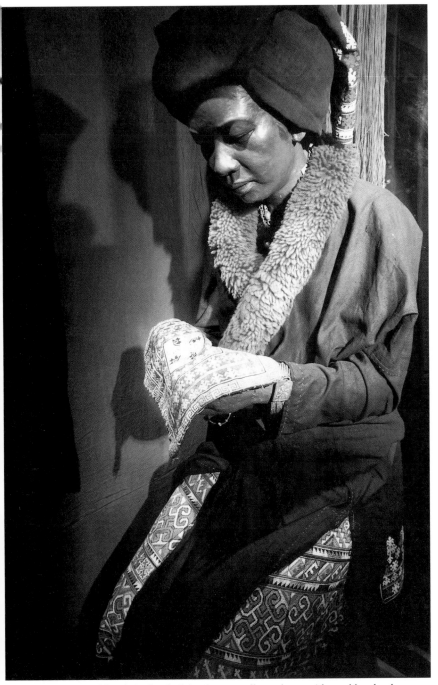

The Yao are noted for their detailed, intricate needlework, as evidenced by the decoration of this woman's traditional costume. Photo: John McDermott.

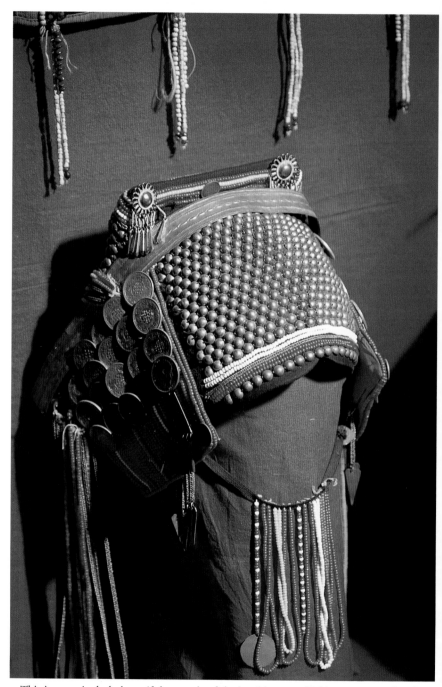

This is a particularly beautiful example of the headdresses of Akha women, still to be seen in their villages today. Photo: John McDermott.

In general, the exhibition space is arranged thematically with specific areas devoted to topics such as villages and housing, the agricultural calendar, fishing, and religious beliefs. While there are similarities among the tribes, each does practice its own form of religion, celebrates its own holidays, and speaks its own language.

Each tribe inhabits a different zone, as well. The Hmong generally prefer to position their villages at a high altitude. The Akha, Lisu, and Lahu are only slightly below them. Karen and Yao settlements tend to be in valleys at a lower altitude.

The colorful costumes of the tribal peoples span the full range of functional and decorative. The tribes have turned clothing into an art form, and the tribal costumes exhibited around the perimeter of the central room are the highlight of the museum. Life-size mannequins display the costumes of the major tribes of northern Thailand.

Clothing style and decoration are one way in which the tribal groups differentiate themselves from others in their own tribe. Clothing also helps to identify social status within the tribe. Sometimes, these sub-groups are named after the tribal dress of the women in the group. The women of the Blue Hmong wear the pleated indigo-dyed skirt with batik design. The women of the White Hmong wear white pleated skirts on ceremonial occasions. The Hmong women excel at needlework and embroider their own clothing, as well as that of their children. Hmong embroidery is characterized by geometric patterns using a wide variety of patterns. Some parts of the garment are left plain, which serves to draw greater attention to the ornament. The Hmong utilize silver extensively in the decoration of their clothing. The attire of the couple seated on a platform in the center of the floor presents two outstanding examples of traditional Hmong dress.

The Karen are noted as master weavers and for their use of seeds as additional decoration. The Yao are known for their intricate embroidery over the entire surface of a garment. The Lahu and Lisu utilize many stripes of brilliantly colored fabric in the creation of their spectacular and quite contemporary looking garments.

But it may be the attire of the Akha women, with their heavy headdresses adorned with silver beads and coins, that has come to best represent the apparel of the hill tribe women. From the top of their silver-encrusted headdresses to the tips of their heavily appliquéd leggings, the Akha women adorn themselves with beads, shells, bright stripes of color, and every imaginable type of geometric and floral design. A tiny Akha woman in a full traditional outfit is an arresting sight indeed.

The hill tribes of Thailand and the Golden Triangle are well served by this small but impressive museum. Whatever the future may hold for them, the fascinating world views and colorful cultural expressions of the hill tribes have found a haven here—one which the visitor is invited to enter and appreciate.

MUSEUM OF CHAM SCULPTURE

INTERSECTION OF TRAN PHU, LE DINH DUONG,
AND BACH DANG STREETS

DANANG

TEL: 051–21951

OPEN: EVERY DAY FROM 7:00 A.M. TO 6:00 P.M.

The world's foremost collection of the sculpture of the ancient Kingdom of Champa, consisting of some 300 pieces of sandstone and terracotta sculpture, is housed in a lovely, airy French colonial building originally constructed from 1915–16 with additions from 1935–36. Under the auspices of the Ecole Française d'Extrême Orient, the French architects, Delaval and Auclair, married the towers and other architectural features of Cham architecture with elements of the colonial style used by the French in Indochina to create one of the most pleasant spaces in the whole of Vietnam. The sculpture is displayed with sensitivity in open-air galleries.

The French were keen about archaeology in Indochina and this museum is one of their chief cultural legacies in Vietnam. They chose the port city of Danang as the locale for the museum since it is near many of the sites that had been excavated up to that point. The museum was formally inaugurated in 1939 and has survived the ravages of Vietnam's many and varied wars in substantially good condition. During the nineteenth century, the legendary French archaeologist Henri Parmentier began to establish the core of the collection that is housed here. Excavations conducted at Tra Kieu, the first capital of the kingdom, and at Thap Mam in the late 1920s and the 1930s added significantly to the collection. The objects in the collection date from the seventh to the fifteenth centuries A.D.

The Kingdom of Champa makes its first recorded appearance early in the first millennium A.D. and originally extended across much of the central part of the land which is now Vietnam. It was primarily an agricultural and seafaring civilization. The Cham cultivated fast-growing rice in their paddies, and their sophisticated maritime culture resulted in their making contact with a number of the contemporary civilizations of Asia. Like the art of many of the other historic kingdoms of Southeast Asia, the art of Champa incorporated elements of Hinduism and Buddhism in its imagery, and it shows the stylistic influences of India, Java, China, and of the art of the Khmer Empire. The Indian influence is dominant and many Cham steles are inscribed in both the Cham and Sanskrit languages.

Cham archaeological sites have suffered greatly from the ravages of war over the centuries. Wars with the Chinese resulted in the sacking of Tra Kieu in the fifth century. The Javanese destroyed the Po Nagar temple in Nha Trang in the eighth century. More recently, the World Heritage Site of My Son, located about 70 kilometers southwest of Danang, suffered significantly during the American involvement in Vietnam in the 1960s and 1970s. Today the scattered remains of Cham towers, symbols of Mount Meru, the sacred mountain of Hinduism, are visible across the landscape of central Vietnam. These brick towers generally consist of a square stupa with a pointed roof surrounded by a moat symbolizing the oceans. The smaller stupas surrounding it fall on the cardinal points. Few of these brick towers retain any of the large blocks

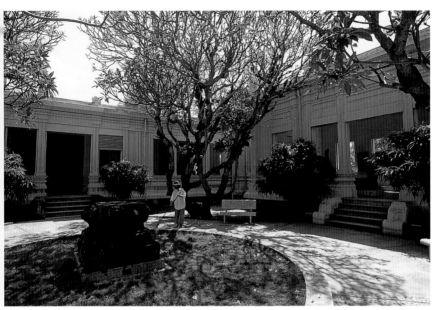

Built in two phases, during the 1910s and the 1930s, the Museum of Cham Sculpture is a successful indoor/outdoor museum with breezy galleries open to the elements.
Photo: John McDermott

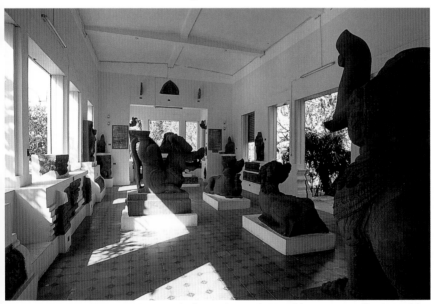

The museum's galleries, with their tile floors, house the world's greatest collection of the art of the Kingdom of Champa. Photo: John McDermott.

of sculpted sandstone that constituted their architectural decoration. Much of what remains from the great Kingdom of Champa is housed in the museum here. The major portion of it is religious art from the towers and temples of the Cham civilization.

The iconography of Cham art seems to have changed little over the centuries. The Cham practiced a polytheistic religion dominated by the image of the goddess Uroja, a word meaning "woman's breast" in the Cham language. She was regarded as the mother goddess and there are numerous images of breasts and nipples in the Cham art preserved in the museum. In addition to the many breasts, the Cham canon included massive solid figures of animals and humans, as well as narrative scenes from Hindu and Buddhist legends.

The earliest capital of the Cham empire, dating to the fourth century A.D., was at Tra Kieu (the Citadel of the Lion), about 40 kilometers southwest of Danang. Little of this site survives, although the number of objects housed at the museum attest to its grandeur. The early Tra Kieu style is characterized by lively, graceful human and animal figures. The Cham excelled in the creation of wonderful animal figures—powerful elephants, amusing cows, and lively lions. The Tra Kieu altar on view here is a masterwork of early Cham art, and features scenes from the wedding story of Sita and Rama, from the *Ramayana*, the Hindu epic. Rama, an *avatar* or human manifestation of Vishnu, arrived at the citadel of King Janaka to win the hand of his adopted daughter, Princess Sita. To do so, he had to lift and string a bow so heavy that it took 5,000 men to carry it. Since Rama strung it with ease (and actually broke the bow in the process), he was permitted to marry the lovely Princess. The altar is the key work from the site.

My Son, originally built as a religious sanctuary in the fourth century, continued to be an active site until the twelfth century. The My Son E1 style from the eighth and ninth centuries marks the point at which Cham art began to break free of the Indian influence that had dominated it and began to develop an exuberant style of its own. The altar from Tower A-1 at My Son, the best example of the style, features scenes of Hindu religious life, rituals, and medical practice framed by lively foliage and frames. (The Ganesha figure at the back of the My Son altar is a copy of the original.)

The My Son gallery is a good place within which to look at the iconography of the Hindu Trinity and their progeny. Brahma the Creator is frequently shown seated on a lotus. Vishnu the Preserver rides Garuda the sacred bird through the air and is accompanied by a Naga or serpent when on land. Shiva the Destroyer and God of Death is usually figured with his mount, Nandi, the sacred bull. In the next generation of Shiva's dynasty, his elder son Ganesha, the cheery, chubby elephant-headed god, was a favorite with Cham sculptors. Ganesha's brother Skanda figures in Hindu mythology as the God of War. The tripartite lingam, or male fertility symbol, displayed here is sacred to all three gods of the trinity. The bottom part is sacred to Brahma, the middle part to Vishnu, and the top to Shiva, symbolizing respectively birth, life, and death.

In the late ninth century, a new royal dynasty emerged and with it a new style, the Dong Duong style, dating to the late ninth and early tenth centuries. It was during this time that Buddhism became the religion of the court of Champa, although the Cham people—as was not uncommon in this region—continued to worship Shiva as well. The altar from the principal shrine at Dong Duong features scenes from the life of Buddha.

Close relations between the courts of Champa and Java in the late tenth century led to a new Javanese influence on the works of this period, referred to as the late Tra Kieu style. The practice of sculpting

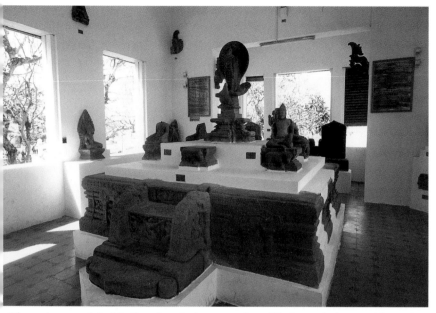

The sculptures of the My Son altar depict scenes from Hindu mythology and from the daily life of the Cham people. Photo: John McDermott.

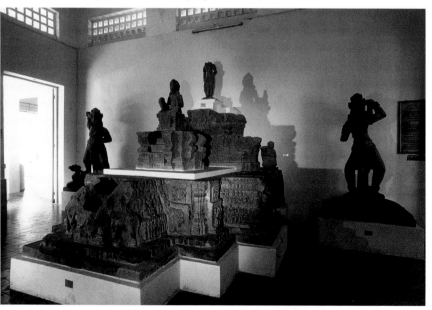

A Dong Duong altar illustrates scenes from the life of the Buddha.
Photo: John McDermott.

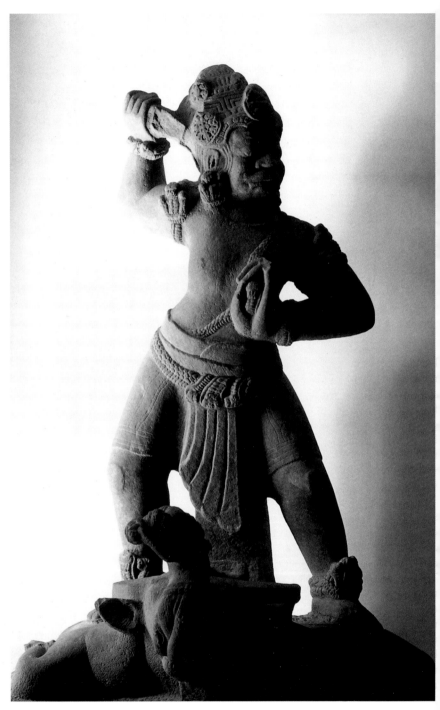

This monumental figure is typical of the sculpture of the Thap Mam style.
Photo: John McDermott.

Priceless objects lie in a sculpture "graveyard" around the back of the museum.
Photo: John McDermott.

arge animal figures was revived. The masterworks of this period are the wonderful *apsaras*, or celestial dancing maidens, born from the churning of the sea of milk in the great Hindu legend of the Creation. Their bodies gracefully carved into geometric forms, the *apsaras* are among the finest works ever created in this part of the world.

After this time, Cham art entered a slow decline characterized by a careful conservatism of patterned decoration and a formalism that began to overshadow the animation and vigor of previous styles. The Chanh Lo style of the eleventh century, and especially the Thap Mam style of the twelfth through the fourteenth centuries, display the influence of art linked to the ascendant Khmer Empire in Cambodia, but it is clear that the creative impetus of the Cham sculptors had peaked and their later art would be less impressive.

Given the variety apparent in the small number of objects in this museum, one is struck by how much must have disappeared. Many of the larger objects were originally part of a pair or group that did not survive. None of the glazed pottery known to have been produced by the Cham and exported to other parts of Southeast Asia has found its way here.

The 100,000 Cham living in Vietnam today are the descendants of the Kingdom of Champa, and constitute one of the 54 ethnic groups represented in the country. They live primarily in the cities and provinces of the southern part of Vietnam. The art of the Vietnamese Cham today consists of more minor creations—copper betel nut boxes decorated with repoussé decoration and elegant basketwork. Their life and culture today form one of the exhibitions at the Vietnam Museum of Ethnology in Hanoi.

VIETNAM HISTORY MUSEUM

1 Pham Ngu Lao Street

Hanoi

Tel: 04–253–518

Open: Friday through Wednesday from 8:15 a.m. to 11:45 a.m.
and from 1:30 p.m. to 5:00 p.m. Closed Thursday.

Along with its sister institution, the Museum of Vietnamese History in Ho Chi Minh City, the Vietnam History Museum in Hanoi displays a wide variety of objects from the long, complicated, and tumultuous history of Vietnam. The building once served as the museum of the Ecole Française d'Extrême-Orient and was built in the 1920s–30s. In 1958, several years after the French withdrawal from the country, the government of France gave the building to the government of Vietnam. Shortly thereafter, it became the Vietnam History Museum. There are some labels in English here, and those objects with only Vietnamese labels are generally comprehensible to the visitor. Included in the galleries are objects ranging from Neolithic tools to a narration of the story of Ho Chi Minh, with displays devoted to the cultures of Dong Son, Funan or Oc-Eo, Champa, and the various Vietnamese dynasties, all arranged more-or-less in chronological order.

The chaotic history of Vietnam spans hundreds of millennia. Because much of this history was defined by the Vietnamese struggle for independence, the physical remains of the past civilizations of the country are not as plentiful as they are in other, less war-torn countries. Still, that which does remain is impressive, and the installations here can serve the visitor as a good general introduction to the history and culture of the country.

In a city noted for its extraordinary wealth of preserved French colonial architecture, the Vietnam History Museum is one of the loveliest examples of the genre.

Indeed, this is one of the most beautiful buildings in Vietnam. The airy entrance rotunda is three stories high and retains a great deal of its elegance. Designed by Emile Hebrande and Charles Batteau together with a team of French architects and Vietnamese assistants, the building is a comfortable blend of Western and Asian architecture.

Many of the objects on exhibit are related to the more recent history of the country. Material pertaining to the pre- and early history of Vietnam is exhibited in the room to the right of the entrance rotunda, along with some objects from the more recent past. The museum's aim is to be comprehensive; in an effort to illustrate the complete history of the country, reproductions of some historic objects are also exhibited.

Archaeological and anthropological undertakings of the past few decades have indicated that hominids may have inhabited northern Vietnam as early as a half a million years ago. Fossils and simple stone tools which date to this time are exhibited here next to a wealth of material from the Dong Son culture.

The Dong Son culture, an advanced Bronze Age civilization that emerged between the sixth and third centuries B.C., and reached its height in the first centuries B.C. and A.D., left a wide variety of objects in bronze. The culture is named for the small town south of Hanoi where the early excavations were concentrated. Dong Son drums with their geometric decorations are the most widely spread relic of the civilization, and more have been found in

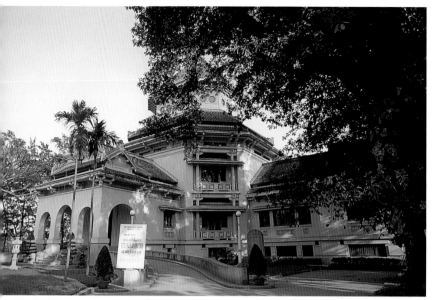

The building now housing the Vietnam History Museum was originally built by the Ecole Française d'Extrême-Orient in the 1930s. Photo: John McDermott.

Vietnam than in any other place. These drums, influenced by Chinese bronze work, are covered with patterning and with naturalistic figures, including frogs. This use of frogs as decoration has led some scholars to believe that the drums were used to call for rain, hence Dong Son drums are occasionally called "rain drums." The drums are large—occasionally three feet in height—and their makers were clearly metalworkers of high achievement. These drums are often considered the first true works of Southeast Asian art.

In addition, urns and jars, spears, knives, and other small weapons are displayed here as well, as are artifacts—early pots and bronzes—from the first through the eighth centuries, and stone, terra-cotta, and bronze ornamental sculpture dating from the twelfth to the fifteenth centuries. There is also a collection of celadon bowls from the twelfth and thirteenth centuries.

There are two main exhibition galleries in the museum. The hall on the ground floor interprets the early history of Vietnam. The upper floor features a selection of sculpture from the Kingdom of Champa, and more recent objects and documents.

A diorama of the Bac Son cave and relics from the Bac Son culture, as well as from other early civilizations are on display here. The Bac Son culture was prominent during the period from about 5000 to 3000 B.C. and the cave featured here is one of the most important sites in the country where there is evidence of early civilization. Remains—in particular jewelry—of the Sa Huynh culture from central Vietnam, as well as bronze objects from other civilizations, are featured in this section of the museum.

Copies of important objects, notably important stele, are exhibited here. In addition, there are a number of dioramas devoted to the various important battles that transpired on the long road to Vietnamese independence. Of particular interest on the non-battle front is the diorama of the Hung Kings' temples, a complex of remains about 60 miles northwest of Hanoi (and worth a visit). These temples have come to be regarded as the birthplace of the Vietnamese people.

163

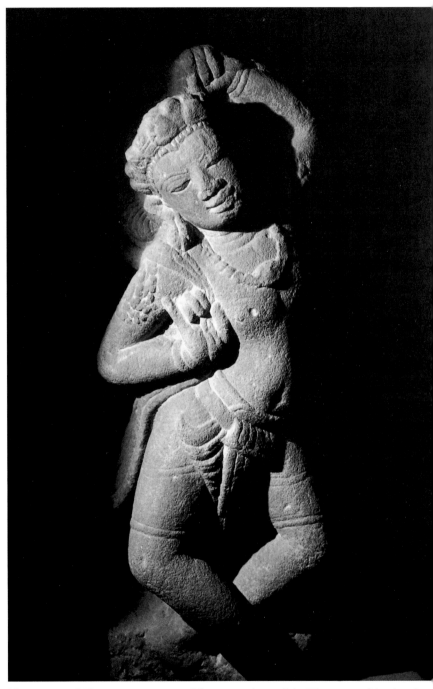

The *apsaras* of Cham art are not as well known as those of the Khmer art of Angkor, but many examples, including this one, are quite lovely. Photo: John McDermott.

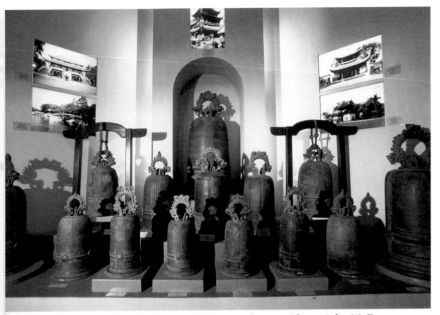

These bronze temple bells date to the Nguyen dynasty. Photo: John McDermott.

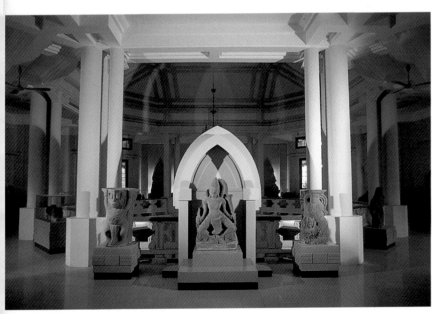

The museum's collections of the sculpture of the Kingdom of Champa are arranged around the second floor of the rotunda. Photo: John McDermott.

Furniture, thrones, and trunks dating to the Nguyen dynasty were lacquered in gold and silver. Photo: John McDermott.

The balcony around the rotunda on the second floor exhibits Cham sculpture and photographs of various archaeological sites and important buildings throughout the country. The exhibition hall itself features pieces of architectural sculpture and a number of ceramic objects from the thirteenth and fourteenth centuries. A copy of a fifteenth-century stele from Hanoi is one of the most interesting objects in the gallery, despite the fact that it is a copy. The Temple of Literature (Van Mieu) in Hanoi, founded in the late eleventh century by Emperor Ly Thanh Tong, an emperor venerated for his learning and charity, was the first university in the country. In the late fifteenth century under Emperor Le Thanh Tong, one of Vietnam's greatest emperors and a great legal, social, and military innovator, steles such as the one copied here began to be erected in the Temple of Literature to commemorate the accomplishments of those who had earned doctorates at the university. This practice continued until the early nineteenth century when the university was moved to Hue. (Gia Long, the same emperor who moved the university, also replaced Le Thanh Tong's legal innovations, called the Hong Duc Code, with his own code.) In addition to this copy, there is an interesting original stele from Vinh Lang in Than Hoa province, dating to 1433.

Another display consists of a collection of documents written in Chinese characters in the eighteenth century before the wide acceptance of *quoc ngu*, the romanized script now in virtually universal usage throughout the country (introduced in the seventeenth century by Alexandre de Rhodes, a French Jesuit). Ceramics from around the country, including some from Bat Trang, a village on the Red River near Hanoi, which became an important center for ceramic production, are also displayed. Examples of Bat Trang ceramics are found in many Vietnamese museums, but the selection here is one of the best. A number of early books are part of the collection here as well.

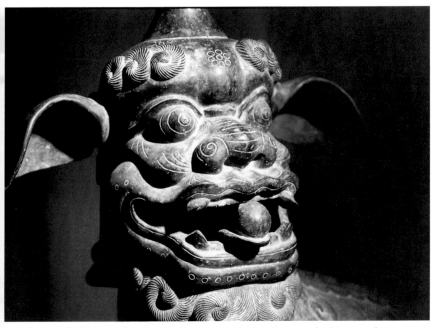

This comical bronze lion head is from a temple that dates to the Nguyen dynasty.
Photo: John McDermott.

Information about the great past leaders of Vietnam and the requisite room devoted to the life and career of Ho Chi Minh are included here. In truth, various museums devoted to the life and times of Ho Chi Minh and the long Vietnamese revolution cover these subjects in greater detail, but the display here will provide a satisfactory introduction for most visitors.

At this writing, the Vietnam History Museum is undergoing a large-scale renovation that may result in some change to some of the galleries described above. The museum will continue to be organized chronologically and will feature galleries devoted to the Neolithic and Bronze Ages, the Dong Son period, the first millennium B.C., the early dynasties (Dinh, early Le, Ly, Tran, Le, Mac, and Tay Son periods), the Nguyen dynasty, and the twentieth-century history of the country, with special attention to its early intellectual leaders. The museum already constitutes an excellent introduction to the history and culture of Vietnam. With these changes, it promises to become even better.

HOA LO PRISON MUSEUM (MAISON CENTRALE)

1 HOA LO STREET

HANOI

TEL: 04-934-2253

OPEN: TUESDAY THROUGH SUNDAY FROM 8:00 A.M. TO 11:00 A.M.
AND FROM 1:00 P.M. TO 4:00 P.M. CLOSED MONDAY.

The French originally built the infamous Maison Centrale as a prison in the late nineteenth century to incarcerate Vietnamese common criminals. It was once one of the largest and most visible structures in central Hanoi. It was also one of the most feared.

During the latter part of the French colonial period, the tall walls of the prison increasingly closed around political prisoners and Vietnamese freedom fighters, becoming a veritable breeding ground for Vietnamese nationalism during the period from the 1930s through the early 1950s. In an attempt to stem this rising tide of nationalism and revolutionary ardor, at one time or another, the French incarcerated many of those who would go on to play important roles in the twentieth-century history of the country.

The list of the Vietnamese who were held at the Maison Centrale reads like a "Who's Who" of the Vietnamese liberation movement. Le Duan, the Vietnamese revolutionary who was secretary-general of the Communist Party, and who became the most powerful figure in North Vietnam after the death of Ho Chi Minh in 1969, was a prisoner here from 1931 to 1932. (There is a Le Duan Street in virtually every major city in Vietnam.) Truong Chinh, one of the founders of the Indo-Chinese Communist Party was there at the same time. During the 1930s, the French incarcerated thousands of Vietnamese political activists and freedom fighters. Rather than dimming their revolutionary fervor, however imprisonment only stoked the fires. The prisoners held political gatherings and even published their own Communist periodical, which was circulated secretly. A prescient French police report of 1933 stated that, "far from reforming the political prisoners, the detention seems to exalt their revolutionary spirit and every one of them makes the best use of his time in prison to refine his own education or to educate the other prisoners. We ought to dread the months to come, since the new Communist organization will be stronger and better tested."

Just before the French defeat in 1954 at the hands of the Vietnamese at Dien Bien Phu near the Vietnamese border with Laos, records indicate that 2,000 prisoners were housed in a space originally built for 450. These prisoners were set free after the Battle of Dien Bien Phu. Many of them became important officials in the fledgling government of North Vietnam.

In 1964, the building began to be used to house prisoners of a different background. Hoa Lo (or Hell's Hole) Prison is better known to Americans of a certain age as the Hanoi Hilton. Over the course of the next ten years until the last prisoner was freed in 1973, Hoa Lo housed 100 American prisoners of war, primarily downed fighter pilots. The first American to be captured by the North Vietnamese was Everett Alvarez, on August 5, 1964. The list of American inmates of Hoa Lo is a distinguished one as well and includes the current United States ambassador to Vietnam, Pete Peterson, captured on September 10, 1966, and Senator John

The Hoa Lo Prison, built as Maison Centrale, and more recently known as the Hanoi Hilton, was razed in the 1990s to make way for an office tower. One corner of the prison was preserved as a museum. Photo: John McDermott.

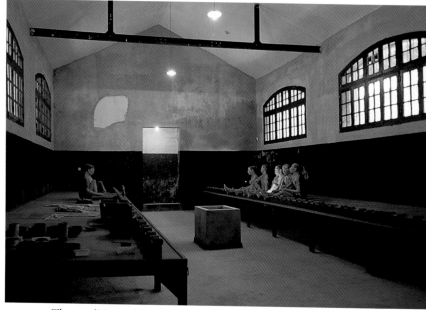

The conditions of imprisonment have been graphically reconstructed.
Photo: John McDermott.

McCain, captured on October 26, 1967.

The reunification of Vietnam in 1975 and the gradual emergence of Hanoi over the past two decades as an international capital signaled the end of Hoa Lo Prison. There was no longer a need for a major prison in the center of the city and, practically speaking, real estate was too valuable to be wasted in this way. In 1993, the notorious Maison Centrale was closed, and shortly thereafter, most of the complex was razed to make way for an imposing new office building that is both in keeping with Hanoi's new image as a capital city and completely antithetical to the architecture of the remainder of the neighborhood. The portion of the prison that constitutes the Hoa Lo Prison Museum is all that remains.

Primarily devoted to displays about Maison Centrale during the French colonial period and to the role of the prison in the growth of the Vietnamese liberation movement, the museum is small, but provides a simple and excellent introduction to these topics. Most of the labels are in

Vietnamese, but the meaning of the displays is quite clear, and the interest here lies as much in the sense of place as in the contents of the building.

The aerial photographs and the large model in the first two rooms give an impression of the massive scale and original layout of the prison. The pottery and bowls used by the prisoners and on display here are quite affecting. Salvaged portions of the architecture, including bricks, doors, and grates, give a sense of the solidity of the original structure.

The preserved cells are grim, dark, claustrophobic spaces intended to dehumanize and destroy the will of the prisoners. The housing for condemned women prisoners makes it clear that the French didn't spare them either. Even women with children were forced to live in bleak cells with no amenities. Leg irons were often locked from outside the cell walls; prisoners were not even afforded a view of the locks that held them motionless. Realistic mannequins lend an air of authenticity to the installations.

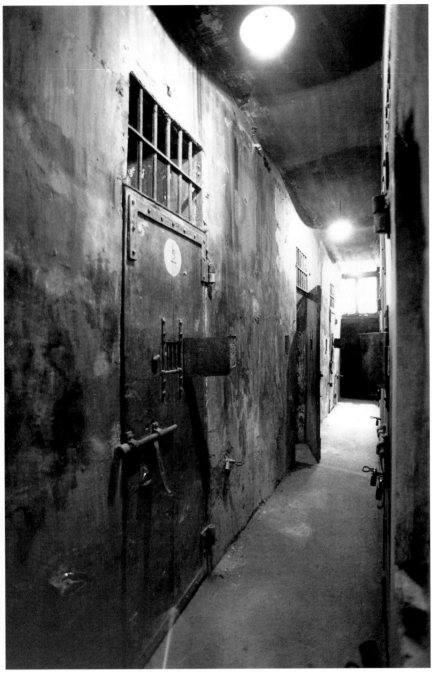

Built by the French to house Vietnamese prisoners, cells like these housed American prisoners of war in the 1960s and 1970s. Photo: John McDermott.

Shackles such as these held prisoners immobile. Photo: John McDermott.

In 1945 and again in 1951, some Vietnamese escaped by crawling through sewer pipes, now on view in the museum. Like the tunnels at Cu Chi outside Ho Chi Minh City, these pipes seem impossibly small, and it is difficult for a Westerner to imagine crawling for long distances through one of them.

One room is devoted to American prisoners of war. Photographs of John McCain, Pete Peterson, and Everett Alvarez are prominently displayed. All the American prisoners of war were returned to the United States on January 27, 1973.

The most chilling object remaining in the museum is a guillotine, complete with two wicker baskets to hold the two separated body parts. Used to execute Vietnamese resistance leaders, this symbol of the French Revolution became a means of keeping the insurgent leaders under control in colonial Indochina. It has a menacing air and looks ready for use if the order were given.

The upstairs galleries with their requisite rows of photographs and documents are a testament to the history of both the prison and the French colonial rule in Vietnam. The French papers, labeled "confidential notes," are an unwitting documentation of the decline of French rule in Indochina.

By their very nature, prisons are dark and depressing places. Moreover, Hoa Lo, with its historical immediacy, is admittedly more familiar and more chilling than numerous ancient examples. But that recent history is real and it is worth sober consideration. It is notable that the Vietnamese have seen fit to save a corner of this fabled building by turning it into a museum.

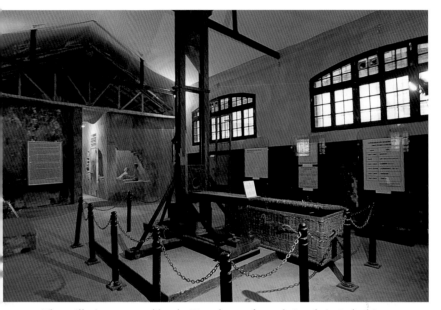

The guillotine was used by the French to enforce their rule in Indochina.
Photo: John McDermott.

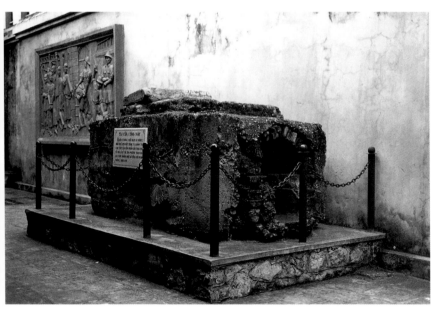

Vietnamese prisoners crawled through narrow, seemingly impassable sewers in both
1945 and 1951 to escape from the prison. Photo: John McDermott.

VIETNAM MUSEUM OF ETHNOLOGY

NGUYEN VAN HUYEN ROAD

CAO GIAY DISTRICT, HANOI

TEL: 04–756–2193

OPEN: TUESDAY THROUGH SUNDAY FROM 8:30 A.M. TO 5:30 P.M.
CLOSED MONDAY AND DURING THE TET (LUNAR NEW YEAR) HOLIDAY,
USUALLY IN LATE JANUARY OR EARLY FEBRUARY.

Housed in a modern building west of the central part of Hanoi, the Vietnam Museum of Ethnology opened in early 1997. It is a splendid addition to the body of museums in Hanoi. The museum was designed with the assistance of staff from the Musée de l'Homme in Paris and exists to "present the lives of Vietnam's 54 minorities, their artifacts, dress, and music." As a division of the National Centre for Social Sciences and the Humanities, the facility serves as a research and training center for ethnographers and conservators, as well as a first-rate introduction to the incredible cultural diversity of Vietnam. Some 25,000 objects are housed in the 2,500 square meter semi-circular two-story building. Viet and Muong cultures are presented on the ground floor, and the other minority cultures on the upper floor.

The museum utilizes a full range of media in its interpretive materials, which are, generally, presented in Vietnamese, French, and English. Excellent wall maps illustrate the range of ethnic habitation. Vivid dioramas of scenes ranging from village markets and shamanistic ceremonies to conical hat production illustrate the daily life of these peoples, which has preserved a high degree of cultural integrity over time. However, the past half-century has brought massive modernization and upheaval to all the people of Vietnam, and the minority peoples have been no exception. Advances in science, health, and agriculture, and the drive toward a market economy have affected all the Vietnamese,

both majority and minority, and, therefore, the museum does not present the culture of these groups as being static. Videos of contemporary life in the villages place the traditions within current modern contexts. A room with a map, a timeline, and a chart explaining the various groups serves as an introduction to the museum.

The Viet (or Kinh) people are the dominant ethnic group in the country, living primarily in cities, river deltas, and on the coasts. They comprise 87% of the current population of Vietnam. The most common elements of their material culture are covered in detail in the exhibits. Lacquerware, found as early as the fourth century B.C. near Haiphong, a northern coastal city, is a traditional art form of the Viet people. Wood carving, pottery, bronze work, and the traditional Dong Ho woodblock prints made for Tet, the explosive and exuberant Vietnamese Lunar New Year celebration, are all featured.

The art of water puppetry is perhaps the most enduring—and endearing—aspect of the popular culture of the northern Viet people, and the large display here is a testament to its close association with popular culture. Water puppetry is over 1,000 years old and evolved from a popular art form that was staged in flooded fields of the Red River Valley to a court entertainment. Most of these puppets were made from fig tree wood. During a performance, the puppeteers stand behind a screen in a pool of water and manipulate the puppets by means of long poles. Stories tend to have either rural or

This well-lit gallery is devoted to popular objects from Viet culture, including water puppets, musical instruments, and religious objects. Photo: John McDermott.

Bicycles are used to transport everything—including these elegant (and practical) fish traps. Photo: John McDermott.

A delightful Spirit of the Earth water puppet with a chubby face and belly grins at the visitor impishly. Photo: John McDermott.

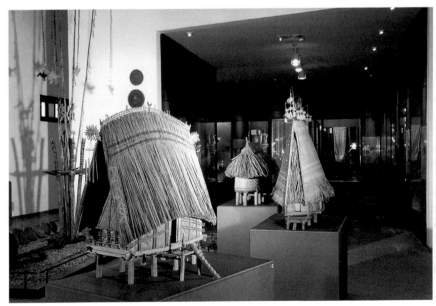

Shown here are models of rapidly disappearing traditional houses from the central highlands of Vietnam. Photo: John McDermott.

mythological themes, and the puppet figures range from representations of villagers and their water buffalo to the mythical creatures that populate the legends in this part of the world. The art of water puppetry is currently undergoing a revival. (Water puppet performances can be seen in Hanoi at the Municipal Water Puppet Theatre at 57B Pho Dinh Tien Hoang, on the shore of Hoan Kiem Lake, or at the Museum of Vietnamese History in Ho Chi Minh City.)

A detailed reproduction of a *len dong*, or spirit possession ceremony, is another highlight of this section.

The minority cultures of the country survive primarily in the mountainous north and in the central highlands. These groups include the peoples from the broad language families of Thai-Kadai, Hmong-Yao, Sino-Tibetan, Mon-Khmer, Austro-Asiatic, and Austronesian. The population of some of these minority groups, such as the Hoa (or Chinese) and the Khmer, number almost a million. Others such as the Chut, a group of hunter/gatherers, number only a few thousand.

Some of these groups have lived in Vietnam for more than two millennia; others are relatively recent arrivals. The Cham, currently numbering only about 100,000, founded one of the original civilizations of Vietnam, the brilliant Champa culture of the first and early second millennium A.D. The culture of the Khmer, now about 900,000 and residing primarily in the Mekong Delta in the southern part of the country, is derived from the Oc-Eo or Funan culture, the other great civilization of first millennium Vietnam.

The diversity of cultures represented here is astonishing. Most of these minority peoples live in agricultural societies. Some practice sophisticated cultivation techniques with irrigation and ploughs and others practice swidden agriculture, cutting and burning hillsides and moving on when the land is worn out. Some have written languages; in other groups, a system of written language never developed. Religions range from animism and ancestor worship to the complex blend of Theravada Buddhism, Brahmanism, and folk culture practiced by the Khmer.

However, despite the variety of their economic practices and religious beliefs, these minority peoples have developed similar—though clearly distinct—material cultures. Textiles, baskets, pottery, jewelry, and wood carving are traditional arts in many of these groups.

Textiles, particularly in the form of the distinctive costumes worn by the women, are a highlight of the museum's collection. In most cases, these costumes begin with basic black cotton cloth to which is added lavish detailing in silver, and brightly colored embroidery and appliqué. Each ethnic group has its own well-defined styling and patterning, and subdivisions of the tribal groups are frequently identified by the color of clothing worn by their women.

The Lahu, a Tibeto-Burmese people found in the far northwest of the country, utilize many strips of brightly colored fabrics, primarily greens, yellows, and reds, to create multicolored striped sleeves and detailing on their garments. Other groups use patchwork squares of brightly colored fabric as well as shells, plastic and lead beads, and silver money as decorative elements on their clothing. Hmong textiles are celebrated for their heavy, intricate embroidery.

Hmong and Yao textiles also utilize the technique of batik. In a resist-dyeing technique, wax is applied to the fabric before it is dipped into vats of indigo, where the cloth is dyed a deep blue. The cloth is then boiled, melting the wax and leaving the designs in the original color of the fabric.

Baskets of bamboo, rattan, and bark are a traditional art form of these ethnic groups, as well. Originally utilitarian objects created to gather, cook, and serve rice and to carry things and children, these

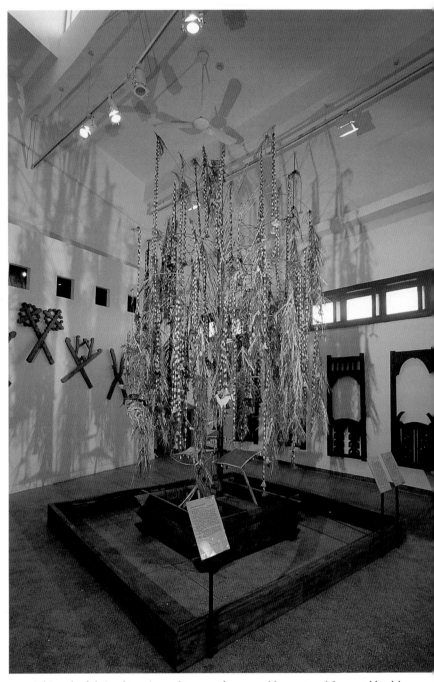

This colorful ritual tree is used to pray for a good harvest and for good health.
Photo: John McDermott.

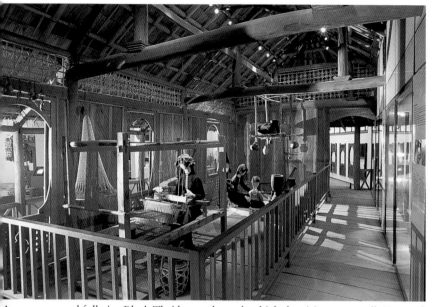

A reconstructed full-size Black Thai house through which the visitor may walk is one of the highlights of the museum. Photo: John McDermott.

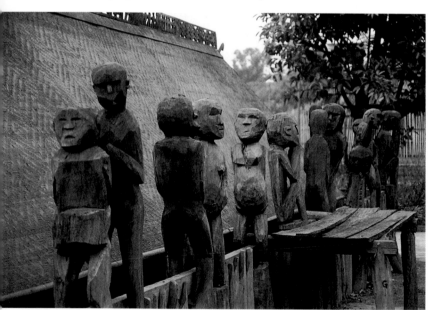

Some of the exhibits at the Vietnam Museum of Ethnology are outside on the grounds. These examples of fertility figures are shown in conjunction with a Gia Rai tomb. Photo: John McDermott.

woven baskets evolved into beautiful objects that are featured prominently in the museum.

Children under the age of 16 make up 44% of the population of Vietnam, and the displays devoted to children's festivals and everyday lives are both charming and informative.

A highlight of the museum is the traditional Black Thai house from northern Vietnam that has been reconstructed in the museum. The houses of the Thai people use a column-and-beam structure and those of the Black Thai have a curved roof, much like the shape of the shell of a turtle. There must be an odd number of rooms and stairs in the house, in all cases three or more.

Outside, a collection of structures representative of the minority peoples is installed. An open-air museum of houses from various ethnic groups is planned for the grounds behind the current building, which should add even more to the overall value and attraction of this museum.

NATIONAL ARMY MUSEUM

28A DIEN BIEN PHU STREET
HANOI

TEL: 04–823–4264

OPEN: TUESDAY THROUGH SUNDAY FROM 8:00 A.M. TO 11:30 A.M.,
AND FROM 1:30 P.M. TO 4:30 P.M. CLOSED MONDAY.

It is often said that history is written by the victors. Nowhere in Southeast Asia is this more apparent than at the National Army Museum in Hanoi. Beginning with the Battle of Bach Dang in 938 and ending with the Liberation of the South (the event better known to Americans as the Fall of Saigon) in 1975, the museum presents a distinctly one-sided interpretation of the long struggle of the Vietnamese for independence.

The museum opened on the fifteenth anniversary of the founding of the People's Army on December 22, 1959. Originally constructed by the French as a military barracks, the structure is another of the lovely French colonial buildings that contribute to making sections of Hanoi rank among the most beautiful cities in the world. The two-story white building with its graceful arcades was renovated to accommodate the collections of the museum, which are arranged on two floors of several buildings in the compound, as well as in a central courtyard. Although similar material is presented in other museums around Vietnam, it is arranged here in a more coherent and comprehensible fashion. The visitor can learn a great deal here about the history of the Vietnamese army and its important role in the modern history of the country.

Outside the entrance, in the front courtyard of the museum, are examples of both Chinese and Soviet tanks and weapons supplied to the North Vietnamese during the twentieth-century conflicts, and examples of American and French weapons captured by the Vietnamese. Among the most interesting of these are a MIG 21, alleged to have shot down 14 U.S. planes in the late 1960s, and artillery used against the French in the Battle of Dien Bien Phu in 1954. There is also a tank used in both the war against the Americans and in 1979 in Cambodia when, as a result of border skirmishes, the Vietnamese invaded Cambodia again (having occupied Cambodia in the early 1960s), thereby initiating the eventual downfall of the murderous Pol Pot regime.

While the emphasis of the installation is on the wars with the French and the Americans, the historical story begins almost a millennium before the struggle with the French began. As is requisite with this type of museum, the first room is a shrine to Ho Chi Minh, the father of the modern country. There are also two rooms to the right of the entrance dedicated to the "Heroic Vietnamese Mothers," a title given to women who lost many children in the struggle for independence. One woman cited here lost nine sons, a daughter-in-law, and a grand-daughter in the conflict.

The historical galleries begin to the left of the entrance with a room devoted to background for the twentieth-century wars, illustrating the on-going struggles of the Vietnamese for independence. A diorama of the Battle of Bach Dang in 938, at which the Vietnamese defeated the Chinese to end a millennium of Chinese hegemony over Vietnam is of particular

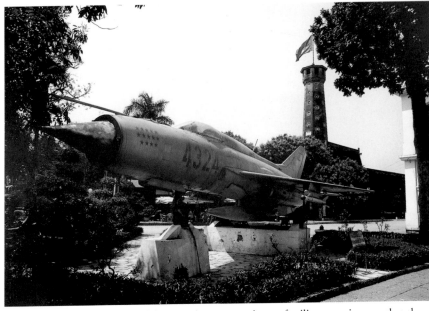

The MIG fighter was one of the most important pieces of military equipment that the Vietnamese had at their disposal during their war with the Americans. Photo: John McDermott.

The galleries are arranged chronologically and exhibit objects, dioramas, and photographs related to the history of the Vietnamese army. Photo: John McDermott.

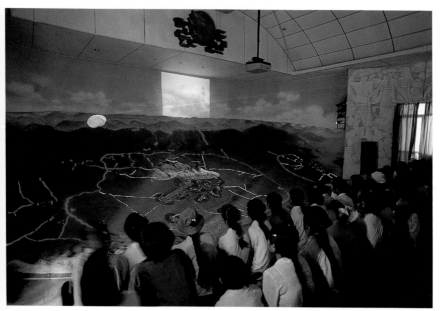

One of the highlights of a visit to the museum is this diorama with a re-enactment of the Battle of Dien Bien Phu in 1954 explained through the use of differently colored lights. The presentation is absorbing, despite the fact that it is all in Vietnamese. Photo: John McDermott.

interest. The next eight hundred years saw a series of further battles. Maps of these battle sites are displayed here, along with weapons and some artifacts from the period.

From here, one proceeds to the galleries where the twentieth-century history of the army begins. Most of the exhibits consist of photographs, newspaper articles, and artifacts from the period. A map showing how the revolution spread through the country in 1945 and a display of the musical instruments used by the Vietnamese army on their declared Independence Day, September 2, 1945, illustrate the beginning of the final struggle for independence. The guns, teapots, and other field items used by the cadres allied with Ho Chi Minh in these early days are of particular note here.

In the sections devoted to the war with the French, there are numerous photographs of Ho Chi Minh—on the front, touring an ordnance workshop, and visit-

ing with his followers. There is an astonishing photograph of the inhabitants of Bui Thi Street in Hanoi piling their furniture in the street in order to impede the progress of the French forces. The primitive field equipment, and the wicked-looking guns and bombs illustrate the conditions under which all the combatants in these wars fought.

The French left Vietnam after their defeat at the Battle of Dien Bien Phu in 1954, and the surrender there of some 10,000 French troops. A great deal of space is allocated to the story of this battle. Between their difficult-to-defend position in a valley in the northwest part of the country, very close to the border with Laos, and the brilliant strategy of General Giap (further complicated by weather that aided the Vietnamese), the French were doomed. The collection features artifacts from the battle, including dented French helmets and pieces of French planes, as well as a devastating photograph of the

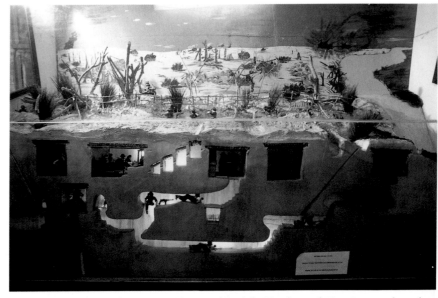

The tunnels at Cu Chi, just outside Ho Chi Minh City, housed Viet Cong and south Vietnamese resistance fighters during the war. Photo: John McDermott.

battlefield after it had been overrun by the Vietnamese. Another photograph depicts the visit of former French President Mitterrand to the battle site, and the installation alludes to the suffering of both the Vietnamese and the French. A room-sized diorama of the battle, complete with lights that illustrate the various sorties and moves of the Vietnamese, is a highlight of the museum (especially to schoolchildren who visit and watch, spellbound). Be aware, however, that the narration is only in Vietnamese, although it is not difficult to understand what is going on.

The back courtyard is filled with the wreckage of both American and French planes shot down by the Vietnamese.

The modern building in the back is devoted to the later years of the Vietnamese conflict and contains exhibits related to the American involvement in Vietnam. Photographs ranging from documentation of the Tet Offensive in 1968 to American and European anti-war protests in the late 1960s and early 1970s cover the walls. The frequently displayed photographs of the American flag being rolled

up at the United States Embassy in preparation for the departure of the Americans, and the famous photographs of the last helicopters taking off from a rooftop in Saigon are displayed here. Several American flight suits, helmets, and pairs of boots from downed fliers are displayed, as is one of the first tanks to crash through the gates of the Presidential Palace in Saigon in 1975. Photographs of the liberation of various cities—Hue, Dalat, and Saigon—in the former South Vietnam are the cornerstone of the displays covering the Spring 1975 offensive and the final reunification of the country.

With galleries labeled "Defeating French Colonials Strategy: Striking Fast and Winning Fast 1945–1947," "Striving Hard to Develop Forces and Gain the Initiative on the Battlefield 1948–1950," and, finally, "Total Victory," it is obvious that an unbiased interpretation of the events of those years is not the mission of this museum. However, given the determination of the Vietnamese during the period from 1945 to 1975 in pursuit of unification and independence, it is understandable

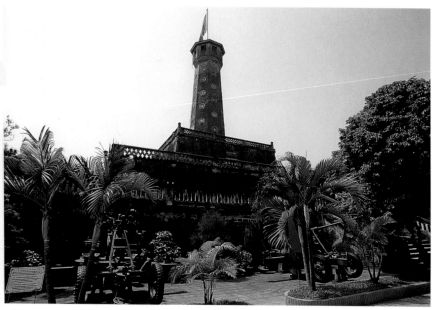

The summit of the Hanoi Flag Tower, on the grounds of the museum, offers outstanding views of the city of Hanoi. Photo: John McDermott.

that they would offer their interpretation of events. In time, the presentation may well become more even-handed and less doctrinaire. Meanwhile, the visitor can learn much about the Vietnamese version of a portion of twentieth-century history and about the Vietnamese themselves through the installations of this museum.

The Cot Co (also known as the Hanoi) Flag Tower is located on the museum's grounds. Built between 1805 and 1812 and one of the few buildings of the Nguyen period to survive the French colonial period, this 100-foot tower is one of the symbols of the city of Hanoi. The six-sided tower was used by French troops for observation and also as a relay station for communications between headquarters and outlying military posts. The tower itself sits atop three rectangular tiers. On the middle tier are several doors. The one on the eastern side is inscribed *Nghenh Huc* ("welcome dawn's sunlight"). The western door is inscribed *Hoi Quang* ("light reflection"), and the southern door *Huong Minh* ("directed at the sunlight"). There is no inscription on the northern door. The short climb to the octagonal "cap" of the tower is well worth the effort (it is only 54 steps) as it affords an excellent view of the rapidly evolving skyline of the city of Hanoi.

VIETNAM FINE ARTS MUSEUM

66 Nguyen Thai Hoc Street
Ba Dinh District, Hanoi

Tel: 04–822–3084, 04–851–3290

Open: Tuesday through Sunday from 8:00 a.m. to 12:00 noon
and from 1:00 p.m. to 4:00 p.m. Closed Monday.

Since its doors were opened to the public in June of 1966, the collections of the Vietnam Fine Arts Museum have offered a comprehensive survey of the art of Vietnam from the elaborately incised drums of the Dong Son culture of the early centuries B.C. to the work of contemporary Vietnamese artists. The building is another of the charming colonial constructions by the French in Indochina. Built in 1937 as a residence house for the daughters of the colonial rulers of Indochina, the graceful three-story building features large open windows with wooden shutters, typical French tile floors, and a lush tropical garden in the front. The interior circular staircase is a brilliant and elegant piece of architectural detail. (The Asian-style eaves on the façade of the building were added when the building was converted into a museum.) The building, which was also pressed into service by the Indochinese Ministry of Information at one point, has been well adapted for its current use.

The museum aims to "collect, preserve and present the most representative objects, the cream of each artistic period" (Cao Trong Thiem, Director of the Vietnam Fine Arts Museum, *The Vietnam Fine Arts Museum* Hanoi, 1999). While the emphasis of the collections and installations is upon the emerging modern and contemporary art movements in Vietnam, there are excellent representative examples of ancient and folk art and pieces from the Kingdom of Champa, in addition to a selection of objects from the Vietnamese dynasties. Pre-twentieth-century art is dis-

played on the first floor, folk art on the second floor, and modern and contemporary painting and sculpture on the third floor. (Those with a low tolerance for socialist realism, exemplified by the prominently displayed painting entitled, *When the Shift Is Over, Let's Join the Best Women Worker's Contest*, may prefer to spend the major portion of their time on the lower floors.) The collections are occasionally re-arranged. Specific objects mentioned here may not be on view at all times, although a representative sample of objects from each of these periods is likely to be exhibited.

The visual arts have a long history in Vietnam, even if compared with the arts of Cambodia and Thailand they are not as well known. Architecture, sculpture, ceramics, inlay, and painting with lacquer all have a place in this tradition. The first floor provides a survey of the fine art of Vietnam up to the twentieth century. In the first room, several Dong Son drums depicting scenes from the everyday lives of the Dong Son people are displayed. There are also a number of rubbings of the motifs found on others, and many large bronze jars from the fifth and fourth centuries B.C. are also exhibited in the first room. The brilliant Dong Son civilization was not closed to the rest of the world and the art of this first great culture of Southeast Asia exhibits evidence of cultural exchange with both China and other parts of Southeast Asia. Unfortunately, the Dong Son culture had little influence on the later art of Vietnam, even though its remains are plentiful throughout the country.

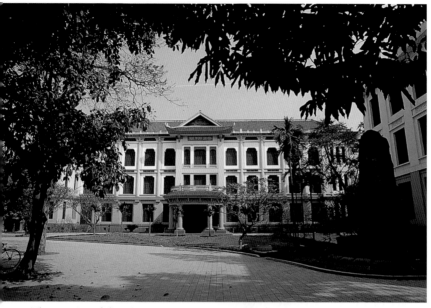

The exterior of the Vietnam Fine Arts Museum, dating to 1937, presents one of the most beautiful façades in Hanoi. The Asian-style eaves over the entrance portico were added later. Photo: John McDermott.

The next three rooms are devoted to the arts of Vietnam from the eleventh through the nineteenth centuries, the time of the Ly Dynasty through the Nguyen period. Vietnamese art reached its peak during the early part of this period, although the later works are of great interest as well. Special attention is paid here to early stone sculpture found near Hanoi, and there are a number of good and expertly carved wood-relief sculptures, including the seventeenth century doors from a pagoda in Thai Binh Province. Despite the fact that there are some paintings on silk exhibited here, fabric—in general—did not survive well in Vietnam's heat and humidity.

The art of the Ly dynasty (eleventh and twelfth centuries) displays a tendency toward decorative patterning and was more refined than the art of previous periods. There was some interaction with the contemporary Cham civilization, and most of the surviving Ly dynasty objects exhibited here are stone sculpture or ceramic. During the Tran dynasty (thirteenth and fourteenth centuries), the artistic tradition was still intertwined with the then-waning Cham civilization. The collection includes a number of wonderful animal sculptures, as well as a set of carved wooden doors with lively dragons. The galleries devoted to the art of the early Le and Mac dynasties (fifteenth and sixteenth centuries) offers a number of animal carvings and an enormous stone stele. The galleries devoted to the art of the later Le and Tay Son dynasties (seventeenth and eighteenth centuries) are dominated by an overwhelming Bodhisattva of lacquered wood, with one thousand eyes and one thousand arms, dating to 1656. Lacquered-wood sculpture from this period, including both emaciated and chubby figures of the Buddha, is of particular interest. While much of what remains from the Nguyen dynasties is to be found in the Museum of Royal Fine Arts in Hue, some objects are on view here, as well.

A number of the most interesting

An extraordinarily elegant and serene stone Buddha, this figure dates to the
eleventh century. Photo: John McDermott.

This example of a Bodhisattva with many arms dates to the sixteenth century.
Photo: John McDermott.

This lively and charming Dong Ho woodblock print is entitled *Jealous Wives*.
Photo: John McDermott.

Popular Hang Trong prints, such as this example entitled *Five Tigers*, are created at Tet every year and frequently figure religious themes. Photo: John McDermott.

galleries in the museum are on the first floor where the charming traditional folk art of Vietnam is exhibited. Dong Ho paintings, mass produced during Tet, the Vietnamese Lunar New Year, frequently portray the themes of labor and ordinary village life, games, celebrations, and the requisite exploits of national heroes. The emphasis is almost always on the figure. Scenes of children in trees plucking

coconuts, and of villagers in traditional cone hats plowing fields are among the scenes on view. Dong Ho paintings are not truly paintings, but are stamped onto a special paper with woodblocks, one block for each color, and then set with scallop shell powder. The related Hang Trong pictures are stamped out with a single woodblock that provides the black outline. The artist then adds the colors by hand. Hang

This 1939 lacquer painting by Nguyen Gia Tri, housed in the museum's gallery of lacquer painting, is entitled *Young Girls in the Garden*. Photo: John McDermott.

Trong pictures frequently have religious themes, relating to the realms of the Buddhist cosmos and to important symbols of the supernatural world, although there are also engaging dragon processions and market scenes.

The funeral sculptures of Tay Nguyen in the central highlands of Vietnam are astonishing and worth a close look. The objects are very powerful in their execution, appearing almost African in design. The always-delightful water puppets of Vietnam, a charming favorite of both children and adults, are represented here as well.

These more traditional folk crafts are supplemented by installations of Vietnamese art from the first half of the twentieth century, including some lacquerware panels that illustrate the high level that this art form can take. Unlike the lacquer work of Burma and Thailand, which tends to take the three-dimensional form of jars, bowls, or some other type of container, lacquerware in Vietnam often took the

form of a flat, two-dimensional object with narrative or decorative scenes. These objects were durable in the relentless heat and humidity of Vietnam, and have survived to a greater degree than paintings on silk and paper. In addition, there are a number of historically significant paintings and woodcuts, primarily landscapes of the lush green rice paddies and mountains of this country, and realistic renditions of the human figure. As a broad generalization, Vietnamese art dating from before the French withdrawal in the 1950s shows a clear European influence in its composition and colors. Boats on the Perfume and Red Rivers are frequent subjects. There are usually lively watercolors of Hanoi street scenes dating to the early twentieth century on view in these galleries. The second-floor corridor that runs the length of the front of the structure is a good spot from which to appreciate the architecture. The visitor can frequently walk out on to the terrace over the entrance portico for a view of the front gardens.

This lovely arcade has windows that open to allow pleasant air circulation and benches upon which visitors can rest. It runs the length of the building and houses some objects from the collection. Photo: John McDermott.

The museum's strongest collections are the late-twentieth-century oil paintings, paintings on silk, and sculpture that are exhibited on the third floor of the museum. These reflect both traditional Vietnamese themes and iconography, and the influence of western media and thoughts. While these galleries may be of more limited interest to the Western visitor, the objects exhibited in them do very clearly reflect the history and culture of modern Vietnam. If the art of the earlier part of the century was influenced by the European aesthetic, the art afterward seems to mark a return to a more typical Chinese-influenced Asian palette. Work dating after the reunification of the country in 1975 often glorifies soldiers and workers and is rather strident in its tone and obvious in its iconography. Within the last fifteen years, though, as Vietnam has opened its doors to the world through its economic reform policy of *doi moi*, contemporary artists there have begun to hone their style and viewpoint. Many of the recent oil paintings, ceramics, and sculpture, while clearly Vietnamese, display a more global vision.

Vietnam's long history of war has not been kind to its art and culture, and the wonderful objects preserved and installed here serve as a haunting reminder of all that has been lost. The country is well served, however by this national collection that illustrates its long and distinguished artistic tradition.

THE MUSEUMS OF HOI AN:

MUSEUM OF HISTORY AND CULTURE, NGUYEN HUE STREET JUST NORTH OF TRAN PHU

MUSEUM OF TRADING CERAMICS, 80 TRAN PHU

MUSEUM OF SA HUYNH CULTURE, 149 TRAN PHU

MUSEUM OF THE REVOLUTION, 149 TRAN PHU (UPSTAIRS FROM THE MUSEUM OF SA HUYNH CULTURE)

HOI AN

OPEN: EVERY DAY FROM 7:00 A.M TO 6:00 P.M.

Now a quiet, tourism-oriented city, Hoi An was one of Southeast Asia's primary windows on the world from the sixteenth through the nineteenth centuries. Maritime traders from all over Europe (Dutch, French, Portuguese, and English) and Asia (Japanese and Chinese) and even from the United States called at Hoi An, then known as Faifo, to purchase the goods produced by the surrounding areas of Vietnam—silks, sugar, cinnamon, gold, and timber among them—and to sell their own wares. (Some material gathered by the Americans who visited Vietnam in the eighteenth century is housed in the Peabody-Essex Museum in Salem, Massachusetts.) Their presence and the influence that they left in Hoi An made it a truly international city during this period. As the officials of UNESCO wrote in 1999 when they declared Hoi An a World Heritage Site: "Hoi An is an outstanding material manifestation of the fusion of cultures over time in an international commercial port. . . ." and "an exceptionally well preserved example of a traditional Asian trading port."

Today many parts of the city appear as they did at the point in the late nineteenth century when the Thu Bon River began to silt up and become too shallow for trading ships to navigate. At this point, Danang superseded Hoi An as the major port of central Vietnam. As a result, Hoi An has remained a delightful backwater of history and culture which, along with Dalat in the central highlands, is one of the most pedestrian-friendly cities in the country. Time spent wandering its blissfully traffic-free streets is well spent and a pleasant respite from the frenetic activity typical of the rest of the country. Although the authors of the Passport Books guide to Vietnam have described Hoi An as "coming to resemble the 'Vietnam' pavilion in a Disney theme park," it has developed into a true center for the arts in recent years. Much work has been done on the museums here, and the art galleries that line Tran Phu and its side streets are some of the most interesting in Vietnam.

The various foreign groups that landed here left their mark. Hoi An was the major port through which the Japanese traded in the early seventeenth century. The most famous landmark in Hoi An is the Japanese Bridge at the far end of Tran Phu. In 1636, the Japanese placed a ban on foreign trade and, as a result, trade with Japan dwindled as Chinese influence grew. Hoi An seems to have been the first Chinese settlement in the southern part of Vietnam. The Chinese influence is visible in the overall atmosphere of the town, as well as in a series of assembly halls. The Dutch East Indies Company had a trading post here from 1636 to 1641. Locally, the cultures of the Sa Huynh and Cham people, and the Vietnamese melded here

The interior courtyard of the Museum of History and Culture lies adjacent to the Quan Cong Temple. Photo: John McDermott.

Temple bells exhibited in the Museum of History and Culture date between the seventeenth and nineteenth centuries. Photo: John McDermott.

The Museum of Trading Ceramics is housed in a restored building on Tran Phu, the main street. This is the upstairs gallery. Photo: John McDermott.

Ceramics from Vietnam (the two on the left), China, and Japan are on exhibit in the Museum of Trading Ceramics, illustrating the rich mercantile heritage of the city. Photo: John McDermott.

The Museums of Sa Huynh Culture and of the Revolution are housed in this historic building on Tran Phu. Photo: John McDermott.

Beads and other jewelry from the Sa Huynh culture are on display on the first floor. Photo: John McDermott.

and influenced the development of the city as well. The first city in Vietnam to experience the influence of Christianity following the arrival of French missionaries in the seventeenth century, Hoi An was also one of the early centers adopting *quoc ngu*, the Latinized script now in use throughout Vietnam. The French were the last to leave their architectural mark here in a series of well-preserved colonnaded French buildings. Hoi An was almost entirely destroyed in the late eighteenth century during the Tay Son Rebellion, the most famous of the many local rebellions of this period. Most of what exists today in Hoi An is from the nineteenth and early twentieth centuries, although much of the city fabric is older.

Given this wealth of architecture, the entire city of Hoi An is, in a very real sense, a museum, and each one of the four repositories that have been designated as the Museums of Hoi An tells a part of the story. Each is housed in a historical building and is usually staffed by helpful Vietnamese who speak some English. They are within easy walking distance of one another and are all worth visiting.

The Museum of History and Culture retains the layout of the seventeenth-century pagoda in which it is housed, and can be accessed from the Quan Cong Temple, with which it shares a courtyard. There is one large room subdivided at the back into three smaller but open spaces. The collection is eclectic and represents an overview of the history and cultures of central Vietnam. In the pre- and proto-history section are photographs and large burial urns from a number of archaeological sites in the area. The Cham culture is described as well, although not in as much detail as in the Cham Museum in Danang. Some Cham objects, including a figure from An Bang, are displayed here. The area devoted to the fifteenth through nineteenth centuries (referred to as the "Dai Viet" period) is the most detailed and features ceramics, coins, grave steles, and

early photographs of the Japanese and Chinese quarters of the city. There are three wonderful bronze or alloy bells from temples and palaces in Hoi An exhibited here. Two are from the seventeenth century; one is from the late nineteenth century. The photographs of historic Hoi An and the painting entitled *A Voyage to Cochinchina in the Year 1792 and 1793* by a London artist, J. Barrow, are worth a look, as well.

Hoi An made its fortune as a trading center, and the Museum of Trading Ceramics is devoted to this one valuable commodity that passed through the port. The building was once a private house and has been recently converted into a museum, which is as interesting for its architecture as for the collections housed inside. Courtyards are characteristic of the architecture of Hoi An, and the courtyard of this museum is especially lovely.

Vietnamese ceramics, particularly the blue-and-white ware from the seventeenth and eighteenth centuries, were prized commodities. Several beautiful examples of this blue-and-white ware are exhibited in the cases in this museum. According to a map on display, Vietnamese ceramics have been found all over East and Southeast Asia, and as far afield as Egypt. Some of the objects exhibited here are from a sixteenth-century shipwreck. The earliest evidence for trade in Vietnamese ceramics seems to date from the fourteenth century.

The Sa Huynh culture, a civilization that appears to be related to the Dong Son culture of northern Vietnam, developed in the area around Hoi An from the middle of the third millennium B.C. The Museum of Sa Huynh Culture serves as a repository for the artifacts of this culture, most of which have been found in burial sites. There are over 50 Sa Huynh sites in the vicinity of Hoi An, primarily near rivers and the ocean. The objects that have survived are primarily large-scale burial urns and their contents. Some of these vessels have cross-hatch decoration on them, and

The Museum of the Revolution is housed on the second floor. Photo: John McDermott.

were found with jewelry and gems inside.

Upstairs from the Museum of Sa Huynh Culture is the local Museum of the Revolution, which documents the participation of the people of Hoi An in the Vietnamese struggle for independence. In truth, much of the revolution bypassed Hoi An. The city was almost untouched during the American involvement in Vietnam. The members of the Executive Committee of the Hoi An Communist Party in the group photograph on the wall look more prepared for a tennis match than for insurgent activities. The views from the balcony on the second floor are lovely.

Hoi An's designation as a World Heritage Site in 1999 will ensure that development and change here are limited and the professionals in the museum community here are committed to improving the interpretation of both the history and culture of the city for the visitors. As an old sign at the end of the exhibition space of the Museum of History and Culture proclaims, "Being proud of the golden time of the town, Hoianians today are thoroughly conscious of their responsibility towards the town in preserving and restoring work for its brighter future."

MUSEUM OF VIETNAMESE HISTORY

2 NGUYEN BINH KHIEM, DISTRICT 1
HO CHI MINH CITY

TEL: 08–829–8146

OPEN: MONDAY THROUGH SATURDAY FROM 8:00 A.M. TO 11:30 A.M.
AND FROM 1:30 P.M. TO 4:30 P.M.; SUNDAYS AND HOLIDAYS FROM
8:30 A.M. TO 4:30 P.M.

The lovely French colonial building that houses the Museum of Vietnamese History sits in a lively and well-attended park that also features the city zoo inside its gates. The structure itself is a loose interpretation of a pagoda, with a bright yellow exterior and a red tile roof. The open-windowed galleries are arranged around a central courtyard. This ensures adequate air circulation to help keep the galleries relatively cool in Ho Chi Minh City's tropical climate. The museum was originally founded in 1929 as the Musée Blanchard de la Brosse by the Société des Etudes Indochinoises, and was renamed the National Museum of Vietnam in Saigon from 1956 to 1975. After the reunification of the country in 1975, the museum was expanded and accorded its current name.

The Museum of Vietnamese History takes as its mission to "reflect the historical aspects of a people and express the cultural characteristics of the Southern provinces." The installation reflects this dual purpose. The first group of galleries is devoted to the general history and cultural background of Vietnam and its place in the region; other galleries are dedicated specifically to the history and culture of the southern regions of Vietnam. The collections are extensive and encompass objects ranging from prehistoric grinding tools to early twentieth-century photographs of the city of Saigon, as Ho Chi Minh City was known before 1975. In fact, the galleries here are jammed with an encyclopedic collection of historical and cultural material, representative of the early Funan

kingdom of Vietnam, as well as objects from the Khmer and Han Chinese periods. There is also an extensive group of objects from the Vietnamese imperial dynasties. The collection of Cham sculpture complements that of the Museum of Cham Sculpture in Danang in both its depth and its breadth.

The graceful entrance rotunda houses a variety of installations rotating from the museums on a regular basis. This may include ceramics from around Asia, or an exhibition of bronzes from the time of the Nguyen emperors. Different objects are on display at different times.

The earliest objects exhibited in the galleries are Paleolithic tools from Do Mountain in Thanh Hoa Province, dating to approximately 300,000 B.C., and axes and grinding blocks from the Bac Son culture, dating to about 6,000 B.C. There are also burial jars and jewelry from the Sa Huynh culture, and a number of wonderful bronzes from the Dong Son culture dating to about 1000 B.C.

The Chinese held sway over Vietnam from 179 B.C. to A.D. 938. After the collapse of the Tang dynasty in the early tenth century, the Vietnamese revolted against their Chinese masters and at the Battle of Bach Dang in 938 defeated them, ending over 1,000 years of Chinese rule. The diorama of the Battle of Bach Dang in gallery 3—in a sense, Vietnam's first battle of liberation—is one of the most popular installations in the museum. In this room there are also photographs of the tombs and monuments of the national heroes and heroines of Vietnam. A small gallery just

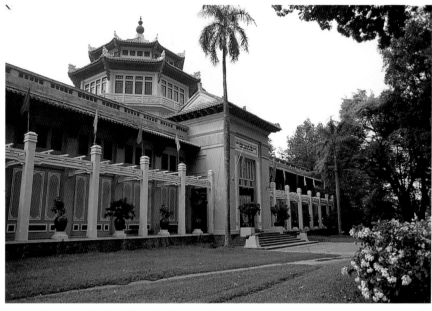

Built in 1929, the building that houses the Museum of Vietnamese History is one of the most beautiful of the remaining French colonial buildings in Ho Chi Minh City. Photo: John McDermott.

off this one contains mummies from the Xom Cai tomb, discovered in the vicinity of Ho Chi Minh City, and dating to 1869.

Several decades after the defeat of the Chinese at the Battle of Bach Dang, power in Vietnam was consolidated under the emperors of the Ly Dynasty (1010–1225). From this point until Emperor Bao Dai from the Nguyen Dynasty abdicated the throne in 1945, a series of dynasties ruled the independent country, specifically the Tran dynasty (1225–1400), the Le Dynasty (1428–1788; though this period is frequently subdivided by historians), the Tay Son Dynasty (1788–1802) and the Nguyen dynasty (1802–1945). A fine collection of objects from these dynasties is exhibited in the next several rooms, although more comprehensive material related to the Nguyen dynasties can be found in the Royal Fine Arts Museum in Hue. The most interesting objects exhibited in the room are thirteen bronze vessels from the time of Emperor Minh Mang (reigned

1820–1840). Minh Mang ordered the casting of prototypes of 33 distinct types of bronze vessels in 1839. Twenty of these have been lost, but are known from the contemporaneous publication, "The King's Inscriptions on Vessels." The other thirteen are exhibited here and offer a partial encyclopedia of the history of bronze casting. Performances of the water puppets, a traditional Vietnamese entertainment, take place on a regular basis in a small theater off gallery 10. Scheduling a visit to include one of these performances will prove well worthwhile.

Beginning in gallery 10, the installations are devoted to the cultures and history of southern Vietnam. These are the most comprehensive galleries in the museum. Several outstanding objects represent the Oc-Eo culture. Oc-Eo was the major port city—although not the capital—of the ancient Hindu Kingdom of Funan, which was at its zenith in the first half of the first millennium A.D.

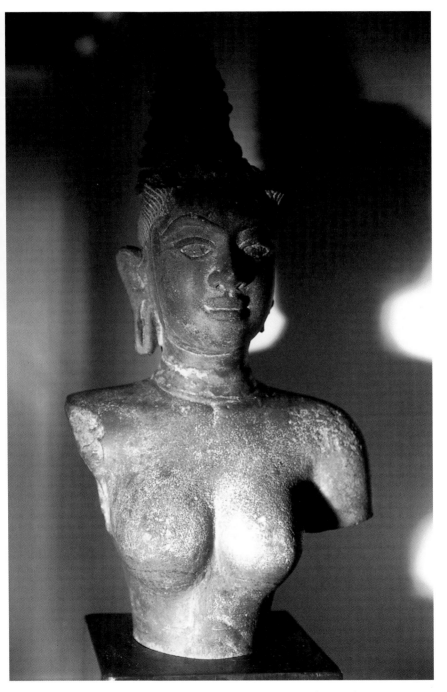

This figure of a Devi is housed in the Cham sculpture gallery. Photo: John McDermott.

A mummy from the tombs at Xom Cai is one of the most popular displays in the museum. It dates to the mid-nineteenth century. Photo: John McDermott.

This gallery is devoted to the art of the Le Dynasty, from the fifteenth to the eighteenth centuries. Photo: John McDermott.

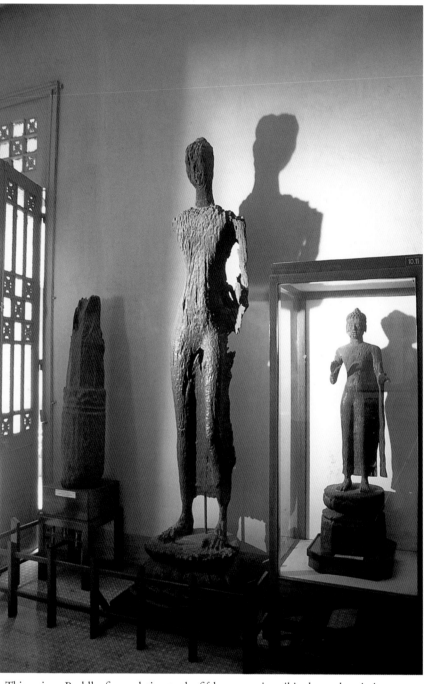

This unique Buddha figure dating to the fifth century is strikingly modern in its stance and figural composition. Photo: John McDermott.

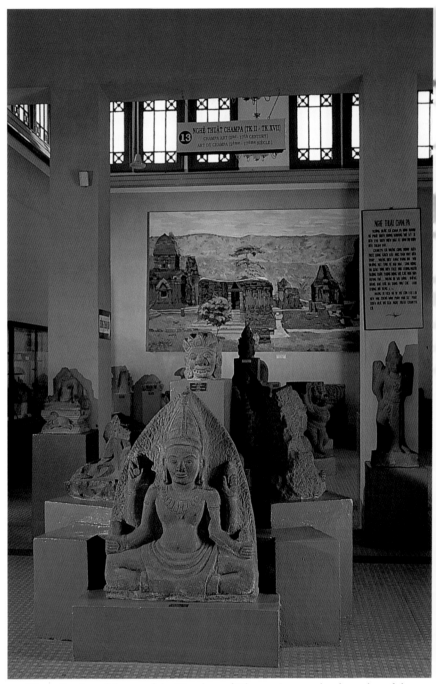

The collection of the art of the Kingdom of Champa is second only to that of the Museum of Cham Sculpture in Danang. Photo: John McDermott.

As was true of most of the coastal kingdoms of Southeast Asia (and like Hoi An a thousand years later), Funan was a trading empire. While there is not much of Oc-Eo left today, objects from its culture have survived and are exhibited here. A wooden Buddha from Long An Province (c. A.D. 500) and an astonishing elongated and attenuated Buddha (c. A.D. 400) from Dong Thap Province are two of the highlights in this gallery. The extent of Funan's reach is illustrated by a coin of the Roman Emperor Antoninus Pius, dated to A.D. 152, and found at Oc-Eo. On a more practical front, there is an interesting display of mortars and pestles.

Gallery 11 is devoted to the ancient, primarily stone, sculpture of the Mekong Delta. Dating from the seventh to the twelfth centuries, many of these objects were influenced by the pre-Angkorian kingdom of Chenla, which had an extensive number of settlements on the Mekong. There are two very endearing Ganeshas, as well as a wonderful horse head and goddess figure, both from the tenth century.

Gallery 12 highlights the long history of the city of Saigon, one of the most beautiful of the French cities in Indochina, and a city with a considerable history prior to the arrival of the French. A collection of photographs and drawings recalls the days when the city, named after the wood of the kapok tree, was known as the Pearl of the Orient. Many buildings and scenes from the colonial period are displayed here in photographs, notably the main market in Saigon (c. 1923) and the Central Post Office (across the street from the French cathedral) from the early twentieth century.

The art of Champa, the grand empire of central and southern Vietnam from the second through the fifteenth centuries (of which a small part survived until the early eighteenth century, when the surviving Cham people fled to Cambodia), is well represented in gallery 13. While not as extensive as the collection in Danang, this collection does contain some outstanding pieces. The provenance of these objects is interesting. Many of them had been collected by the Société des Etudes Indochinoises and were transferred to Saigon in 1929 when the original museum was founded. The Ecole Française d'Extrême Orient transferred other items from the Musée Louis Finot in Hanoi to this museum. Other pieces have been acquired by the museum since 1975.

An elegant bronze standing Buddha from Dong Duong and a late ninth-century sandstone Devi figure bear witness to the genius of Cham sculpture. In addition, there are some charming figures of elephants from the seventh to the tenth centuries, and wonderful sandstone figures of *apsaras* and dancers. The Tra Kieu period of the ninth and tenth centuries is particularly well represented by figures of lions, garudas, and other beasts. A number of smaller objects are exhibited here, as well.

Gallery 14 contains an ethnographic survey of the minority peoples of southern Vietnam. For those who have visited the Vietnam Museum of Ethnology in Hanoi, the treatment here may seem somewhat synoptic, but for those who have not, it can offer an introduction to the subject through photographs of the people of Vietnam, carvings, and a helpful map of minority settlements.

Before one leaves the museum, the objects in gallery 15 give a comparative look at the iconography of the figure of the Buddha in Asia. There is little or no explanation of the differences and the imagery, but the Buddha figures from Vietnam, Cambodia, Thailand, China, and Japan exhibited here provide a visual—and quite self-explanatory—panorama of the subject.

The brightly colored gowns of the Nguyen emperors are a highlight of the exhibition space. Photo: John McDermott.

MUSEUM OF ROYAL FINE ARTS

3 LE TRUC STREET
HUE

OPEN: EVERY DAY FROM 6:30 A.M. TO 6:30 P.M DURING THE SUMMER;
FROM 7:00 A.M. TO 5:30 P.M. DURING THE WINTER.

The Nguyen Dynasty, the last royal rulers of Vietnam, controlled the country from 1802 to 1945 from the capital city of Hue in central Vietnam. During this period, Vietnam was, for the first time, unified from the northern border with China to the South China Sea and the Gulf of Thailand including all the territory that comprises the present country. The period of the Nguyen Dynasty also saw the arrival of the French. The French attacked several times in the decades of the 1840s and 1850s. A series of skirmishes over the next few decades resulted in the Emperor Tu Duc signing a treaty in 1862 giving the French three provinces in Cochinchina in the south and the whole of Cochinchina soon became a French colony. In 1882, French forces seized Hanoi, and soon after, the royal city of Hue was declared a French Protectorate. As the influence of the French—and especially the influence of one of their chief exports, Catholicism—spread, the influence of the Nguyen emperors waned. By the time of the abdication of Emperor Bao Dai in 1945, the dynasty was no more than a façade with little to support it. The end of the Nguyen dynasty marked the beginning of the final thirty-year struggle of the Vietnamese for independence.

The departing dynasty left behind an impressive range of architecture in Hue, much of it based on Chinese prototypes. In particular, the huge citadel with its Forbidden Purple City, the Hall of the Mandarins, and the nine Dynastic Urns, was much influenced by Chinese art and architecture. Unfortunately, the former imperial city of Hue was the site of some of the bloodiest and most violent fighting of the Tet Offensive in 1968, and much of this architectural legacy now lies in ruins. Although the complex is in the process of being restored, fields are now tilled and cultivated where magnificent buildings once stood.

However, the tombs of the Nguyen emperors in the countryside surrounding the Perfume River still survive to a large extent, and embody some of the great remains of nineteenth- and early twentieth-century Vietnam. In particular, the tombs of Minh Mang, built in the early 1840s, and of Tu Duc, built in the mid 1860s, are accessible and well worth the day-long excursion from Hue. The last of these tombs, that of Khai Dinh built in the 1920s, is constructed of concrete and shows the clear influence of Western art. Its siting is lovely, but the execution is clumsy and heavy when compared with the traditional Vietnamese architecture evident in the earlier tombs.

The Nguyen emperors left a rich material legacy. Although many of the best objects were destroyed during decades of war, the Hue Museum of Royal Fine Arts houses a selection of furniture and other household articles used by members of the royal families during the nineteenth and early twentieth centuries. The museum is housed in the attractive Long An Palace, built by the Emperor Thieu Tri in 1845 on a different site. Dismantled and rebuilt on the present site in 1909, the museum occupies a quiet, green compound near the Imperial City and the Hue Military Museum. The collections consist primarily of objects used by the Nguyen emperors

The Long An Palace now houses the Hue Museum of Royal Fine Arts. Built by the Emperor Thieu Tri in 1845, it was moved here in 1909. Photo: John McDermott.

These awe-inspiring ceremonial weapons are on display in the museum.
Photo: John McDermott.

The stunning visual impression conveyed by the interior galleries is a highlight of any visit to the museum. The intricate wood architectural detailing adds to the elegant atmosphere. Photo: John McDermott.

and their families in their daily lives and are housed in one large room with several levels and many columns and beams, and lit primarily with natural light from the windows and doors. Generally, the objects are arranged by medium within the museum.

As is true of many museums in the country, this one has been known by several different names during its history. Originally designated as the Musée Khai Dinh, it became the Museum of Antiques in 1947, and the Hue Museum (also called, at times, the Imperial Museum) in 1958. It was renamed the Hue Museum of Royal Fine Arts in 1995. As is the case at many museums in this region of the world, the surroundings are of as much interest as the objects in the museums. The lines of the building are graceful, and both the exterior and interior architectural detailing are worth a close look (in particular, the inscriptions inside). The grounds are very attractive, and a number of bronze bells, historic cannons, gongs, and stone figures are exhibited here. The atmosphere of the

grounds actually follows the visitor inside; as one walks through the museum, the chirps and calls of the birds and insects living in the museum compound are audible throughout the building.

The collections here indicate that the Nguyen emperors lived up to their royal status. Furniture, household goods, and clothing are all of elegant design and execution, and the strong influence of Chinese style and art is quite evident.

Household items appear to have come from all over Asia, and even beyond. Chinese wine jugs of the eighteenth and nineteenth centuries and Japanese porcelain jars of the seventeenth and eighteenth centuries vie with glass and crystal imported from France by the last two emperors, Khai Dinh and Bao Dai. (Among these is an incongruous glass shade with a Christmas tree on it.) Wonderful silk books used during the reign of Tu Duc are exhibited together with silver objects, incense burners, and stone tea sets used at the Royal Palace.

Incense was burned in elaborate urns such as this, which is a smaller version of some of the giant incense urns inside the Imperial City. Photo: John McDermott.

The emperor's servants would have carried this royal sedan chair. The red lacquer and gold are typical of the decorative taste of the Nguyen dynasty. Photo: John McDermott.

The stones on this armature were played like chimes or bells. Photo: John McDermott.

Blue-and-white porcelain, celadon, teapots, and a variety of ivory objects were also used at the court.

The royal furniture is of particular note. A rattan screen from the reign of Tu Duc and a series of large metal and ceramic bowls used for weighing rice are prominently displayed. The emperors favored red lacquer. A large collection of red-lacquered furniture from the time of Khai Dinh and a red-lacquer sedan chair are both on view in the back of the museum. In addition, traditional Vietnamese mother-of-pearl furniture, including a round table and four chairs and a large square table with a marble top and two benches for seats, is on view, as is a unique glass screen with bat and phoenix designs flanking a sun.

Music was very important to the Nguyen emperors and the instruments included in the collection are of great interest. Especially fascinating is a group of stones of varying sizes hung in two tiers from an armature to form an exotic and large scale Vietnamese version of hanging bells.

One of the clear highlights of the collection is the silk robe collection of the emperors and empresses. Of particular note are the fabulous and brightly colored robes of Tu Duc and Minh Mang, exhibited at the back of the museum.

The overwhelming impression created by the objects displayed here is that of a demoralized dynasty, increasingly powerless, and reduced to living behind closed doors in the isolation of the Imperial Palace. However, many of the individual objects are wonderful, and the museum and its lovely building and grounds provide a very good introduction to the early modern history of the city of Hue. Given the events of the thirty years that followed the end of the Nguyen dynasty, these objects comprise an ever more precious record of a recently disappeared past.

APSARA: a celestial dancing maiden in Hindu mythology, frequently bare-breasted, born from the Churning of the Sea of Milk, as shown in the relief sculptures of Angkor Wat; the *apsaras* are depicted in the art of the kingdoms of Angkor and Champa.

AVATAR: a deity who descends from heaven to earth; frequently used to refer to one of the ten incarnations of Vishnu on earth.

BENCHARONG: a Thai term meaning "five colors" and used to describe a type of enameled ware originally produced in China for the Thai and to Thai specifications; now produced in Thailand.

BODHISATTVA: an enlightened being; in Theravada Buddhism (see below), the Buddha was a Bodhisattva prior to attaining enlightenment; in Mahayana Buddhism, a Bodhisattva is a being who has achieved enlightenment but who has chosen to remain on earth to help others achieve a similar status.

BODHI TREE: the sacred tree under which the Buddha achieved enlightenment; frequently used as a symbol of the presence of the Buddha in a scene.

BRAHMA: one of the gods of the Hindu trinity; the Creator.

BUDDHA: one who has achieved enlightenment and an understanding of the causes of human suffering and who, through this understanding, is freed from the cycle of birth and rebirth; also, the historic figure (Prince Siddhartha, born in Lumbini in southern Nepal).

BUDDHISM: religion originally dating to the sixth century B.C. that advocates respect for all life; major branches are Theravada Buddhism (practiced in Myanmar, Thailand, parts of Laos, Cambodia, and Sri Lanka; emphasizes individual achievement of enlightenment), Mahayana Buddhism (predominant in Vietnam, China, Korea, Japan, and parts of Tibet and Nepal; utilizes Bodhisattvas to assist in achieving enlightenment), and Tantric or Vajrayana Buddhism (practiced primarily in Tibet and the Himalayan regions; a more mystical form of Buddhism).

CHAM: peoples who inhabited central and southern Vietnam; the Cham people still survive in small numbers today in Vietnam and in Cambodia.

CHEDI: a solid monument built to enshrine a relic of the Buddha or of one of his followers; essentially the same as a stupa.

DEVA/DEVI: Sanskrit term for a god or goddess.

DONG SON: referring to a Bronze Age and early Iron Age archaeological site in northern Vietnam; also used to refer to the entire culture.

GARUDA: a mythological bird frequently depicted as half-human; in Hindu mythology, the chariot or vehicle of Vishnu.

HINDUISM: Indian polytheistic religion with origins in the second millennium B.C.

ISLAM: monotheistic religion based on the teachings of Mohammed as detailed in the Koran; predominant religion of Malaysia, Indonesia, and Brunei today.

JATAKA: scenes and stories from the life story of the Buddha; each story illustrates a virtue.

KHMER: referring to the people, language, or, more generally, to the civilization of Cambodia, or of Angkor.

KINNARA/KINNARI: celestial creature that

is half-human and half-bird.

MAHABHARATA: one of the two great Indian epics; stories from the *Mahabharata* are frequently depicted in the narrative art of Southeast Asia.

MARA: evil tempter of the Buddha.

MUDRA: a hand gesture, posture, or "attitude" of the Buddha; each mudra of the Buddha has a different and specific meaning—dispelling fear, subduing Mara, preaching, meditating, teaching, praying for rain, etc.

NAGA: a sacred snake in Hindu mythology.

PRANG: Thai term for a sanctuary tower.

RAMAYANA: one of two great Indian epics, telling the story of Prince Rama; stories from the *Ramayana* are frequently

depicted in the narrative art of Southeast Asia.

SHIVA: one of the gods of the Hindu trinity; most frequently depicted as the Destroyer, although he is also a Creator; also spelled Siva.

STELE: stone tablet usually set into the ground, frequently large, with writing or figures inscribed on it.

STUPA: a Buddhist shrine, at times containing some relic of the Buddha; used interchangeably with chedi.

VISHNU: one of the Hindu trinity; the Protector; also spelled Visnu.

WAT: in Thailand and in Laos, a complex of Buddhist religious buildings usually including a temple, sleeping quarters, teaching quarters, and a crematorium, and frequently surrounded by a wall.

BIBLIOGRAPHY

ASEAN Committee on Culture and Information. *The Directory of the Museums of ASEAN.* ASEAN, 1988.

Cao Trong Thiem, editor. *Vietnam Fine Arts Museum.* Hanoi, 1999.

Chandavij, Natthapatra and Pramualratana, Promporn. *Thai Puppets & Khon Masks.* Bangkok: River Books, 1998.

Dagens, Bruno. *Angkor: Heart of an Asian Empire.* New York: Harry N. Abrams, Inc., 1995.

Fisher, Robert E. *Buddhist Art and Architecture.* New York: Thames and Hudson, 1993.

Frey, Edward. *The Kris: Mystical Weapon of the Malay World.* Oxford University Press, 1986.

Girard-Geslan, Maud; Klokke, Marijke J.; Le Bonheur, Albert; Stadtner, Donald M.; Zaleski, Valérie; Zéphir, Thierry; and Underwood, J.A. *The Art of Southeast Asia.* New York: Harry N. Abrams, Inc., 1998.

Guide to the National Museum Bangkok. Bangkok: Division of National Museums, Department of Fine Arts, third edition, 1994.

ICOM Asia Pacific Organisation. *Directory of Museums of the Asia Pacific Countries: Volume I.* Paris: ICOM, 1993.

Jessup, Helen Ibbitson, and Zéphir, Thierry, editors. *Sculpture of Angkor and Ancient Cambodia: Millenium of Glory.* National Gallery of Art, Washington, D.C., 1997.

Kamm, Henry. *Cambodia: Report from a Stricken Land.* New York: Arcade Publishing, 1998.

Kwok Kian Chow. *Channels and Confluences: A History of Singapore Art.* Singapore: Singapore Art Museum, 1996.

Lewis, Paul and Elaine. *Peoples of the Golden Triangle: Six Tribes in Thailand.* New York: Thames and Hudson, 1984.

Museum of Cham Sculpture in Danang. Hanoi: Foreign Languages Publishing House, 1987.

Narula, Karen Schur. *Voyage of the Emerald Buddha.* Kuala Lumpur: Oxford University Press, 1994.

National Heritage Board, Singapore. *Collecting Memories: The Asian Civilisations Museum at the Old Tao Nan School.* Singapore, 1997.

Nguyen Vinh Phuc. *Hanoi: Past and Present.* Hanoi: Gioi Publishers, 1995.

Rawson, Philip. *The Art of Southeast Asia.* New York: Thames and Hudson, 1990.

Siam Society. *The Kamthieng House: An Introduction.* Bangkok: The Siam Society, 1966.

Siam Society and Davis, Bonnie. *The Siam Society Under Five Reigns.* Bangkok: The Siam Society, 1989.

Strachan, Paul. *Pagan: Art and Architecture of Old Burma.* Tokyo: John Weatherhill, Inc., 1995.

Subhadradis Diskul, M.C.; Warren, William; Pokakornvijan, Oragoon; and Baidikul, Viroon. *The Suan Pakkad Palace Collection.* Bangkok: Chumbhot-Pantip Foundation, second printing, 1991.

Suksri, Naengnoi and Freeman, Michael. *Palaces of Bangkok: Royal Residences of the Chakri Dynasty.* London: Thames and Hudson, 1996.

Tarling, Nicholas, editor. *The Cambridge History of Southeast Asia.* Cambridge, England: Cambridge University Press, 1995.

Tribal Research Institute, Technical Service Club. *The Hill Tribes of Thailand.* Chiang Mai: fourth edition, reprinted 1998.

Vietnam Historical Museum. *Champa Collection.* Ho Chi Minh City: 1994.

Vietnam Museum of Ethnology. Ho Chi Minh City: Vietnam Museum of Ethnology, 1998.

Warren, William. *The Prasart Museum: Treasures of Thailand.* Singapore: Ibis Books, 1990.

Warren, William. *The House on the Klong: The Bangkok Home and Asian Art Collection of James Thompson.* Tokyo: John Weatherhill, Inc., seventeenth printing, 1996.

Warren, William. *Arts and Crafts of Thailand.* San Francisco: Chronicle Books, 1996.

Page numbers in *italics* refer to illustrations